Digital Photography
Top 100
3rd Edition

Simplified®

TIPS & TRICKS

by Rob Sheppard

Visual

Wiley Publishing, Inc.

Digital Photography: Top 100 Simplified® Tips & Tricks, 3rd Edition

Published by
Wiley Publishing, Inc.
111 River Street
Hoboken, NJ 07030-5774

Published simultaneously in Canada

Copyright © 2007 by Wiley Publishing, Inc., Indianapolis, Indiana

Library of Congress Control Number: 2007931522

ISBN: 978-0-470-14766-5

Manufactured in the United States of America

10 9 8 7 6 5 4 3 2 1

Trademark Acknowledgments

Contact Us

For general information on our other products and services contact our Customer Care Department within the U.S. at 800-762-2974, outside the U.S. at 317-572-3993 or fax 317-572-4002.

For technical support please visit www.wiley.com/techsupport.

Permissions

Canon camera images by Canon U.S.A., Inc.

Olympus camera images by Olympus America Inc.

Wiley Publishing, Inc.

U.S. Sales

Contact Wiley at (800) 762-2974 or fax (317) 572-4002.

PRAISE FOR VISUAL BOOKS

"I have to praise you and your company on the fine products you turn out. I have twelve Visual books in my house. They were instrumental in helping me pass a difficult computer course. Thank you for creating books that are easy to follow. Keep turning out those quality books."
Gordon Justin (Brielle, NJ)

"What fantastic teaching books you have produced! Congratulations to you and your staff. You deserve the Nobel prize in Education. Thanks for helping me understand computers."
Bruno Tonon (Melbourne, Australia)

"A Picture Is Worth A Thousand Words! If your learning method is by observing or hands-on training, this is the book for you!"
Lorri Pegan-Durastante (Wickliffe, OH)

"Over time, I have bought a number of your 'Read Less - Learn More' books. For me, they are THE way to learn anything easily. I learn easiest using your method of teaching."
José A. Mazón (Cuba, NY)

"You've got a fan for life!! Thanks so much!!"
Kevin P. Quinn (Oakland, CA)

"I have several books from the Visual series and have always found them to be valuable resources."
Stephen P. Miller (Ballston Spa, NY)

"I have several of your Visual books and they are the best I have ever used."
Stanley Clark (Crawfordville, FL)

"Like a lot of other people, I understand things best when I see them visually. Your books really make learning easy and life more fun."
John T. Frey (Cadillac, MI)

"I have quite a few of your Visual books and have been very pleased with all of them. I love the way the lessons are presented!"
Mary Jane Newman (Yorba Linda, CA)

"Thank you, thank you, thank you...for making it so easy for me to break into this high-tech world."
Gay O'Donnell (Calgary, Alberta,Canada)

"I write to extend my thanks and appreciation for your books. They are clear, easy to follow, and straight to the point. Keep up the good work! I bought several of your books and they are just right! No regrets! I will always buy your books because they are the best."
Seward Kollie (Dakar, Senegal)

"I would like to take this time to thank you and your company for producing great and easy-to-learn products. I bought two of your books from a local bookstore, and it was the best investment I've ever made! Thank you for thinking of us ordinary people."
Jeff Eastman (West Des Moines, IA)

"Compliments to the chef!! Your books are extraordinary! Or, simply put, extra-ordinary, meaning way above the rest! THANKYOU THANKYOU THANKYOU! I buy them for friends, family, and colleagues."
Christine J. Manfrin (Castle Rock, CO)

CREDITS

Project Editor:
Tim Borek

Acquisitions Editor:
Kimberly Spilker

Copy Editor:
Scott Tullis

Technical Editor:
Lee Musick

Editorial Manager:
Robyn Siesky

Business Manager:
Amy Knies

Editorial Assistant:
Laura Sinise

Manufacturing:
Allan Conley
Linda Cook
Paul Gilchrist
Jennifer Guynn

Book Design:
Kathie Rickard

Production Coordinator:
Adrienne Martinez

Special Help:
Cricket Krengel
Jade Williams

Layout:
Carrie Foster
Jennifer Mayberry
Amanda Spagnuolo
Christine Williams

Screen Artist:
Jill Proll

Illustrators:
Ronda David-Burroughs

Cover Design:
Anthony Bunyan

Proofreader:
Broccoli Information Management

Quality Control:
John Greenough

Indexer:
Sherry Massey

Vice President and Executive Group Publisher:
Richard Swadley

Vice President and Publisher:
Barry Pruett

Composition Director:
Debbie Stailey

Wiley Bicentennial Logo:
Richard J. Pacifico

ABOUT THE AUTHOR

Rob Sheppard was the long-time editor of *Outdoor Photographer* and helped launch *PCPhoto* magazine. He is recognized for his commitment to helping photographers learn and understand the technology and art of photography. He facilitates workshops throughout the country and has authored 20 books about photography, including *The National Geographic Field Guide to Photography: Digital, The Outdoor Photographer Landscape and Nature Photographer's Guide to Photoshop CS2,* and *Adobe Camera Raw for Digital Photographers Only.* His website is at www.robsheppardphoto.com.

HOW TO USE THIS BOOK

Digital Photography: Top 100 Simplified® Tips & Tricks includes 100 tasks that reveal cool secrets, teach timesaving tricks, and explain great tips guaranteed to make you more productive with digital photography. The easy-to-use layout lets you work through all the tasks from beginning to end or jump in at random.

Who is this book for?

You already know photography basics. Now you'd like to go beyond, with shortcuts, tricks and tips that let you work smarter and faster. And because you learn more easily when someone *shows* you how, this is the book for you.

Conventions Used In This Book

① Steps

This book uses step-by-step instructions to guide you easily through each task. Numbered callouts on every screen shot show you exactly how to perform each task, step by step.

② Tips

Practical tips provide insights to save you time and trouble, caution you about hazards to avoid, and reveal how to do things in <Topic> that you never thought possible!

③ Task Numbers

Task numbers from 1 to 100 indicate which lesson you are working on.

④ Difficulty Levels

For quick reference, the symbols below mark the difficulty level of each task.

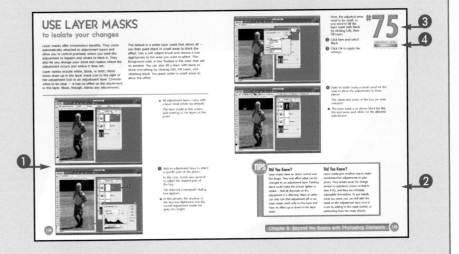

DIFFICULTY LEVEL	Demonstrates a new spin on a common task
DIFFICULTY LEVEL	Introduces a new skill or a new task
DIFFICULTY LEVEL	Combines multiple skills requiring in-depth knowledge
DIFFICULTY LEVEL	Requires extensive skill and may involve other technologies

Table of Contents

Table of Contents

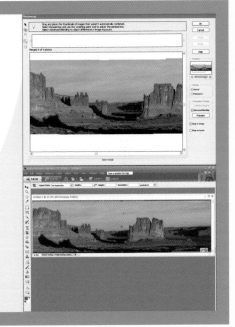

Table of Contents

Chapter 1

Get Ready to Take Photos

No matter what your preference for subject matter or your level of photographic skill, you can always improve your photography if you do the right things before shooting. A little preplanning and forethought can go a long ways in helping you get better photos.

Choosing what and where to shoot is the first step that you must take before shooting. You can find good events, places, and subjects to shoot all around you if you stay alert to the possibilities. Read local newspapers, check out travel books, or browse online resources to find out what is happening in your area. You can find great photo opportunities at local fairs, botanical gardens, nature preserves, national parks, or even zoos. And when outside shooting is difficult, consider setting up a still life inside or creating a mini-studio situation so you can photograph at any time.

The more you know about your equipment, the more you can concentrate on getting the photographs that you want and not on learning how to use your camera. Spend time with your camera and its manual before you have to use it for something important. It can be very disappointing spending valuable time and money to take a trip only to find that you did not take good photos due to improper camera settings or lack of knowledge about how certain features work.

When you go to shoot, you will be more satisfied if you are realistic; a day of shooting does not always result in one or more good photos. All photographers have bad days that end up with only mediocre photos — especially when the shooting conditions work against you!

Select good
PHOTO OPPORTUNITIES

The best photo opportunities for any photographer are those subjects that you enjoy. Why not photograph those things you have an affinity for? If you enjoy gardening and appreciate the thousands of different variations of iris, shoot irises. Or if you are a people-watcher and find pleasure in observing folks in action, choose places where you can find active people in settings that make great photographs.

When planning a trip, give yourself plenty of time to stay and take photographs. Allow yourself some flex time to compensate for bad weather or other shooting conditions that might prevent you from photographing. You might spend an entire day or more at a location, but the light never really becomes good enough to shoot. Avoid the scheduling trap of trying to see too much too quickly. You may miss the kinds of shots that you had hoped to capture because you saw everything, but shot little. Photography takes time, and time is often the most important factor in capturing truly great photographs.

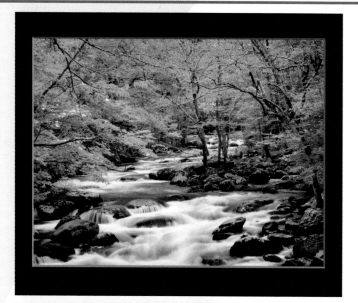

When shooting well-known places such as the Great Smokies in Tennessee or Arches National Park in Utah, take the traditional shot and then shoot creatively, too.

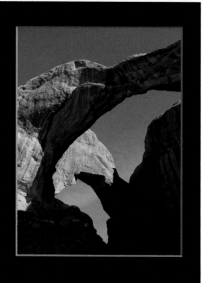

Being patient can pay off with the right light. The famed Double Arch in Arches National Park needs a certain combination of sun and shade in order to look its best.

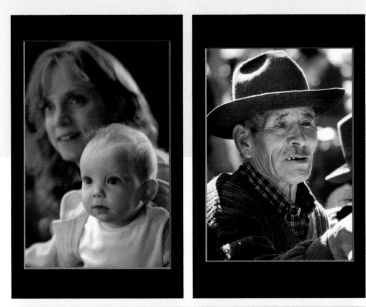

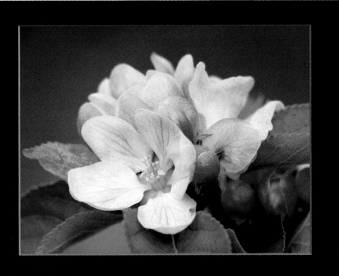

People are easiest to photograph when they are involved in activities that keep their attention away from the camera.

#1

DIFFICULTY LEVEL

When traveling, markets can be great places to photograph people, such as this gentleman in Chinchero, Peru. Markets are a place where people are more involved in buying and selling than in paying attention to a photographer.

Gardens offer terrific opportunities for interesting and colorful close-up images, such as this shot of crab apple blossoms.

TIPS

Photo Tip!

When you find a good place to take photographs, visit it again and again. Your images will improve each time that you return because you will learn the best times and subjects for photos.

Did You Know?

Some of the best photo opportunities may be in your own backyard. Explore details, shapes, or colors that might make good photographs and give them a try. A digital camera's LCD review will help your refine your shots.

Photo Tip!

Use the Internet to learn where and when to shoot. There are many online guides and forums that provide all the information you need to find wonderful places and subjects to shoot that will suit your interests.

It starts with
FOUR LETTERS

Most photo enthusiasts today began with film. Many of them have enjoyed the advantages of digital cameras, but they feel uncomfortable with computers and the digital world. They often think that all this digital stuff adds a layer of complexity that can be difficult, so much so that it can prevent them from really getting the most from this new technology. By keeping in mind the letters *I*, *C*, *A*, and *N*, you can overcome any apprehension you may have about shooting digital photos.

The letters *I*, *C*, *A*, and *N* represent possibility and potential. Put them together and you get the phrase "I can," thereby banishing the thought, "I can't."

There is no question that a lot of photographers get stopped by some of the new digital tools and throw up their hands saying, "I can't do this."

Everyone from teenagers to octogenarians can learn digital photography and love its possibilities. "I can" does not mean that you can do everything right away. After all, no serious photographer understood everything about a film camera without some study and practice. You might not know it all right away, and you might still be working on learning the technology, but with practice, you will be able to accomplish great things with your digital camera and the computer!

From your family to exotic foreign locations, possibilities for great photos are everywhere. A lot of your success depends on your ability to silence the self-critic and say, "I can do this!" for your photography. At left, an intimate portrait of brother and sister shot to emphasize the graphic and color qualities of the image.

Travel gives you wonderful chances for new subjects, but remember that in popular locations like this in Cusco, Peru, a lot of photographers have already taken pictures of striking architecture. Just taking an attitude of "I can find something different here" can lead to new and interesting compositions.

DIFFICULTY LEVEL

Layers intimidate a lot of photographers. It looks so alien to photography that "I can't" escapes and runs amuck in their heads. That does not have to be the case. You might not understand layers yet, but you will discover how useful they are so you will say, "I can do layers."

Once you believe in possibilities, you can find good photographs almost anywhere. I like to keep a small digital camera with me wherever I go so I can capture whatever catches my eye, no matter what the location.

TIPS

Photo Tip!

When you know that you will share a photo online, you do not need a high image resolution. Try cropping a detail from a large image before you resize it for the Web. A small bird in a mostly blue-sky print can become a large bird that fills the frame when it is cropped for the Web. To learn more about cropping, see Task 62.

Did You Know?

Adjustment layers in Photoshop Elements allow image adjustments that can be readjusted as many times as needed with no effect on image quality. They offer you flexibility and a lot of power to change your image, plus they are a good way to get started using layers. See Task 73 to begin working with layers.

MASTER YOUR CAMERA
to get great photos

To consistently produce the best photos with your digital camera, learn all that you can about it. Today's sophisticated digital cameras are amazing. Even pocket point-and-shoot cameras enable you to take excellent photographs with their superb automatic features and high sensor and lens quality. However, most digital cameras offer many additional features that are worth learning so that you gain important creative control over how photos are taken and ensure that you get exactly what you want.

One of the best features of all digital cameras is the LCD screen that lets you review the image and camera settings immediately after taking the photo. This enables you to check that you have composed the photo as you like and that the camera settings were set as you expected. Some digital cameras even provide a *histogram* to give you a visual impression of the exposure. These review features encourage you to make adjustments while you are still there with your subject.

You have made an investment in purchasing a digital camera. Although you do not have to know everything about it in order to use it well, the more controls you master on your camera, the better the return on your investment.

The instant review LCD monitor on a digital camera gives every photographer the chance to check the shot. This lets everyone become a better photographer because camera controls can be adjusted, and then the results immediately seen on the LCD.

Digital cameras house a lot of great technology that works in the photographer's favor. Learn a bit about the specifics of your camera and you will gain even more from that technology.

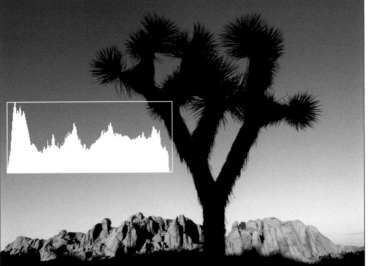

Advanced compact digital cameras and digital SLRs can display a histogram with the image on the LCD. You can get consistently better exposures if you learn to read a histogram (see Task #25).

TIPS

Did You Know?

The more you learn about and use different features on your camera, the more possibilities you have for creative control. However, sooner or later you may forget which settings you have changed and shoot using the wrong settings. Use your camera's LCD review to make a quick check of things like exposure and white balance. Learn how to quickly check other settings or to set them to the defaults in order to avoid shooting with the wrong settings.

Caution!

Many digital cameras have shooting modes that automatically choose a faster ISO setting if there is not sufficient light. Make sure that you know which shooting modes allow this to avoid taking photos that have too much *digital noise* (which can come from high ISO settings).

CHOOSE THE IMAGE FILE FORMAT
to suit your needs

Each time that you press the shutter release, you capture an image with the image sensor. The image is then written to a file in a user-selected format with or without applying your chosen camera settings. Most digital cameras other than basic point-and-shoots offer two formats: JPEG and RAW.

Most digital photographers use the JPEG format. It offers a nice balance between image file size and image quality, plus it is universally recognized by software that can use photos such as word processors or page design programs. The JPEG format is a compression format; it uses a

mathematical algorithm to smartly reduce the file size while losing minimal image quality. At high quality settings (which you should generally use), the loss is negligible, yet you can capture more images on a memory card.

RAW image files are proprietary files that have minimal processing applied to them by the camera, plus they hold more tonal information than JPEG files. A RAW file can be processed with much more flexibility and adjustment range than is possible with JPEG.

RAW format images are proprietary, data-rich files that you must convert before you can view and edit them.

Approximate Image File Sizes for 8MP Camera		
Format	*Megabytes*	*Number of Images on 1GB Memory Card ***
JPEG (high quality)	3.3	303
JPEG (low quality)	1.2	833
RAW	8.3	120

* This is only an estimate. JPEG and RAW file sizes vary depending on the detail in a scene.

These file sizes are typical for an 8-megapixel camera. File sizes from other digital cameras will vary.

JPEG versus RAW Formats	
JPEG	**RAW**
All camera settings embedded in file	Image stored with minimal processing from sensor, allowing more post-shoot changes
Fastest, most convenient format	Most flexible, adaptable format
Smaller file size	Larger file size
Easily viewable images	Requires RAW conversion software
Camera shoot and file-to-memory speeds faster	Camera shoot and file-to-memory speeds slower
Fast to view	Slower to view
8-bit file (less picture information)	16-bit file (more picture information)

Did You Know?

The RAW format is the best image format to use if you want to get the best possible pictures from your digital camera. Camera settings, such as white balance, contrast, saturation levels, sharpening, and other settings, are not applied to a RAW image file. After you shoot, you have control over these settings when processing them with a RAW image converter. Many photo enthusiasts shoot in RAW format most of the time, or choose RAW + JPEG if the camera offers that setting.

Did You Know?

You can shoot more JPEG images in a row compared to RAW before the camera's memory buffer is filled, making the camera stop in order to catch up. On the other hand, RAW allows instant changes to white balance after the shoot with no quality effect on the image.

Set the
IMAGE RESOLUTION AND COMPRESSION LEVEL

In addition to letting you choose a file format for your photos, most digital cameras enable you to choose the image resolution. Usually, you will choose the highest resolution — after all, that is what you paid for in the camera.

Image resolution is expressed in terms of pixels, such as 3456 x 2304 pixels. If you multiply these two numbers together, you get the total pixel count — for example, 3456 x 2304 = 7,962,624, or just about 8 megapixels (8MP). More pixels in a picture enable you to print at larger sizes, which is one good reason to buy a digital camera with a higher megapixel rating.

This is not a simple decision, however. More pixels on a small sensor can mean increased noise in the image (noise looks like grain in film or "snow" on a TV with poor reception). Also, as pixel counts increase, so does file size, meaning you need more memory to hold the same number of images, requiring you to purchase higher-capacity memory cards for extended shoots. You could gain space by choosing a smaller image resolution or a low JPEG compression. Unfortunately, both of these options reduce image quality. Choose the highest resolution and highest quality JPEG compression unless you have special need for small images, such as those used only on the Web (which needs a much lower resolution).

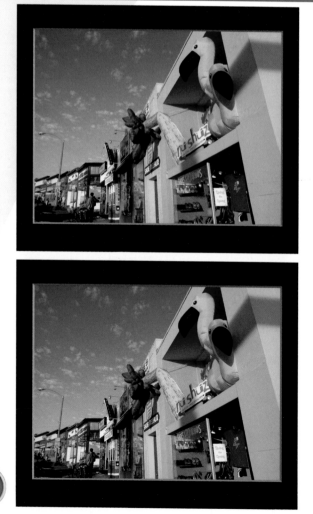

This photo is cropped slightly from a 7-megapixel camera with an image size of 3136 x 2352 pixels. This particular photo is the full image file.

This image is at a much reduced resolution of 1200 x 900 pixels. Yet, both look fine at this size because either resolution supports the small size of the images as shown on this page.

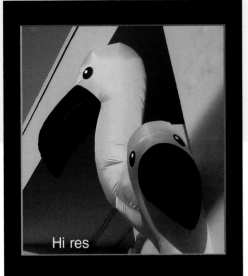

Hi res

Low res

The cropped image shows the difference. The top photo is cropped from the larger image file and looks fine printed here.

5

DIFFICULTY LEVEL

The second one comes from the smaller file and starts to show loss of sharpness and pixilation. The point is that the small file is much more limited on how large it can be displayed or printed compared to the big image file.

Did You Know?

By reducing the image resolution to store more photos in your camera, you reduce your ability to crop photos later and the opportunity to get the largest possible prints. Memory card prices are very reasonable for high storage capacities, so buy extra cards so that you can store your images at the maximum image resolution and with the least image compression. This helps you avoid taking a prized shot that is too small or has too much compression to make a good print.

Did You Know?

Each time you save a JPEG file after editing it, your image degrades. Therefore, JPEG should not be used as a working file format when adjusting it in Photoshop Elements or any other program. Save a working file in an uncompressed image format such as TIFF (.tif) or Photoshop (.psd). JPEG can be used later for archiving finished files to save disk space.

Control your camera's light sensitivity with the
ISO SETTING

In traditional film photography, you choose film for a certain sensitivity based upon an ISO rating, such as ISO 100 or ISO 400. Digital cameras also enable you to change ISO settings, which are similar to, but not the same as, film ratings. Digital camera ISO settings come from the camera amplifying the signal from the sensor rather than a built-in rating as in film.

This sensitivity affects how you can deal with certain photo needs, from the amount of light to a desired shutter speed. Low settings such as ISO 100 are less sensitive, or "slower," than ISO 400 because it takes

a slower shutter speed to properly expose the image. A higher ISO setting enables an image to be recorded with a faster shutter speed.

Choosing an ISO setting is one of the most important settings that you can make. High ISO settings, such as ISO 800, enable you to shoot in lower-light settings with faster shutter speeds, but you end up with more digital noise in your photos. Digital noise is similar to grain in traditional photography and is minimized when you choose a low ISO setting.

This photo was shot at ISO 1600 to enable a faster shutter speed, avoiding image blur in low levels of indoor light.

Digital noise is easily visible in most of this photo. Still, people expect indoor photos like this to have noise.

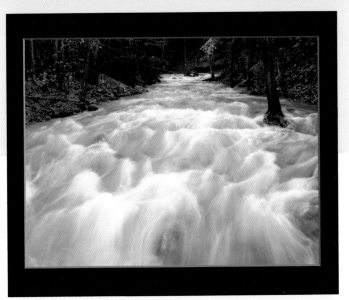

This photo was shot at ISO 100 to give the image the highest color and sharpness, plus best tonalities, while keeping noise low.

Digital noise is minimal throughout this photo, but it did require using a tripod because a slower shutter speed (⅓ sec.) was used.

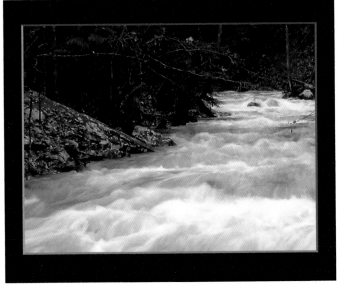

Did You Know?

You generally get the best picture quality by using the lowest ISO setting your camera offers, such as ISO 100 or 200. A higher setting, such as ISO 800 or 1000, will have considerably more digital noise.

Photo Tip!

Although digital noise is generally an unwanted characteristic of a digital photo, you can use it as a creative design element. In the days of traditional film, photographers often used grain to add a romantic look to their people and travel photos.

Did You Know?

When you edit a digital photo with an image editor such as Adobe Photoshop Elements, you are likely to get more noticeable digital noise when you perform steps such as increasing contrast, adjusting saturation, and sharpening an image.

Improve color with the
WHITE BALANCE SETTING

Color photography has always had a challenge with getting accurate color. A common problem is an undesirable *color cast,* such as a red, blue, or green haze over the image. This was difficult to deal with when using film and often required special films or filters to balance the color with the light.

Digital photography has really changed this because of white balance settings. Now you can select an in-camera white balance setting so that your camera will record correct colors when shooting under a variety of different lighting conditions, such as incandescent light, tungsten light, sunshine, or clouds. You will find icons representing presets for each of these in the white balance setting area. Auto white balance (AWB) gives less consistent results (even when working with RAW files).

Besides letting you choose an appropriate white balance setting, many digital cameras have a custom white balance setting that can record very accurate colors. Each camera deals with this setting differently, though custom white balance requires that you have a neutral white or gray card for the control. If your camera offers such a feature (and most do), it is worth learning about and using.

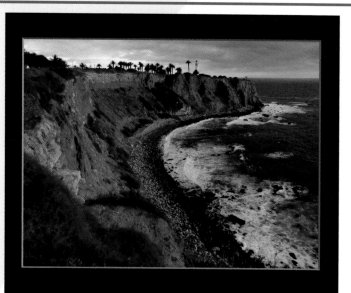

This photo was taken at sunset with the white balance set to Cloudy. Cloudy gives a warm sunset that looks more like traditional film-captured sunsets.

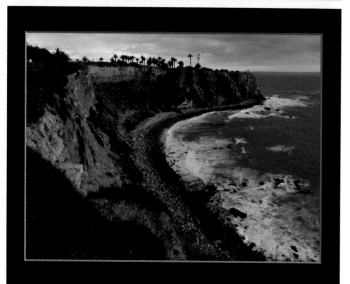

This photo was taken at sunset with the white balance set to Tungsten. Tungsten brings out more of the rocks' natural color, but makes the sunset colors look more blue than is generally accepted.

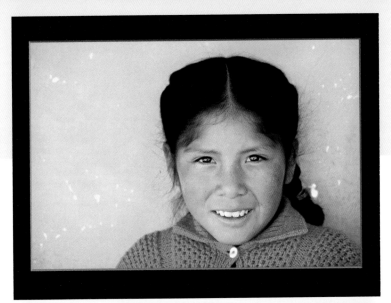

A strongly colored background can cause AWB to give false results. This portrait of a Peruvian girl was made using the Shade preset.

DIFFICULTY LEVEL

The slight warm color cast to this image is important because it reflects the time of day it was captured. A Daylight preset was used to preserve that color cast.

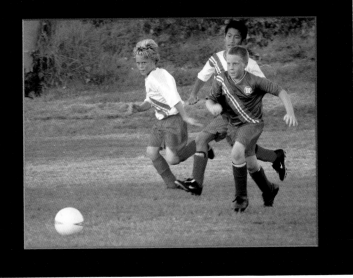

TIPS

Photo Tip!

Sometimes you can add a preset white balance setting to add an attractive color tone to a photo. For example, using a cloudy white balance setting can add warmth to an otherwise cold or blue-toned scene.

Did You Know?

Most digital image-processing software offers several color-correction tools. However, many of them work best if you have a pure white or neutral gray tone in your image. If your subject requires absolutely accurate color, consider placing a white or gray card in the same light as your subject for a reference shot, and then remove the card for your real photos. You can then use that reference shot to help you get very accurate color in your final photos.

SHOOT YOUR BEST
from the start

Digital photography is so adaptable and flexible that many photographers start thinking they do not have to worry so much when taking pictures because they can "fix it in Photoshop." That idea can get you into trouble.

Underexposure can cause problems with color in dark areas, as well as dramatically increased noise. Overexposure can change highlights to detail-less white that can never be recovered. The wrong shutter speed will cause sharpness problems from camera movement during exposure to blurred subjects. An incorrect white balance can create color cast problems.

You do not have to be a pro to shoot your images correctly from the start. Simply know your camera and be sure to make wise decisions for how you use it. This requires a little discipline and knowledge of photographic craft, which this book is designed to help you with.

Although image-processing software provides you with tremendous image-adjustment power, you can always do more with well-crafted photos than you can with marginally acceptable ones. You spend less time working on an image in Photoshop if you have an excellent image to begin with.

The wrong exposure and detail will also be captured wrong in a photo like this that holds a large range of tones.

Part of the appeal of this simple photo of a fall blackberry leaf is its sharpness. That comes from the right technique of using a tripod, careful focusing, and exposure control from the start.

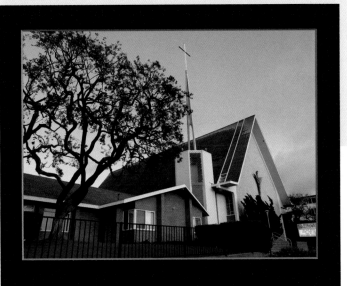

Choosing the right white balance preset (Daylight) gave this late-day shot the warmth on the building.

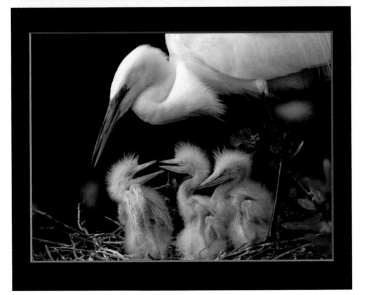

The wrong exposure on this shot would have washed out the white details of the parent egret's body.

TIPS

Photo Tip!

Once you have your digital camera, get a good-sized memory card (prices are very reasonable now). Taking photos does not cost anything, so get out and shoot as much as you can. Learn to try different exposure settings and compositions, and shoot plenty of photos so that you have a choice among them.

Did You Know?

You can use any camera to quickly adjust exposure without using any dials. Point your camera at something dark, lock exposure (usually by pressing the shutter halfway), then move the camera back to the composition in order to add exposure. Do the same with something bright to darken exposure. You do need to be careful of distances here because locking exposure on many cameras also locks focus.

Pack for a
SUCCESSFUL SHOOT

Every photographer has a different comfort level with how much gear he or she needs to bring along. But it is easy to carry too much. Photographers develop back and shoulder problems from the weighty gear bags they tote around.

If you really must bring a lot of gear, take along a smaller bag and use it when you know you do not need the whole kit. It can be literally painful to lug a heavy camera backpack along steep trails when you never really needed that heavy telephoto lens that was included.

Staying comfortable during shooting also helps you photograph more successfully. It is hard to be creative if you are cold, bug bitten, hungry, or sunburned. Bring along items that will make your outing more enjoyable, productive, and safe.

Before you head off for a shoot, carefully consider what you should take with you in addition to your photography equipment. A few nutrition bars, water, gloves, bug repellent, sunscreen, and a hat can unquestionably contribute to your taking better photographs.

Use multiple bags for your gear to be used for specific shoot needs. Avoid always carrying your gear in one heavy bag.

Water, sunscreen, insect repellent and bite medication, and snacks are just a few things that will make your picture-taking time more enjoyable.

This photo is a nice shot from the cloud forests of Costa Rica when it was pouring rain! Not having an umbrella would have ruined this shoot.

Take a hat to protect yourself from the sun and use a headlamp, such as the Princeton-Tec, to make your walks safe when walking in the dark.

TIP

Did You Know?

Some of the most useful information for photographers is found on the Internet.

Sunrise/Sunset/Twilight/Moonrise/Moonset/Phase information: http://aa.usno.navy.mil/data/docs/RS_OneDay.html

Weather: www.weather.com

Outdoor photography: www.outdoorphotographer.com

Online mapping service: www.mapquest.com

Best state parks: http://usparks.about.com/cs/stateparks/a/bestparks.htm

Photo advice from the author: www.robsheppardphoto.com

Chapter 2

Consider Light More Than Illumination

Light is more than just something needed to make a photograph. The right light can make your images really come alive, while the wrong light can kill them. Although you definitely want to focus your attention on your subject and compose carefully to get the shots you want, you can greatly improve your photos if you are aware of what light is doing to both your subject and the rest of the picture. What often distinguishes really good photographs from all the rest is how light is used to capture the photograph.

To see the light (literally), you have to go beyond framing a subject in your viewfinder or LCD. You have to look at your scene in terms of what the light is doing. Is the light making the subject easier to see? Or does it obscure it? Does the light flatter your scene? Or does it make it harsh and unappealing? Would your subject look better in another light? Is the light soft and diffused, or is it bright and intense? Does the light have a nice, warm golden glow, or maybe an unwanted color cast?

Use the LCD on your camera to see what the light is doing to the picture as captured by the camera. When you do not have good light, consider ways in which you may improve it, or find another time to try again. The more you take advantage of quality light, the better your photos will be.

Top 100

PICK GOOD LIGHT
for better photos

Digital photography is all about capturing light on an image sensor; the better the light, the more potential you have for getting great photographs. The quality of light varies greatly from when the sun comes up in the morning to when it sets in the evening. Fast-moving clouds can change it even on a second-by-second basis.

A good way to learn what light is best for the subjects that you enjoy shooting is to shoot those subjects in all sorts of light and see what the photographs look like. This is such a great advantage of digital photography — you can easily do this with no cost for processing photos, and you can easily compare images on the camera LCD or in the computer.

Keep in mind that great light is not constant. Sometimes you must wait for those perfect moments to capture a perfect shot. Or you may have to return to an interesting subject, simply because the light at the time just does not make the scene work as a photograph.

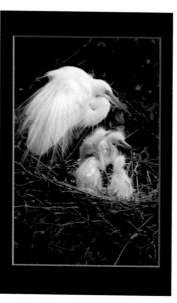

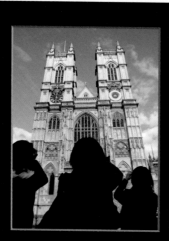

A low sun gives a dramatic, warm light on grain elevators under a clear sky.

A soft light from a low-density cloud cover gives good light on these egrets without making the contrast too high.

High-contrast sunlight makes this photo work by allowing the people to be silhouetted against the cathedral.

Rich fall colors plus the right light can make spectacular color in a photo.

The soft, morning light on this patch of lupine flowers makes it easy to capture detail in the shadows and highlights.

Even the artificial light of a public aquarium can create great light if you watch how it affects your subject and use your digital camera's white balance and exposure controls selectively.

TIPS

Did You Know?

Bad weather conditions offer great photographic opportunities that give your photos more variety than just good-weather images with blue skies. Look for dramatic clouds, thunderstorms, even rain or snow that can make light dramatic. Changing weather conditions are an excellent time to shoot because the light can be quite dramatic then.

Photo Tip!

Clouds can be very helpful to photographers because they can diffuse bright sun and reduce the overall light intensity and contrast, especially when photographing people. Clouds can make an otherwise clear sky a little more interesting. Have patience for clouds to move to where they will help you get better photographs.

Shoot effectively in BRIGHT SUN

Direct light from the sun ranges from perfect to awful as it illuminates your subject for a photograph. A big challenge in working with bright sun as the main light is that it is a bold and strong light. That makes it unforgiving if used poorly with many subjects.

Direct sunlight creates strong contrast with very bright highlights and dark shadows. A key to understanding the light from bright sun is to understand how important the shadows are. Shadows in the right places make your scene dramatic and powerful. Shadows in the wrong places make an attractive subject ugly and make your viewer struggle with even the best of compositions.

Another key aspect of bright sun is that the light has a very strong direction. That means that even a slight change in camera position often gives you a new light because it strikes the subject from a different angle in relation to the camera position. That change can be enough to make poor light become good light on a particular subject.

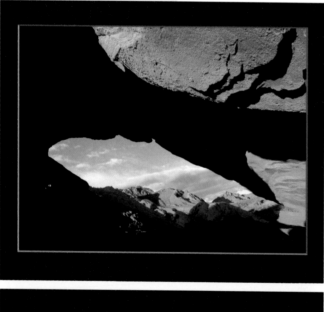

The shadows of bright sun can be as important as the sunlit areas of the image as seen in this shot of a small arch in the Mohave Desert near Las Vegas.

Backlight can be a very effective and dramatic light, though you may have to experiment with it a bit in order to master it.

SHOOT IN THE SHADE
for gentle light

The drama of direct sun can visually overwhelm many subjects because of its contrast. One way of dealing with the harshness of bright sun, and inconvenient shadows, is to look for shade for your subject. Shade is an open light without the contrast of bright sun, yet it usually still has some direction to it. Direction in a light makes your subjects appear more three-dimensional.

Shade works especially well for people and flowers. You might find your subject in the shade, or you might move that subject into the shade. If neither is possible, you may be able to shade the subject itself.

I have had people stand to block the sun, or I have draped a jacket over my tripod to create some shade. You can often find creative solutions to making shade on your subject.

I would strongly suggest that you set your white balance to the shade setting in these conditions (see Task #7). Shade contains a lot of blue light that comes from the sky, which your camera often overemphasizes. Shade settings remove that blue. Auto white balance settings tend to be very inconsistent in the shade.

A bright sky produced the gentle, directional light on this shaded azalea.

A nice glowing light that fills a Peruvian woman's face and clothing results from sun bouncing off surrounding surfaces into the shade.

Take advantage of the
GOLDEN HOUR

DIFFICULTY LEVEL

Golden hour is a magic time when the sun is low to the horizon and casts a golden, warm light on the landscape, but only for about an hour that starts an hour or less before sunset and lasts up to about 20 minutes after it. Although both sunrise and sunset can give this type of light, it is the sunset that usually has the warmest, most flattering light.

This has been a classic light for pro photographers, from those working for National Geographic to cinematographers creating Hollywood films. In fact, whole films have been shot entirely at this time (which is one reason why films can be so expensive — but the light sure looks good!).

This light looks great at any angle, but you will find the richest color and best tonalities with the light coming from the side or to the front of your subject. Front light on a subject is very unattractive in the middle of the day, but near sunset, it transforms into a radiant, beautiful light on many subjects.

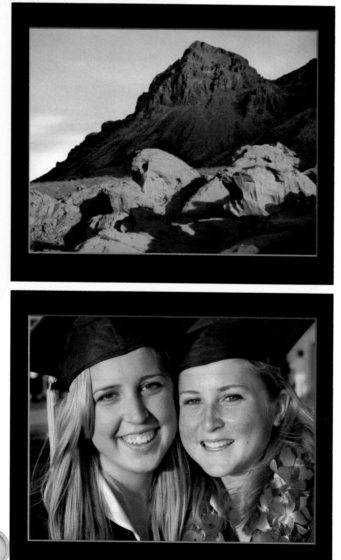

A low sun gives dimension and warmth to this landscape in the Lake Mead Recreational Area in Nevada.

Low sun near the time of sunset gives nice, glowing skin tones to this double portrait.

Control light with a
REFLECTOR

One helpful and inexpensive photographic accessory is a reflector. You can use anything that is white or light gray to reflect soft natural light toward your subject. Reflectors can also block light, effectively creating shade to reduce overly bright and high-contrast direct sunlight. Most portable light reflectors made for photography fold up to one-third of their open size, and they often offer a white side and a second colored side, such as silver, gold, or bronze.

A handheld reflector is especially useful for adding light to a subject's face for a portrait. Besides filling shadows with natural light, you can add a warm color tone by using a gold-colored reflector. When shooting a backlit subject, a silver reflector can be used to bounce more light into the shadows in order to reveal greater detail. Reflectors can also be used with flash and other lights.

White Fome-Cor(r) panels, which can be purchased at most art stores, make excellent inexpensive light reflectors. Although they are not as convenient to store and carry as collapsible light modifiers, they are lightweight and easily found.

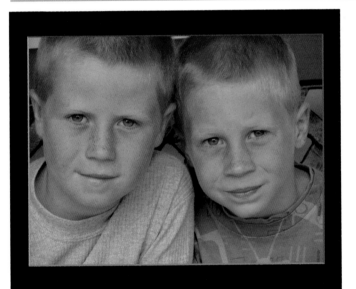

A white reflector in front of and below the subjects brightens the faces of these boys and helps to bring out the color in their eyes.

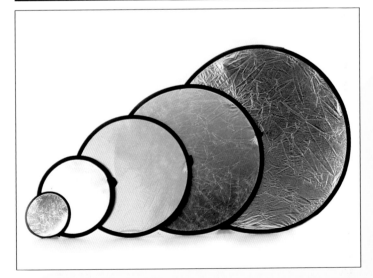

Reflectors come in all sizes and in different finishes, as seen in this line-up of Lastolite portable reflectors.

Control natural light with a
DIFFUSER

DIFFICULTY LEVEL

A *diffuser* is the natural complement to a reflector. This is anything that can be put in between the light and your subject to soften and diffuse the light. Like reflectors, diffusers made for photography fold up for portability, and they sometimes come with a special white cover that can be used as a reflector.

A handheld diffuser is especially useful for softening light on a flower in bright, harsh sun, or to diffuse bright, harsh light from a flash or other light when photographing people. To get the most effect, however, you need a diffuser that is large in relation to your subject. This spreads the light out more. Just putting a small diffuser over a flash, for example, does not really spread the light much and does not give as good a softening effect.

If you want to experiment with a diffuser without spending a lot of money, try using tracing paper purchased at an art store or a white translucent shower curtain. They make excellent inexpensive light diffusers. Although they are not as convenient to hold as collapsible light modifiers, they are lightweight and easily used.

Shot on a bright, sunny day, this sweet pea flower gains a gentle light from the use of a diffuser over it.

Light from a flash is diffused through a three-foot, portable diffuser to make the light gentler on the people's faces.

Open up harsh shadows with
FILL FLASH

DIFFICULTY LEVEL

Bright sun can cause harsh light on faces, with deep shadows around the eyes or under hat brims. This shows up even stronger in the resulting photographs.

There is a solution, something that you can do immediately whenever you are faced with harsh shadows on a nearby subject. Nearly all digital cameras allow you to force the flash to fire in these conditions to fill in those harsh shadows. Some cameras have a "fill flash" setting of some sort, too, but all you really need to do is turn the flash on and use the "always on" setting. The camera will then add flash to the dark shadows, opening them up and revealing your subject much better.

This works only for subjects that you are fairly close to, though the actual distance is affected by the power of the in-camera flash. Usually, fill flash works best at distances less than eight- to ten-feet. Pros often use accessory flash for added power to boost this distance. Fill flash limits the shutter speed and f-stop possible with digital SLRs (try using the P mode at first).

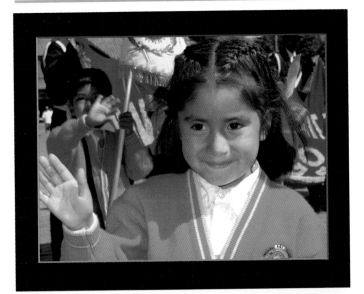

Without fill flash, you would never see this young girl's face. You can see the shadow on her face. The flash is revealed in the catchlight in her eyes.

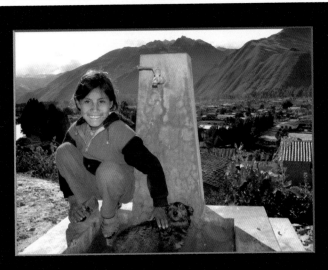

Fill flash lights up this girl's face and reveals the dog being washed at this outdoor water outlet.

Illuminate portraits with
WINDOW LIGHT

Getting a good portrait is highly dependent on the quality and quantity of light available. That is one of the reasons why so many portrait photographers strongly prefer to shoot inside a photo studio where they have a high degree of control over lighting. One of the most useful lighting accessories in a portrait studio is a *soft box*, which is a large light box that diffuses the light from a flash or other light to make soft, natural-looking light for well-lit portraits.

You can get much the same soft, evenly diffused light in your own home without the expense of having a studio by shooting portraits with the subject standing or sitting in front of a window. Shoot when the light comes from the sky, not directly from the sun, or you can use the diffused sunlight that comes through a white sheer drape. You can change the direction of the light on your subject by moving the camera and subject at different angles to the window. This can give you everything from dramatic sidelight to open front light.

This portrait was taken with a large picture window to the right side. A white wall to the left acted as a reflector.

Here, two windows provided the light, one to the front of the subject at the left, and one behind, creating a little separation light.

This pastor was shot in an alcove, near a large patio door. The warm walls around him gave a warm, reflected light into the shadows.

DIFFICULTY LEVEL

Sometimes, direct sun from a window can work with a little help. A reflector on the left and below gave a nice light to the face, while a white wall on the right kept the shadows open.

TIPS

Did You Know?

Window light can change quite dramatically in color depending on where the light is coming from. Light from a blue sky is very cool in color, and clouds can give everything from warm to cool light. Try setting your camera's white balance to Cloudy or Shade for nice warm skin tones. You can even try using a custom balance setting with the light.

Apply It!

If the light from the window is too harsh, use a reflector to bounce light back to the subject. Just place the reflector opposite the light and reflect the light onto the subject. Large white art boards made of foam in-between white paper, called FomeCor®, which can be purchased at most art stores, make excellent accessories for your window "studio." They can be quickly propped up and used as reflectors to modify and enhance the light coming from a window.

Get your flash off-camera for
DIRECTIONAL LIGHT

The flash on your camera is very limiting. It tends to make flat light, with harsh shadows behind your subject, and often creates red eyes in your subjects. Avoid those problems by getting a flash that allows you to move it off-camera. For digital SLRs, this means using an accessory flash with an extension cable (though some newer cameras do have wireless flash capabilities).

For small, compact, and point-and-shoot cameras, you can also use this technique by purchasing one of the little flashes that are designed to be triggered by

your on-camera flash (these can also be used with a digital SLR, but for more versatile light, the accessory flash with cord works better).

You don't have to get the flash far off-camera for it to work well. Hold the flash with one hand off to the side and point it at your subject. This provides nice directional light with far more attractive shadows than the on-camera flash will do. You can also point the flash at a white wall or a reflector to create a very nice, softer sidelight.

Too often, pictures taken with the on-camera flash look like mug shots, with their harsh, flat light and unattractive shadows behind the subject.

Same subject, but what a difference! The light was held off to the left, and the subject moved away from the wall. A nearby table light adds a little light to the subject's hair on the right side.

A flash to the right of this close-up scene created a strong, dimensional light and gave enough light for high depth-of-field this close to a tomato and a beetle.

This close-up of a snail looks like it was shot in sunlight. It wasn't! It was in the shade. An off-camera flash held up and to the right provided the light.

TIPS

Did You Know?

When you shoot close-up or macro photographs with flash, you usually gain high sharpness. This is because the flash gives a lot of light, allowing a small f-stop for more depth-of-field, plus flash has such a short duration that it freezes subject and camera movement.

Caution!

Vendors other than the major camera vendors make several excellent accessory flash units, though you will probably have to get the extension cord from the manufacturer. However, be careful if you decide to purchase an independent-brand flash other than the one that made your camera. Check to be sure it will link with your camera so you can use all the features.

USE BOUNCE FLASH
for better indoor lighting

Another way to create a more attractive light from a flash is to bounce it off a wall, a ceiling, or a reflector. Bouncing the light spreads it out, making it a gentler light and also generally more natural-looking. You need to have a flash that allows you to point the flash tube away from the camera, at a wall or ceiling. Many accessory flash units have a tilting flash head to allow this. You can also hold an off-camera flash so it hits a wall.

Bounce flash does absorb light from your flash. It requires more powerful flash units the farther the

surface is from your flash. Be careful you do not get too close to a portrait subject if you are bouncing a flash off the ceiling or you can get heavy shadows under the eyes, for example. Also, be very aware of even slight colors to a wall or ceiling. If you bounce off such colored surfaces, that color will appear on your subject — perhaps a good thing if the wall is warm, but definitely not so good if the wall is green!

The flash here was bounced off the corner of a white wall and ceiling to get this big, gentle light that works well for a group.

The flash for this orchid photo was bounced off the ceiling for a nice, attractive light on the petals. A black background creates some drama for the image.

Prevent
RED EYE

DIFFICULTY LEVEL

Flash can cause a distinct problem when shooting people in low-light conditions — their eyes flash red as if they are possessed. This dreaded red eye is caused by light from the flash reflected back from a subject's retina to the camera. To avoid getting photographs whose subjects have red eyes, many camera manufacturers have added red-eye reduction features. Although these features can reduce or eliminate red eye, they often make your subject blink or react poorly to the camera.

To avoid getting red eye, you simply need to shoot so that the angle between the flash and lens to the

subject's eyes is more than five degrees. Using a high-accessory flash, an off-camera flash, or bounce flash will help avoid getting red eye. Digital cameras do well without flash in bright interiors. You could try camera settings that do not require a flash. You are more likely to get red eye when shooting in a dark environment because the pupil will be wider and more prone to reflect red light.

A night shot of grunion catching almost guarantees red eye — unless the flash is off-camera as it is here.

Bounce flash is good for a group and never causes red eye.

Control
Exposure

Exposure systems in today's digital cameras are amazing. It wasn't all that long ago in the history of photography that cameras didn't even have meters, let alone complete metering systems with the power of a minicomputer. A camera's metering system examines the light coming through the lens as it is reflected by the subject, compares that light with the surrounding light, and calculates an exposure that will give you good results. Even the cheapest of digital cameras offer metering that makes exposures far more reliable than in years past.

But great exposure that really expresses your interpretation of a subject is not so simple. Plus, poor exposure can quickly take your photos from good to unacceptable. Metering systems can misread the amount of light and give you a photo unlike what you have in mind. To improve your chances of getting the exposure you want, it helps to understand how to make the most of your digital camera's exposure system and its features. In fact, a really great aid to better exposure is the camera's LCD, its exposure warnings, and the histogram. If you are not happy with the picture that you took, you can shoot until you get what you want — and it does not cost a thing!

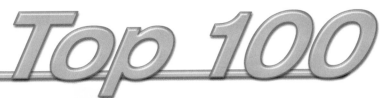

UNDERSTANDING EXPOSURE
to get the photos that you want

The right exposure is whatever makes your subject look its best in the type of photograph you create. That means exposure is definitely subjective. However, most people know when an exposure is right or wrong. Overexposed photographs are overly light, and detail is lost in the highlights. Underexposed photos are overly dark, and detail is lost in the shadows. The key thing about exposure is that important detail, dark or light, is captured properly so that the scene is light or dark appropriate to the subject.

Unfortunately, the world typically offers up a range of tones greater than what is possible to capture with a sensor. First, you might not be able to hold detail throughout the image with your exposure. Then if you cannot, most digital photos look their worst with any kind of overexposure or very dark underexposure. Good exposure results from the appropriate combination of shutter speed, aperture, and ISO speed. Exposure can be determined solely by the camera, interpreted by you (as the photographer) and the camera together, or solely by you.

UNDEREXPOSED

Underexposing this photograph resulted in a muddy-looking image hiding detail in the shadows.

PROPERLY EXPOSED

This well-exposed photograph holds color in the sky and reveals details in the shadow areas.

OVEREXPOSED

Overexposing this photograph lost color in the sky and made the overall image look "washed out."

INCORRECT METERING I

The dark shadows of this scene over-influenced the metering system, causing overexposure so that the bright light washed out the center head of the sculpture.

INCORRECT METERING II

The brightly lit leaves in this image caused the meter to read the exposure incorrectly, resulting in underexposure that made duller colors than seen in the next photo.

CORRECTED METERING

The exposure for this photo was corrected to compensate for the bright leaves so that they would be exposed to gain the best color.

TIPS

Did You Know?

One advantage of using the RAW format is that RAW captures more tonal steps between pure black and pure white as seen by the sensor. The result is an image that allows more correction to exposure in RAW conversion software. Still, RAW is no magic bullet that fixes bad exposure. You still need to be sure you have not made an image too light or too dark because once bright areas become pure white, or black becomes pure black, no amount of adjustment will retrieve detail in those areas.

Photo Tip!

If you are shooting in tricky light or you are shooting a scene that seems to be difficult to meter correctly, consider using the *auto-bracketing* feature if it is available on your camera. Auto-bracketing enables you to shoot three sequential shots, each with a different exposure. The camera automatically shoots at user-selected + and − exposure changes around the metered setting.

Know
WHAT METERS REALLY DO

Exposure meters can only measure how much light comes from a scene. The meter cannot know if that scene is a light scene in dark conditions or a dark scene in bright light. So, the meter really gives an exposure that results in an average or middle-gray tonality for everything, which is not appropriate for every subject.

Camera metering systems have multiple metering points over the image area to give the camera's built-in metering computer something more to work with than a single (and perhaps misleading) meter reading. Still, there are problems with certain types of scenes.

An image made up of dark tones over the whole composition will usually be overexposed because the meter wants to make it bright, not "knowing" that the scene is not bright. A photo that has mostly bright tones will typically be underexposed because the meter wants to darken it, not "understanding" that the scene is not darker.

Finally, a scene with a strong contrast between the subject and background often causes the meter to improperly expose the subject. A bright background causes a dark subject to become underexposed, and a dark background can make the subject overexposed.

The dark shadows that make up much of this scene in the Great Teton National Park can easily over-influence the meter, causing an exposure that is too much for the smaller area of sunlit mountains.

The meter doesn't know the difference between bright light and a light subject, so it underexposes white scenes like the water here, making the rocks too dark.

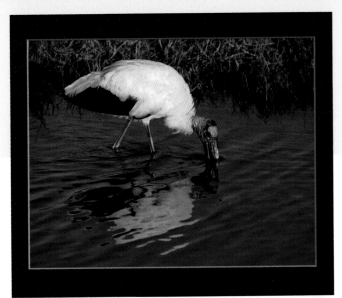

Meters often overexpose a white subject in front of a dark background, such as this feeding wood stork. The right exposure shown here keeps white details by using some compensation by the metering system.

The light on this small pear has a beautiful open quality to it, but many meters expose such a white scene too dark, making the image dark and muddy looking.

TIPS

Photo Tip

RAW files can be helpful in difficult metering conditions. With RAW software, you can often bring out detail in the shadows while holding tonalities in the highlights, even when the light is contrasting and hard to meter. That doesn't mean you can be sloppy with RAW exposures, though. You need to do the best you can for every subject in order to get the best possible detail and color from a scene.

Did You Know?

One thing you pay for with more expensive cameras is more metering points in the scene for the metering system to evaluate. With more points, the system can better find the key tones to favor, while ignoring single-point anomalies of light, such as a bright spot in an overall moderate-toned image.

Discover different
EXPOSURE MODES

Most digital cameras offer a variety of automatic exposure modes, including program, shutter priority, and aperture priority, as well as manual mode. Choosing an exposure mode determines which exposure settings you can select and which exposure settings the camera automatically selects based on other choices you have made.

In P or program mode, the camera automatically chooses both shutter speed and aperture settings. When you select the S or shutter priority mode (also called Tv for time value), you choose a shutter speed, then the camera automatically chooses the aperture setting to get a good exposure. Select a shutter speed appropriate to the subject — a fast speed such as $1/500$ sec. for action or a slow shutter speed such as $1/2$ sec. for a blur effect.

In the A or aperture priority mode (also called Av for aperture value), you choose the aperture setting that you want, and the camera selects the appropriate shutter speed. Choose a small aperture for deep sharpness or depth of field, and a large aperture for shallow or selective focus effects.

In situations in which you want complete control over both shutter speed and aperture, choose the manual mode.

You usually select an exposure mode by turning a dial that includes settings like this one — P is program; Tv is shutter priority; Av is aperture priority; and M is manual.

For snapshot photos and general use, select the program automatic exposure mode.

Choose aperture priority mode when you want to control depth of field; in this mode, you select the aperture and the camera automatically sets the shutter speed.

DIFFICULTY LEVEL

Choose shutter priority mode when you want to control shutter speed; the camera then automatically sets the aperture.

TIPS

Did You Know?

Program-shooting modes such as Landscape, Macro, and Portrait offered by many digital cameras often result in a good photograph. However, they are not likely to produce photos as good as you can get if you understand and correctly use the shutter priority or aperture priority mode settings.

Caution!

Many program-shooting modes allow the camera to automatically change the ISO setting if the metering system thinks a change is needed. Sports mode, for example, shifts to a higher ISO if it needs a faster shutter speed. When the camera selects a higher ISO speed, there is potential for more digital noise in the image. If you do not want to have excess digital noise, make sure that you know when to avoid using a mode that causes automatic ISO speed changes.

Choose an appropriate
PROGRAM MODE

Although built-in exposure meters are extremely sophisticated, they can give readings that do not provide the exposures you want. To give you more control over what light is metered, most digital cameras offer more than one exposure meter mode.

Some of the more common exposure meter modes are *multisegment* (called such things as ESP, Evaluative, and Matrix metering), *center-weighted,* and *spot.* The most useful is the multisegment mode, which takes multiple readings across the scene, then smartly compares them inside the camera in order

to get a better exposure (it does not average readings). Multisegment, however, is available only for autoexposure modes.

The center-weighted mode places most of the meter emphasis on the center and bottom of the image and is a good all-around mode for manual exposure. Spot metering reads only a tiny part of the image so that you can very precisely meter the most important light in a scene or a subject that is different than its background.

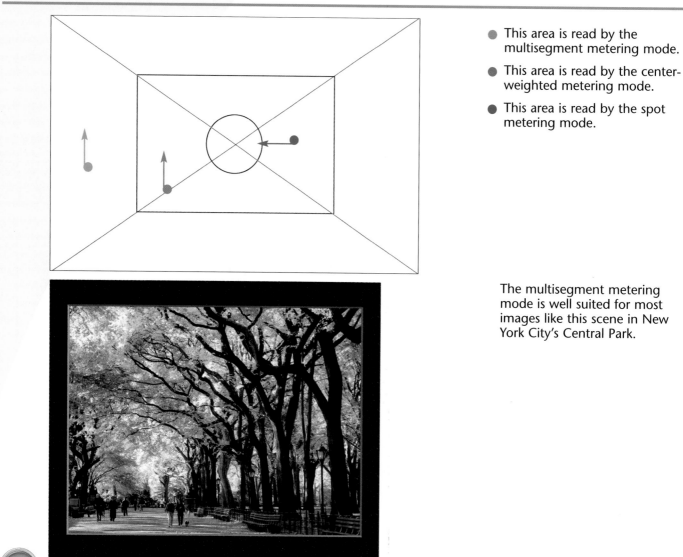

- This area is read by the multisegment metering mode.

- This area is read by the center-weighted metering mode.

- This area is read by the spot metering mode.

The multisegment metering mode is well suited for most images like this scene in New York City's Central Park.

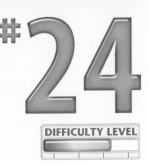
Bright light along the edges is less likely to fool the center-weighted metering mode, where priority is given to the center and bottom of the image.

This scene was correctly metered using the spot metering mode to meter just the red rock in the foreground, then the snow-capped mountains in the distance separately in order to figure out the right exposure.

TIPS

Did You Know?

Many digital cameras have selectable autofocus points that enable you to focus on off-center subjects. Many cameras also link metering modes to these selectable autofocus points, such as favoring the point in multisegment metering, or linking the spot meter to a point. This feature makes it easy to focus on an off-center subject and to meter the light from that same point.

Photo Tip!

When your chosen exposure-metering mode does not result in the exposure that you want, you have two choices. You can either adjust the exposure by using exposure compensation (see Task #26) or by using the manual mode, in which you choose both the aperture and shutter speed settings without any assistance from the built-in meter.

USING THE HISTOGRAM
to get the exposure you want

Many digital cameras include a special graph called a *histogram* that shows the brightness levels of an image ranging from pure black on the left to pure white on the right. It can give you excellent information that will help you better adjust your exposure.

There is no such thing as a perfect shape to a histogram. It can only reflect the real-world brightness levels of your scene. However, the key to reading a histogram is to watch the left and right sides. If the histogram slams up against the right side so that its

slope is abruptly chopped off, it is said to be "clipped," and this represents an image with lost or "blown-out" highlight detail.

If the histogram is bunched up against the left side and there is a gap on the right, the image is underexposed. Shadow and dark color detail will be lost. In general, adjust your exposure so that highlight detail is retained without clipping and so that the histogram is not crammed to the left side with a big gap on the right.

The photo here of a scene by Turnagain Arm in Alaska is properly exposed, as seen in the histogram with a complete graph of brightness levels from left to right.

This rock face in Joshua Tree National Park was exposed incorrectly as seen by the gap at the right in the histogram. The bright rocks are dark, and the sky is way underexposed.

This image is seriously overexposed and washed out. You can see the right side of the histogram is clipped off, meaning the bright areas are pure white instead of detailed highlights.

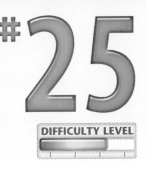

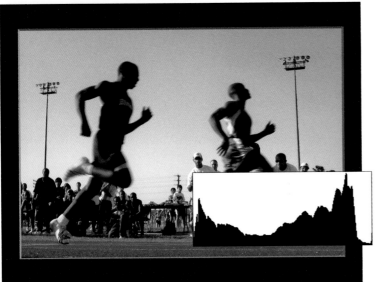

The range of tones for this finish at a track meet is perfect for the scene. Slight clipping such as seen in the histogram is normal when small highlights, like the edge-lit white shirts, are very bright.

TIPS

Caution!

Many digital cameras enable you to change the brightness of the LCD screen used to view images that you are about to take or have taken. Changing the brightness level or viewing the screen in bright light can cause you to misread the exposure. If your camera offers a histogram, you can use it to give you an accurate view of the exposure, regardless of the LCD screen brightness setting or bright light.

Did You Know?

Digital photo editors, such as Adobe Photoshop Elements, have a feature that is similar to the histogram on some digital cameras for reading the overall brightness of an image. The Levels command provides a histogram along with the ability to modify the tonal range and overall image contrast.

Improve exposure with
EXPOSURE COMPENSATION

Sometimes the built-in light meter in your camera can misinterpret a scene and give you a poor exposure. A good way of correcting this to get a good exposure is to use exposure compensation. Most cameras offer this feature, which often appears as a +/- button or menu choice.

Exposure compensation enables you to modify the exposure up or down from the metered reading by a specified amount. By doing this, you can continue shooting using the modified meter reading settings and get good exposures. For example, a +1 exposure compensation increases the exposure by one f-stop or the shutter speed equivalent and -1 reduces it the same; a + ½ setting increases the exposure a half step, and – ½ reduces it by the same amount.

Exposure compensation can be particularly useful if your scene is overall very bright, such as on a beach or in the snow, or very dark, such as when a lot of shadow fills the image area. In those cases, the meter will misinterpret the exposure. Make an exposure compensation adjustment and see if your histogram has improved.

METERED SETTINGS

This photo was shot using the metered settings. The meter was over-influenced by the bright lights and underexposed the photo.

+1

This photo was shot with a +1 exposure compensation setting to make the image look more natural and bring out more dark details.

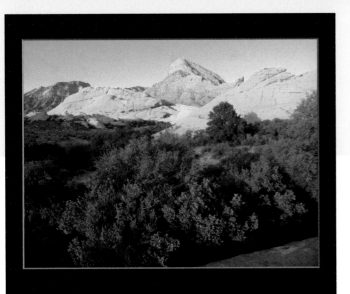

This photo was shot using the metered setting. The meter was misled by the dark trees through most of the scene.

–1

A -1 compensation corrected the overexposure for the background rocks.

TIPS

Did You Know?

A quick exposure compensation technique uses the exposure lock that most cameras have. Point your camera toward a bright light to make your exposure give less light to the scene, lock the exposure by holding down the shutter halfway, then reframe your original composition. Give more exposure by pointing the camera toward something dark. A caution: This also locks autofocus, so be careful where the camera focuses.

Photo Tip!

There may be times when you want to shoot with more than the exposure compensation available on your camera. In those cases, check to see what exposure the camera is setting, then choose the manual shooting mode with an exposure more or less than the camera meter system recommends. Check your histogram to confirm the exposure.

Avoid blown-out
HIGHLIGHTS

If any photography rule should not be broken, it is that you should avoid blown-out highlights, unless you want them for creative reasons. A *blown-out* highlight occurs when you use exposure settings that make part of the image pure white where there should be details.

The problem with pure white is that you cannot bring detail into a photograph where no detail exists in the image file. There is no fixing an annoying bright area that has no detail by using the computer. No magic bullets exist for this condition in image-processing software such as Adobe Photoshop Elements.

If your camera LCD has a histogram, it probably also has a highlight alert, which is a feature that shows blinking patches on bright white areas in the photo. These blinking patches mean that you need to decrease the exposure until there are no more blown-out highlights. Watch your histogram, though, because you don't want a gap at the right, either. If a histogram is clipped at the extreme right, this also indicates that you need to reduce your exposure.

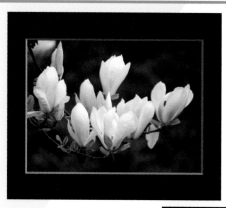

The right exposure holds the detail in these white magnolia blossoms.

The wrong exposure blows out the detail in the same blossoms.

On many cameras, blown-out highlights appear as "blinking highlights."

The pure white highlights from the flare around the sun are normal and should not be exposed for detail. This is a well-exposed photo of an early morning forest in Tennessee.

The white of the clouds is very important to this aerial scene in the Mojave Desert. Over-exposure would hurt the texture and form of the clouds.

TIPS

Did You Know?

When shooting with a digital camera, most of the time you should choose exposure settings to properly expose for the highlight area of a scene. Using image-processing software such as Adobe Photoshop Elements, you can often bring details back into an underexposed area; you cannot, however, bring detail back from an overexposed highlight area where all the details are blown out, because there are few or no details in the near-white or pure-white areas.

Did You Know?

One place that pure white is acceptable is where there are spectral highlights. A *spectral highlight* is a bright spot from a shiny, highly reflective surface. Generally, spectral highlights should be small and very focused.

Shoot two exposures to get
MORE EXPOSURE RANGE

Photography and print professionals refer to the range between the darkest parts of an image and the lightest parts of an image as the *tonal range*. A composition that has very bright parts, such as a bright white sky, and very dark parts where there are deep shadows is said to have a wide tonal range and can be difficult to capture with a digital camera. The contrast of that tonal range can be beyond the capability of the sensor.

One way to capture details in the shadow areas and in the highlight areas is to use a special digital technique. By putting your camera on a tripod, you can shoot once to expose for the highlights and then again to expose for the shadows. The resulting two images can be merged together using an image editor such as Photoshop Elements (see Task #82). Or you can shoot once using the RAW format and convert the image twice — once for shadow detail and once for highlight detail. You then merge the two together (see Task #81).

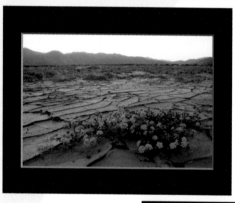

You could easily see the flowers and the sunset while standing at this scene, but the camera could not. This photo was exposed for the ground.

This dark photo was exposed to get a good rendering of the sky.

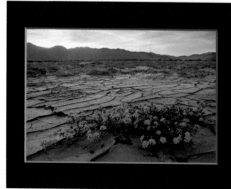

The final shot shows the combination of the good parts of the two exposures so that a more accurate rendering of the scene can be shown, rather than the incorrect interpretation that was limited by the sensor's capabilities.

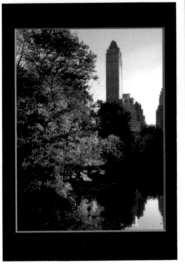

This scene of the southeast corner of New York's Central Park was shot in RAW. The tonal range of the image was improved by first processing for the bright sky and buildings.

The same RAW file was then processed for the dark areas and the fall colors.

The two versions of the same image file were then combined to get the best tones and colors from each.

TIPS

Did You Know?

Many photographers use a graduated neutral density filter to enable them to capture a wide dynamic range. This filter is half dark and half clear with a gradual blend through the middle. It can be a very useful tool to help limit bright light from part of the scene (such as the sky) while allowing dark areas to record normally (such as the ground), so that the sensor can better handle the tonal range of the scene.

Photo Tip!

You can expose a scene with a wide dynamic range to get excellent silhouettes. Silhouettes are dramatic pictures that look great if you keep the silhouettes dark from underexposure while you keep the background (such as a sunlit hillside) bright, but with detail and color. Check your histogram and LCD review to be sure you got the right exposure. You can always darken the silhouettes to pure black in an image-processing program such as Photoshop Elements.

4

Control Sharpness and Depth of Field

Modern cameras and lenses enable you to take very sharp photos; however, incorrect focus, limited depth of field, and subject and camera movement sometimes produce blurry, unattractive images. Although there are times you may want to blur a photo for artistic effect, blurring is usually a symptom of a poor-quality photo.

Although you need to understand how to control sharpness in a photo, it is equally important to be able to visualize the effect that you will get from shutter speed and depth of field. For example, you should know how depth of field is affected when you change the aperture setting from f/4 to f/8. One nice

feature of digital photography is that EXIF data—information including the shutter speed and aperture used for a particular photo—is saved with your file. Study your shots using the EXIF data and you will get better at choosing your settings. See Task #46 to learn more about EXIF data.

Focus, shutter speed, and depth of field are three variables that enable a digital photographer to shoot more creatively. To develop the "mental view," shoot a series of photos as you try various combinations of these controls and then learn from their differences.

Top 100

USE A TRIPOD
for top sharpness

DIFFICULTY LEVEL

Lenses made for digital cameras are very sharp. To consistently get the full sharpness from those lenses, you need to own and use a tripod. A tripod is especially important when you shoot in low light-levels and use a slow shutter speed. The longer the focal length of lens you use, the more important it is to use a tripod because the magnification of the telephoto also magnifies any camera movement during exposure, which blurs a photo.

Besides enabling you to consistently take sharply focused photos, a tripod also makes it easy for you to shoot a more precisely and carefully composed photo. Carrying and using a tripod can seem like a nuisance at first. However, once you discover how much of a difference it makes, it will be hard for you to take photos without one. Photographers that regularly use a tripod get better photographs. Carbon-fiber tripods are more expensive than aluminum, but they are also lighter and are more likely to be carried and used by a photographer.

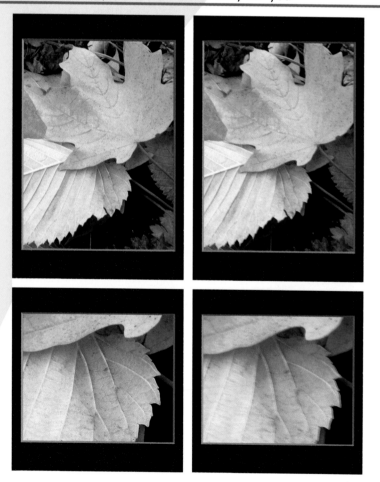

Compare these two photos. The first is shot with a tripod, the second is not. Blur causes the second to look just a little duller.

These enlarged details show the difference from sharp tripod image to blurred shot from camera movement during a slow shutter speed.

Show action using a
FAST SHUTTER SPEED

DIFFICULTY LEVEL

The world is full of fast action, and you can stop it in your photos by using a fast shutter speed. Choose at least $1/500$ for fast action or you will get some blurring of your subject. Faster shutter speeds of $1/1000$, $1/2000$, and so on, give you even more options for stopping action.

Action is hardest to stop when it is close to you and moving across your image area from one side to another. Action gets easier to stop (and will allow a slower shutter speed) when it moves toward or away from you and is farther away. Still, it can be helpful to check your LCD review to be sure you are stopping action with the right shutter speed.

You may have to use your widest f-stops paired with fast shutter speeds and even change your ISO setting as your shutter speeds need to be faster. As shutter speeds get shorter, less light gets to the sensor, often requiring you to increase the ISO setting. While there can be a trade-off in increased noise, it is still better to have sharp action with noise than blurry action without.

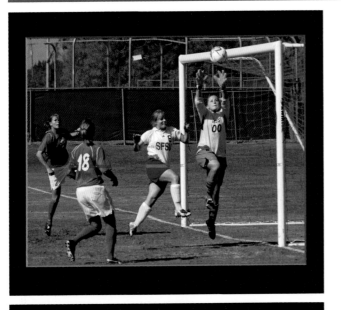

A $1/1500$ shutter speed stopped this soccer action. The lens was used with its widest aperture and the ISO setting was increased to 200.

These long-distance runners were captured at $1/750$, also with the lens shot wide open to allow for the fastest shutter speed.

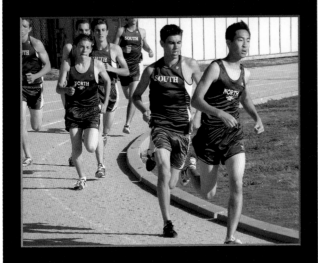

Show action using a
SLOW SHUTTER SPEED

Action looks great frozen in a photograph due to the use of a fast shutter speed. However, you can gain a really creative effect that shows action as movement-in-progress by using a slow shutter speed that will blur your subject. In general, this means shutter speeds of $\frac{1}{15}$ second or less, but it depends on your subject. To avoid getting a blurred background, use a tripod to limit the blur to the moving subject. Try shots both with and without a tripod.

Choosing the right shutter speed is critical. Choosing one that is too slow yields too much blur, but choosing one that is too fast eliminates any sense of movement. The digital camera is ideal for this because you can experiment with different speeds and quickly check the results on your LCD.

If the light is too bright, you might not be able to get a slow enough shutter speed. In such cases, you can use a neutral density filter (a dark gray filter) to block some of the light entering the camera, which enables you to choose a slower shutter speed. To learn more about photographing with a neutral density filter, see Task #50.

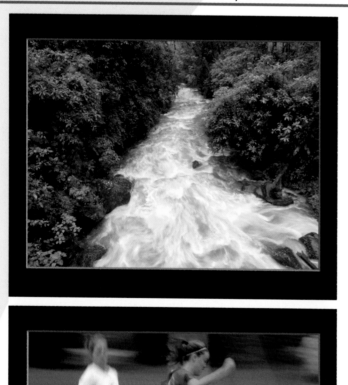

The classic use of a shutter speed ($\frac{1}{6}$ second) was used to blur the action of a rushing jungle stream in Costa Rica.

The day was cloudy and made it hard to use really fast shutter speeds, so blurring action through a slow shutter speed was the answer. The shutter speed of $\frac{1}{13}$ second was chosen by shooting and looking at the LCD for the effects of different speeds.

Add drama by PANNING WITH THE SUBJECT

Another technique for showing action is to follow a horizontally moving subject with your camera while using a slow shutter speed. This is called *panning* and gives varied effects depending on the shutter speed. The result can be a dramatic photo showing the subject in a variety of blur/sharp views contrasted with a nicely blurred background with blurred horizontal lines that emphasize the movement.

The challenging parts of this technique are to choose the right shutter speed, pick the right background, and pan with the subject so that the moving subject is not double-blurred because the panning speed does not match the speed of the moving subject.

Getting the effect you want when panning requires a lot of experimentation and practice. Do not get hung up on a lot of details — just set a slow shutter speed and photograph a moving subject as you follow the movement with your camera. Then check your LCD to see the image you captured. You will get a lot of junk, but you will also start finding some interesting and creative interpretations of movement.

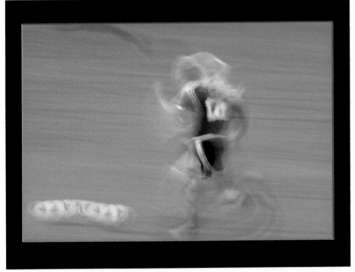

This shot shows a soccer player in action, blurring the image with a ¼ second speed and panning with the movement. It really emphasizes the speed and movement of the player and ball.

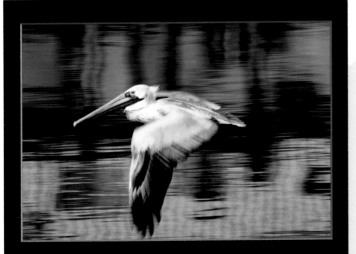

A shutter speed of ¹⁄₁₂₅ was used to freeze the flying pelican against the wonderfully colored and blurred background of a seaside harbor.

Understand
DEPTH OF FIELD

Depth of field is the amount of sharpness in your photo from front to back. Depth of field is affected by distance to the subject, focal length, and aperture or f-stop. The farther you are from the subject, the more depth of field increases; the closer you are, the more depth of field decreases. If you photograph a distant scene, you can just about use any setting and get enough depth of field. But if you are doing close-ups, you need to check your f-stop and focal length if you want deep depth of field.

Wide-angle lenses give more apparent depth of field than telephotos. In fact, short focal-length lenses of any kind increase depth of field, which is why compact digital cameras have a lot of depth of field (the lenses have very short focal lengths).

As you change your f-stop, you change your depth of field. Here is a set of f-stops starting from wide or large to small: f/ 2, f/2.8, f/4, f/5.6, f/8, f/11, f/16, f/22. Depth of field increases as the f-stop is changed toward f/22, and it decreases as the choice goes to the front of the line at f/2.

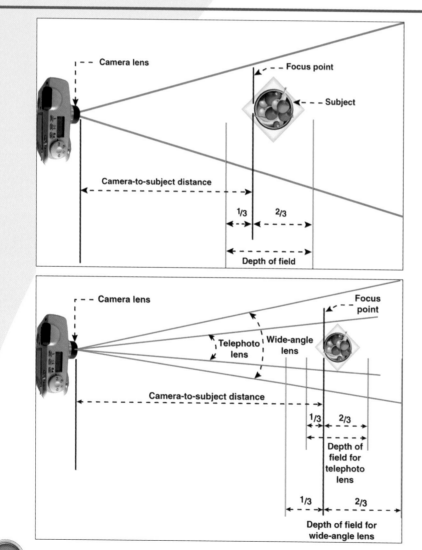

Depth-of-field sharpness is not evenly spaced around the focus point. At normal distances, one-third of the depth of field is in front of the focus point, and two-thirds is behind the focus point.

Shorter focal length lenses (wide-angle lenses such as 28mm) have more apparent depth of field than long focal length lenses (telephoto lenses such as 100mm).

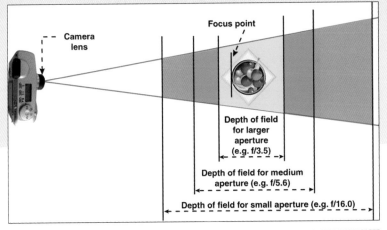

Aperture size or f-stop is a key factor in depth of field. Small apertures result in greater depth of field. Wide f-stops result in less depth of field.

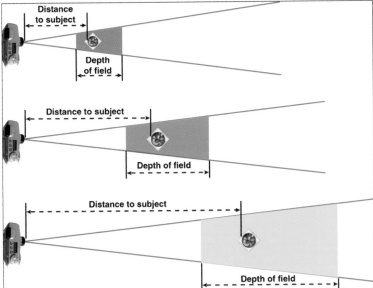

Camera-to-subject distance also affects depth of field. The farther away a subject is from the camera, the greater the depth of field will be.

TIPS

Did You Know?

The larger the aperture, the "faster" the lens is because it lets in more light than a slower lens or one with a smaller aperture — in the same amount of time. A fast lens can be very useful in low light conditions, but it will also be much larger and heavier than other lenses.

Photo Tip!

When you want the maximum depth of field and you are shooting in low light, or you are shooting close-up shots, you may find that the movement of the camera caused by pressing the shutter release button results in unwanted image blur. To avoid this, use a tripod and set the self-timer so that the camera can take the photo without you pressing the shutter release button.

Control focus creatively with
DEEP DEPTH OF FIELD

Deep depth of field can be dramatic. A landscape, for example, that is sharp throughout the image is a classic way of capturing such a scene. If you are at a distance from your subject, you will find that with wide-angle and moderate focal-length lenses, standard image sharpness will cover your scene with almost any f-stop you set.

When this changes, though, you cannot simply use any setting that program-mode auto exposure provides. If you are close to the subject, if you want to have sharpness starting with something close and going way back into the background, or if you are using a telephoto lens, you will need to select a small aperture to get maximum depth of field.

Use aperture-priority exposure as described in Task #23. Choose one of the smaller f-stops your lens allows, such as f/11 or f/16 for a digital SLR or f/8 for a compact digital camera. Remember that small apertures often result in slow shutter speeds that require the use of a tripod or some other way of supporting your camera during the exposure.

A distant scene, such as this rocky landscape of Arches National Park, generally has enough depth of field at standard, program autoexposure settings.

A wide-angle lens combined with a small aperture makes it easy to get great depth of field in a landscape (f/8 with a compact digital camera).

This image was taken with a small f-stop of f/11 and a wide-angle lens to give this intimate landscape a deep depth of field.

DIFFICULTY LEVEL

This image was taken with a small f-stop of f/16 in order to guarantee all parts of this scene from the nearest bristlecone pine to those on the horizon were sharp.

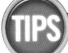

TIPS

Did You Know?

Sharpness and depth of field is affected by the size of the print. A small print often looks sharper than the same image printed much larger. Larger images can dramatically show off a great photo, but they also magnify any faults in the image, including sharpness problems. Depth of field actually appears to shrink with larger prints.

Photo Tip!

Most digital SLRs have a depth of field preview button. This button can help you see the sharpness in an image as you look through the viewfinder. It stops the lens down to the taking aperture. This makes the image very dark, but if you look closely (and this may take some practice), you can see how the background sharpness changes as the f-stop is changed.

Create cool effects with
SHALLOW DEPTH OF FIELD

Many beginning photographers always try to get everything in focus. That is not always practical (you may have to use too-slow a shutter speed) or even effective with your subject. A shallow depth of field where the subject is sharp and surrounding objects in front of or behind the subject (or both) are soft from lack of sharpness, can create a dramatic image that viewers can clearly see. In addition, a shallow depth of field can help your subject stand out against what would otherwise be a confusing background if sharp.

Photography is all about controlling a wide range of variables and understanding the effects you get. When you use a longer focal length, a wide-open aperture, or a close distance to the subject in order to get a shallower depth of field, you are specifically controlling what your viewer can and cannot see in a photograph. This can be a very strong way of showing off your subject and giving some power to your composition.

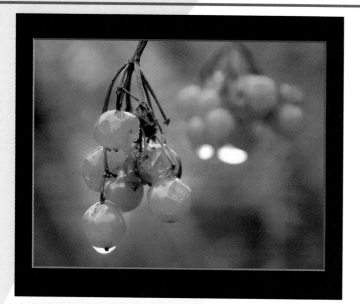

A wide-aperture or f-stop setting limits depth of field, as seen in this photograph of high-bush cranberry berries photographed at f/3.5.

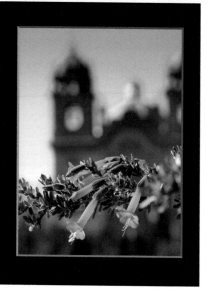

Here, a telephoto lens combined with a wide aperture of f/5.6 softens the background and makes the flowers stand out.

This image was taken with both a telephoto and a wide aperture of f/4 to create a dramatic, almost abstract image of a natural scene.

#35

DIFFICULTY LEVEL

Using a lens with a long focal length and selecting a large aperture created a shallow depth of field to isolate the young boy's face from the rest of the photo.

TIPS

Did You Know?

Due to the small size of the image sensor used in many compact digital cameras, the lens has a very short focal length, giving it inherently more depth of field. If you mostly want to shoot photos with maximum depth of field, such a camera is wonderful. If, instead, you want to be able to shoot subjects with blurred backgrounds, try zooming to the longest, most telephoto focal lengths and selecting the widest possible f-stop setting.

Photo Tip!

When you are taking a portrait, try using a long focal length with a wider f-stop (such as f/4 or f/5.6) to get a small depth of field to focus attention on your subject and to blur the background. This also allows a faster shutter speed, helping to make sure the sharp part of the image is as sharp as possible.

Understanding
FOCAL LENGTH

Technically, *focal length* is the distance in millimeters between the optical center of the lens and the image sensor in a digital camera when the lens is focused on infinity. However, focal length by itself does not describe how much of the subject is seen in the image area, as is commonly thought. This is affected by the angle of view which is highly dependent on both the focal length and the size of the image sensor (this has always been true with film, as well, where the film size changed with format type).

To make it easy to compare angles of view, the camera industry often uses the term "35mm equivalent focal length." This is simply a way to compare focal lengths to a single reference and does not mean the focal length actually changes. Long focal-length lenses (or telephotos), such as a 200mm "35mm equivalent focal length," have a narrow angle of view and magnify the subject within the image area. To capture a wider angle of view, you need a wide-angle lens (or shorter focal length).

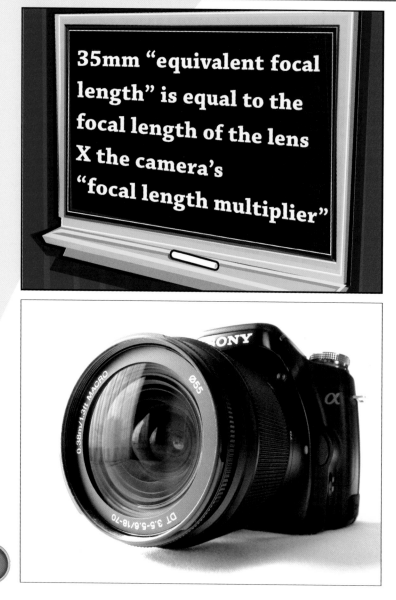

35mm "equivalent focal length" is equal to the focal length of the lens X the camera's "focal length multiplier"

FOCAL LENGTH MULTIPLIER
You can usually find the focal length multiplier for your camera in your camera's documentation.

A zoom lens gives you a range of focal lengths that can be used as needed. This lens is an 18–70mm Sony zoom that offers a 35mm equivalent focal length range of 28-105mm.

This photo on the left shows a night scene of New York City shot with a 35mm equivalent focal length of 24mm.

The same scene was then captured with a smaller angle of view by using a lens with a focal length equivalent of 80mm.

TIPS

Did You Know?

Many zoom cameras have an X rating, such as 2X or 4X, which is not directly related to the focal length. It just means that the maximum focal length is "X times" longer than the minimum focal length. For example, a lens with an 8X zoom lens means that the longest focal length is 8 times the shortest focal length. This can be misleading because it does not tell you what you are really getting in angle of view from your lens.

Photo Tip!

Some digital cameras have a digital zoom feature that gives you an even longer focal length than you get with the optical zoom. Optical zoom is done solely through the optics of the lens and uses the maximum quality of lens and sensor. Digital zoom is actually a crop of the center of the composition which is then enlarged digitally — it may help in a pinch, but it is extremely inferior to optical zoom.

CONTROL PERSPECTIVE
with focal length

When you stand in the middle of railroad tracks that vanish into the horizon, you are experiencing *perspective*. Perspective is also experienced by how you perceive similar objects as they change in distance — they are large when close and get smaller with distance. When shooting photos with a camera, you can use focal length to control perspective and therefore the feeling of depth in a photo. Wide-angle lenses deepen the experience of perspective in a photograph, and telephoto lenses flatten out perspective.

This can be a very creative control for a photographer. Instead of simply zooming your lens to change the size of your subject in the frame, try moving closer or farther from the subject. If you back up and use a telephoto setting, perspective will be flattened, bringing the background closer to your subject. Get closer with a wide-angle setting and the background seems to jump back into the distance. Both effects really change the impression of the scene within the photograph and are worth doing some experimenting with.

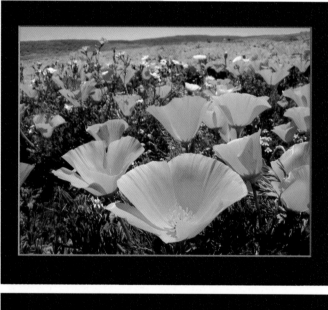

A wide-angle lens up close created an image with a very deep perspective on these California poppies.

A telephoto lens captured perspective of the same fields of poppies with a very different look, where the colors and forms look "flattened" or much closer together.

This photo was taken with a wide-angle lens to give more of a feeling of space and depth in the room.

#37

DIFFICULTY LEVEL

In this photo, a slight telephoto focal length was used to flatten the scene slightly, making the background look closer to the subject.

TIPS

Did You Know?

Hollywood uses perspective tricks all the time to create drama in movies. For example, the director of photography for an action film might use an extreme telephoto to flatten perspective and compress distance so that it looks like a truck is about to run over the hero, when in fact, the truck is not that close. Or in a romantic film, a wide-angle lens on a heroine alone in a park might be used to deepen perspective and make her look even more alone.

Photo Tip

One way to discover how strong perspective can be in photographs is to do some experiments with a zoom lens. Try it at its widest focal length and get close enough to your subject that the subject nearly fills the image area from bottom to top. Then zoom into the most telephoto focal length and back up until the subject once again fills the image area from bottom to top. Now compare the images and the relation of subject to background.

CONTROL BACKGROUND
with focal length and aperture

Controlling the background in a photo is often a key factor in getting a good composition. You can easily control the background with a long focal-length lens, which has a shallow depth of field and a narrow angle of view. The shallow depth of field helps to create a soft-focused background. The narrow view makes it easier to change the background by moving the camera location to the left or right, or even up or down a few inches, with minimal effect on the composition of the subject.

Several factors determine how much you can control the background. The distance from the camera to the subject and the distance between the subject and the background are two important factors, along with the focal length. The closer the camera is to the subject, the narrower the depth of field will be, which helps to blur the background. Likewise, the farther the background is from the subject, the more you can blur the background. A tripod is a good aid to precise composition and successful control of the background when shooting with a long focal-length lens.

The longer the focal length of a lens, the more a slight move to the right or left may change the background.

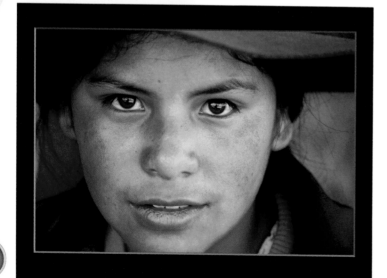

The girl in this portrait was carefully positioned to make a nice soft background with colors that enhance the subject.

The softly blurred background with contrasting colors helps to isolate and focus attention on the flowers in the foreground.

The closer the background is to the subject, the more difficult it is to get a softly blurred background, so it helps to move until you get enough distance to create an attractive blur to the background.

TIPS

Did You Know?

Aperture settings are written as f/4.0 or f/8.0. But, in fact, the aperture size is really a fraction, $\frac{1}{4.0}$ or $\frac{1}{4}$, and $\frac{1}{8.0}$ or $\frac{1}{8}$, which means that an f/4.0 aperture is actually larger than an f/8.0 aperture because one-fourth is larger than one-eighth.

Photo Tip!

The greatest depth of field is obtained by selecting the smallest aperture. When shooting with a small aperture, you need to use a slower shutter speed to get a proper exposure. This is why you need to use a tripod when the objective is to shoot with the maximum depth of field.

Take Better Photos

Taking good photographs has more to do with a photographer's vision than the brand of camera used. The time you spend shooting, reviewing, and digitally processing your photos plus the knowledge you have of your camera is worth more than buying and using expensive photographic equipment. Expensive digital cameras do have certain features that specific photographers need, such as high-speed shooting for sports photographers. But if you really want to improve your photographic success, learn how to shoot better. Learn to choose subjects that you are passionate about. Assess and choose good shooting conditions. Determine your own photographic vision.

You also need lots of time to shoot, study, edit, and wait. You may need to wait for better light, less wind, or even for the subjects that

you want to arrive. When conditions are good and you are ready to take pictures, you must know your camera well enough that you are ready to start shooting without fumbling with your camera. The exciting new world of digital photography offers every photographer many new benefits that make it easier, faster, and cheaper to learn to make excellent photographs more often.

One of the best standards to use to determine if you have taken a good photograph is to simply ask yourself if you like it and if you enjoyed the process of making it. Listen to the advice and opinions of others, but shoot for yourself and your own enjoyment. If you do, and you work hard and put in the time, you will become a good or maybe even a great photographer.

LOOK FOR PHOTOGRAPHS,
not subjects

Today's digital cameras consistently enable the taking of decent, sharp images of a subject — a snapshot. However, a good photograph goes beyond that simple rendering of a subject and becomes something that is interesting on its own, regardless if a viewer knows the subject or not. A good photograph is the difference between someone picking up a picture and commenting politely on the subject or telling you that you have a great shot. Of course, as photographers, we want the latter.

A photograph is something that is crafted, carefully made with attention to how the image is exposed and composed. A very simple, yet effective, way to focus on the photograph instead of simply capturing a rendition of the subject is to use the review function of your LCD monitor. After taking a picture, look at it in the LCD and ask yourself if you like this "photograph," not just if you captured the subject. How does this little photograph appeal to you on its own, irrespective of its relation to the subject?

Seals on a beach — the subject is clear, but the image is not much more than a snapshot. If you do not care about seals, you probably do not care much about this picture.

Compare this to the upper photo on this page. This image was crafted as a photograph with attention to focal length choice and composition.

Certainly not a bad photo of the electronics district in Tokyo, but the subject powers the photo, so if you do not care about Tokyo, the photo will not hold your interest.

The scene changed here because a slow shutter speed was employed to create an image that goes beyond a simple record of the buildings.

The scene changed again because dusk created an interesting light, the composition showed some unique relationships in the image, and a slow shutter speed blurred the cars on the road for added photographic interest.

TIPS

Photo Tip!

When you are shooting in less-than-ideal conditions, look for inventive ways to "find the photographs." A torrential downpour may leave you with wonderful patterns in water puddles that reflect your subject. Or wind that is too fast to enable you to take close-up photos may help you get creative soft-focus photos if you use a slow shutter speed to capture blowing flowers.

Did You Know?

A surprising number of excellent photographs have been taken in "bad" weather that seems to affect the subject badly. Heavy fog, thunderstorms, and snow blizzards often make for excellent photographs that are interesting beyond the subject. The next time that you think the weather is bad, go shoot and see what you get. In particular, look for changes in weather.

Consider the
POSSIBILITIES

Each time that you press the shutter button to take a picture, you consider many different variables, including exposure, composition, lighting, depth of field, angle of view, and ISO setting. To get better photos, think about how you can change the variables to take many different photographs. Pros call this "working the subject."

The more you experiment and study your results, the more you will know what you like and how to further develop your own personal style. For good practice, compare your images in the LCD review as you go.

This can help you see fresh and interesting photographs that you might have missed if you only looked at the images back home on the computer.

A story that illustrates this: A famous photographer was asked to review another photographer's portfolio. He looked quickly through the images and said, "Take a couple of weeks and go shoot a few thousand more photos." He replied this way because the other photographer had not yet considered enough of the possibilities.

These two photos were taken within three minutes of each other, yet they look dramatically different. The first is boldly colored with the low sunrise light hitting the rocks and Joshua tree directly, while the exposure keeps the sky color strong.

This second image came by turning around and looking for an interesting Joshua tree that could be silhouetted against the sky, plus finding an angle to allow the sun to flare along the trunk.

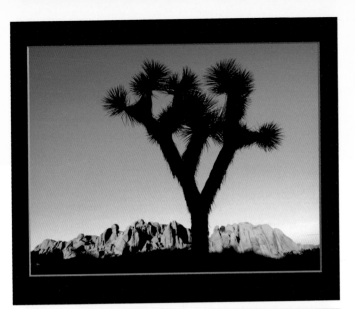

These two images look similar, but they create a very different impression with the viewer. The first photo was shot with a wide-angle lens which creates a deep perspective and makes the rocks look more distant, while the Joshua tree looks like it has more space behind and around it.

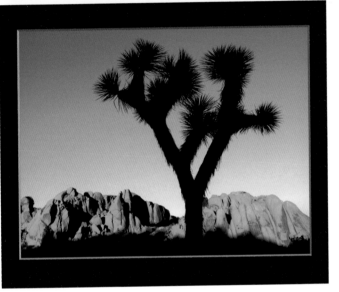

In this shot, a telephoto was used from a position farther away. This kept the Joshua tree about the same size, but it brought the background rocks visually closer to the tree and created a tighter space.

TIPS

Apply It!

You can sometimes get new and interesting photographs by going to extremes. Shoot at extreme f-stops, extreme shutter speeds, and extreme angles of view. An interesting exercise is to shoot the same subject with two extreme choices, such as a very wide, then a very small aperture. A great exercise is to shoot your subject with a zoom lens, shooting one shot with the widest setting, then the very next with the most telephoto.

Photo Tip!

The sunburst effect from a bright sun in the photo is fairly easy to accomplish with any digital camera that allows you to set your aperture (with either aperture-priority auto exposure or manual exposure). Stop your lens down to one of the smallest f-stops possible with your lens (f/8 with a compact digital camera or f/16 with a digital SLR). Then shoot toward the sun, with the sun in the image and near something dark (for the sunburst to flare against).

Compose for
MAXIMUM EFFECT

How you compose your photo strongly affects how your image affects a viewer and how clearly your subject is shown. The rule of thirds (though really not a rule, but a guideline) gives you some positions in an image where you might place the main subject, horizon lines, or strong verticals. Imagine a tic-tac-toe board overlaid on the image. Horizons often look good placed where the horizontal lines are, and strong vertical picture elements can go where the vertical lines are. The subject then seems at home at any one of the four points where the lines intersect.

Using a digital camera with a zoom lens enables you to try different compositions without having to move as much. You can shoot a wide-angle photo and then zoom in to compose a much tighter view of the subject. The angle to the subject is another important part of composition that you control when you look for high or low places that you can use to photograph from. Look for creative angles that show your subject or scene in new and interesting ways.

This photo was composed using the rule of thirds. You can see it with and without a grid showing the guideline in action (some cameras even have a rule-of-thirds overlay that can be chosen for the viewfinder or LCD view).

You can see the face fits the rule-of-thirds guide very well and creates a nicely balanced image.

The rule of thirds is a good guideline, but not something to follow as if it were law. This photo uses the rule as a start, and then stretches it for effect.

Composition is ultimately about making the subject a star. Keep the photo simple by only including what is needed to support your subject and by keeping out distractions.

TIPS

Apply It!

One way of thinking about composition is to consider it based on these three words: include, exclude, and arrange. What do you include in your photo from edge to edge? What do you exclude from the photo? How do you arrange the elements of the photo? Where does the subject go? Where should the horizon sit? How close to the edges can you place important parts of the scene?

Did You Know?

It takes effort to see new ways to compose. Yet, if you took a dozen good photographers and asked them to shoot the same subject, there would be many, many different compositions. Find a subject and see how many different compositions you can shoot as an exercise to further your composition skills.

Compose for
IMPACT

People see photos all the time, typically from the minute they wake up until they go to sleep at night. Any photos you create will compete with this huge volume of imagery whether you like it or not.

One way of getting attention for your photos is to compose in such a way that your photos have added impact. Impact comes from the use of a technique that grabs viewers' attention and stops them long enough to really look at your photo.

You do not need to make every image have high impact. That can be wearing for a viewer and it can overwhelm your subjects. But having impact in at least some of your photos will lift the quality of all of them.

Impact from composition means finding a composition that is uncommon and unexpected. Shoot from a high angle for a subject always seen from below. Or try a shot with your camera on the ground. Look for compositions that deliberately break the rule of thirds. Search out compositions that are different and unique.

This water lily image is definitely not your normal sort of composition. It is way outside the rule of thirds and shot from a very low, water-level angle.

Here you see a very extreme angle where the camera is actually inside the clump of lupine flowers and low enough to see the sun.

Everybody shoots sunsets, and mostly they put the sun right in the middle of the frame. That is not only a rather dull way of composing, but it is also so common that the average viewer will pass it right on by.

Here the sun has been placed high in the frame to give it more emphasis and to create a long leading highlight in the water. This is not your typical sunset shot and gives the image far more impact.

TIPS

Apply It!

As you shoot photos with impact, remember that simply applying a technique can fight your ultimate photo. How is that? When a technique is not appropriate to the subject, it can overwhelm it, making the subject struggle to be seen by the viewer. The impact technique might create some initial interest for the viewer, but the viewer will get frustrated by the technique's fight with the subject.

Did You Know?

Advertising photographers use high-impact techniques all the time. They must create images that grab the viewer's attention — that is the whole purpose of advertising. Look at ads now with a different perspective. Ask yourself how a compositional technique might have been used to create impact. Or see if you can discover other ways the photographer worked to gain attention through something unexpected.

Use the
FOREGROUND

A very effective technique for improved compositions is the use of a strong foreground. You will see that throughout the book because this is one of my favorite techniques. It works well for almost any subject. You can make your subject the strong foreground element, with the background creating an interesting environment behind it. Or you can use a strong foreground as a frame that creates depth and compositional impact because of the relationship of the foreground to the background.

You can shoot this with a lot of depth of field as described in Tasks 33 and 34, so that the foreground and background are both sharp. You can also create a much different effect by making a foreground framing element out of focus so that it strongly contrasts with the sharp subject in the background, as explained in Task #35. What usually does not work is to have the foreground with an "in-between" focus that is neither out of focus nor really in focus (though it can be okay to have a foreground subject sharp and a background that is not quite as sharp).

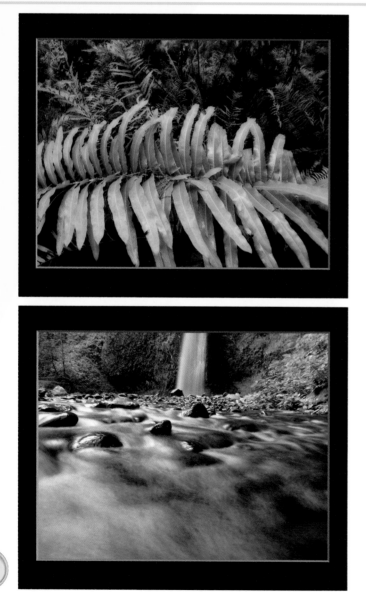

The fern in the foreground is a very strong compositional element to the photograph. The background creates a setting for the fern.

A very strong foreground of running water creates a strong composition in this photo.

This angle was chosen very carefully to allow an out-of-focus pitcher in the foreground to frame the shortstop.

Shooting through driftwood created a strong foreground frame for a Florida sunrise.

TIPS

Did You Know?

Many of the world's most successful and well-known photographers have a style that makes their work notable and can help inspire you to try new ideas. Check out the works of Frans Lanting, Freeman Patterson, Pete Turner, and Annie Leibovitz — to name just a few. David Muench's landscape work is a place to see some great inspiration for the use of foreground in a photo, too.

Did You Know?

If you want to sell your photographs in an art show or display them in a gallery, you are more likely to have your work shown if you have a distinct style, shoot on a theme, or both. A series of random photographs with no connection can be considerably less interesting than a group of photos with a consistent style or theme.

SHOOT DETAILS
to create interest

Although the first and natural inclination is to shoot an entire subject, shooting tightly composed details can create captivating photos. Detail photos often are more interesting than full-subject shots because you can take a photograph that shows either detail that the viewer had never noticed or detail that may cause the viewer to take a closer look while wondering what the subject is.

Capturing just part of a subject emphasizes the detail that is ordinarily overlooked when viewing the entire subject. When composing detail photos, look for picture elements such as form, color, texture, or shape.

When shooting details, be aware of the fact that you can shoot an increasing level of detail, too. For example, you can shoot just part of a tree with an interesting shape, such as a specific branch, a few leaves, a single leaf, or even just part of a leaf showing the intricate lines and texture. As you move in to concentrate on increasingly smaller detail, you may want to consider using a macro lens or macro feature.

The close-up photo of this dandelion seed head was taken to reveal details not ordinarily noticed in photographs that show the entire dandelion.

The detail in the individual blooms of a lupine flower are missed by most people who concentrate on the entire flower stalk.

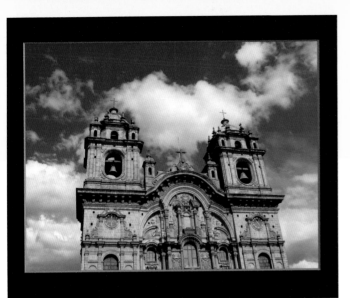

Here is a photo of a church in Cusco, Peru. It is a fine record shot but not as engaging as the detail photo.

44

This close-up shot of the door of the church in Cusco shows much more color and drama than the overall shot. Plus it shows the viewer details that cannot be seen in the full church image.

TIPS

Apply It!

To catch viewers' interest, take a photo of just part of a subject to let them imagine what the rest of the subject looks like, or to even make them wonder what it is that they are looking at. Also, detail-oriented photos can frequently reveal details to viewers that they would not normally have noticed.

Photo Tip!

When shooting a detailed photo with a small subject, use a macro lens or shoot in macro mode if one is available on your digital camera. Shooting with a shallow depth of field can often add to the success of the photo.

BRACKET
your compositions

One sure way to get better compositions is to *bracket* them. This means taking multiple compositions of the same subject, changing something about the photograph each time.

One way to do this is to take your best photo of the subject, then ask yourself, "Where is the next photo of this subject?" You take that picture, then ask yourself again, "Where is the next photo?" This forces you to really look at your subject and to find true photographs that go far beyond a simple snapshot.

With the digital camera, take a picture, and then look at it in the LCD. Look at it and see what you could do differently with that same subject. Then try that shot and review it in the LCD. Do the same thing — look critically at the little picture and ask yourself how it could be changed (not simply improved). Your objective is to try lots of different compositions that may lead you to better shots, not necessarily to make every shot better than the previous one.

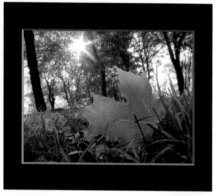

Three variations on a single subject — the first is shot with a wider-angle lens and more depth of field, and includes a sunburst.

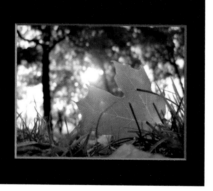

The second is shot with more of a telephoto and a wider aperture for more selective focus. Note how much the background has changed the composition.

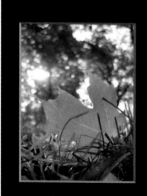

The third uses a vertical orientation. Verticals instantly give a different look to your composition. Note, too, how the background has changed again.

These four photos of some wonderful old buildings in Denver show off how one might look for varied compositions of the same subject.

The shot on the left shows the setting and includes a modern building for contrast.

The next shot shows a detail of the buildings' facades with the sky as an important color and graphic shape.

The last two shots get in close and emphasize the patterns in the surfaces of the buildings.

TIPS

Photo Tip!

Turn your camera's auto rotate off to get a better view of your verticals. Auto rotate turns verticals so that they appear vertical when the camera is held horizontally — this puts the long side of the photo into the short side of the LCD and wastes a lot of space. If you do not auto rotate, you have to rotate the camera to better see your verticals, but you see them at maximum size within the LCD monitor.

Did You Know?

Most photographers rarely shoot verticals. This is partly because cameras are not designed for easy vertical photography. Because of photographers' tendency, then, to mainly shoot horizontals, you can get striking photos that most other photographers do not have simply by shooting verticals more often.

Learn to shoot better by
STUDYING EXIF DATA

When you take a digital picture, the camera records or "writes" the image to an image file, and includes other useful information called *metadata* (literally, data about data) such as the date and time that the picture was taken. The camera also records settings such as shutter speed, aperture, exposure compensation, program mode, ISO speed, metering mode, and flash information.

All this photo-specific information or metadata is written to the image file in an industry-standard format called the *EXIF* (exchangeable image file) format. Most image-processing software today, including Photoshop and Photoshop Elements, allows

you to read this data in a file info or similar menu option. Most digital camera manufacturers also provide image browser software that lets you read EXIF data while browsing thumbnail images. Also, you can read EXIF data from image-management applications such as iView Media Pro (www.iviewmultimedia.com), Adobe Photoshop Lightroom, and ACD Systems ACDSee (www.acdsystems.com). Metadata also includes information that you can write to the file, such as copyright and caption information in the IPTC data (International Press Telecommunications Council).

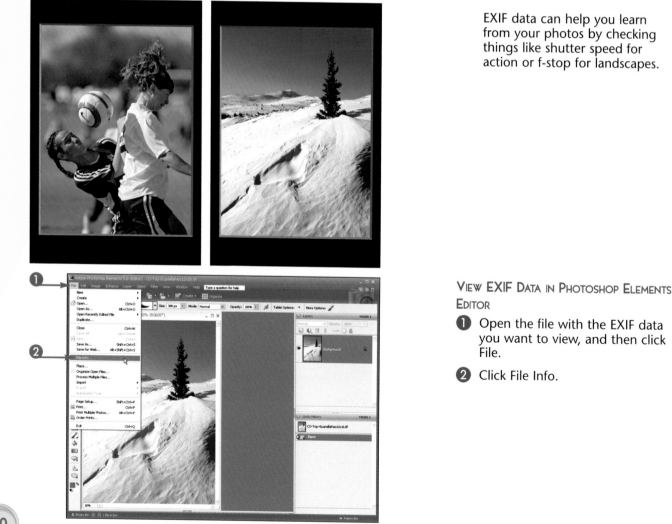

EXIF data can help you learn from your photos by checking things like shutter speed for action or f-stop for landscapes.

VIEW EXIF DATA IN PHOTOSHOP ELEMENTS EDITOR

❶ Open the file with the EXIF data you want to view, and then click File.

❷ Click File Info.

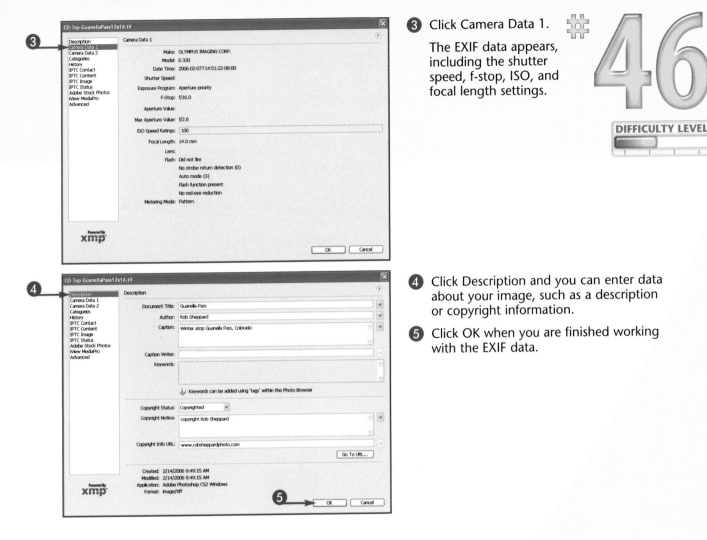

3 Click Camera Data 1.

The EXIF data appears, including the shutter speed, f-stop, ISO, and focal length settings.

4 Click Description and you can enter data about your image, such as a description or copyright information.

5 Click OK when you are finished working with the EXIF data.

TIPS

Apply It!

EXIF data can be useful for learning how to take better photos. After taking a few photos with different f-stops to control the depth of field, or when shooting multiple shots with different exposures using exposure compensation, look at the image and the EXIF data to learn which settings look the best for your photo's needs.

Did You Know?

Besides being able to read the EXIF data that the camera writes into a digital photo file, you can also add your own textual information. Open an image in Adobe Photoshop Elements Editor and click File, then File Info to open the File Info dialog box. Click any one of the IPTC links to show dialog boxes where you can enter image titles, copyright notices, keywords, and much more.

Get better photos with
PATIENCE, PRACTICE, AND EFFORT

Photography is an art. As is true with all art, the creation of good art takes practice, patience, and effort. Camera marketers would have you believe that if you buy expensive digital cameras, you can expect to immediately get wonderful photographs. Because you are reading this book, you undoubtedly have discovered this is not true. To get the most from any camera, you have to practice, practice, and practice some more, shooting lots of photographs as you learn the craft of photography.

Then you often must be patient, waiting for the right light, the perfect gesture, the wind to stop, and so on. Time spent shooting and patience to wait for the best shooting conditions significantly affect your photographic success.

Finally, the difference between a snapshot and a great photo often comes from the effort the photographer puts into the picture-taking. Cameras are good enough to take okay snapshots easily, but the great shot comes with that extra attention and effort to create and capture something special.

Sometimes traveling to a distant location can inspire you to find new and exciting photos.

Or just keep a small digital camera with you at all times so you can photograph a unique group of mushrooms near your daughter's soccer field.

That extra effort for a perfect shot may mean getting up before dawn to capture a great sunrise.

DIFFICULTY LEVEL

Maybe the scene will test your patience as you wait for clouds to soften the light on a spring stream in Tennessee.

TIPS

Did You Know?

Professional photographers typically shoot a lot of photos. For example, a sports photographer shoots hundreds of images in a single football game, continually striving to get great shots. With digital cameras, the cost to shoot each photo is less, and you have the advantage of instantly viewing the photo that you took.

Did You Know?

One of the best ways to learn more about photography is to shoot often and shoot several pictures of the same subject or scene using different camera settings and compositions. Then, study the results as you go by viewing them on your LCD and making changes to your photographic effort as needed in order to improve the shot. You can learn even more by viewing them along with the EXIF data on your computer screen later.

Try Creative Photo Techniques

Although you can take snapshots to document the events around you, photography can be so much more than that. To develop your visual eye and increase your ability to effectively use your camera to capture your unique vision of the world, you need to experiment and try different ideas. The more you shoot, experiment, and study your work and the work of others, the better your photography will be.

Coming up with creative photo ideas is sometimes challenging, but always a lot of fun. And you will always learn from your efforts. In addition to trying ideas that are presented in photography books, play around with new ideas yourself.

A great thing about digital is that there is no cost to experiment. If something seems interesting, try it out! See what it looks like on the LCD monitor. Experiment freely with different features on your camera. Push settings to the extreme to see what results you get. Think of ways to shoot that put focus on the subject, capture bold or subtle colors, or reveal patterns or shapes in complex scenes, or just shoot to play and learn from that play. Playing with a digital camera can be easy and fun, but you have to allow yourself to do it. Many photographers want to make every photo a serious endeavor. Yet, the more you play to see how you can shoot creatively, the more you will understand how to shoot well!

Top 100

Focus attention on your
SUBJECT

There are many ways to focus a viewer's attention on the subjects in your photographs. One way to do this is to simply fill that image area with your subject so the viewer has no other choice than to see the subject. When you frame up a tight shot of a subject, try taking two steps closer to make it even more dramatic in that photo.

Another way to do this is to look for contrast. Contrast in tonality, color, texture, background, focus, perspective, and other visual design elements makes your subject different from the rest of the photo.

The next time that you shoot, look over your scene carefully to find elements that might contrast with your subject. Can you use a telephoto lens for shallow depth of field to contrast sharpness, or can you use a wide-angle lens to show a huge expanse of open space with a tiny subject that draws a viewer's attention? Whatever strategy you use, placing more attention on your subject often results in a better photograph.

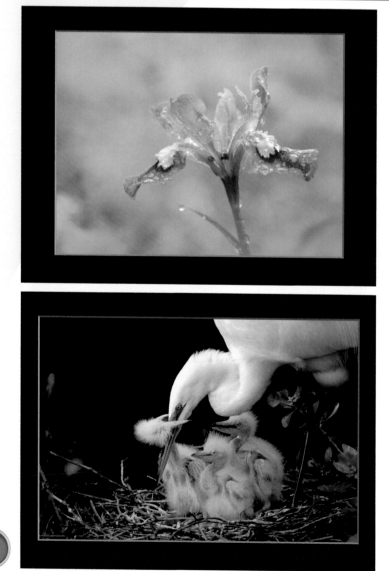

A telephoto lens and a large aperture were used to make this crested iris stand out against a blurred background.

The dark shadows behind this egret family keep attention on the birds.

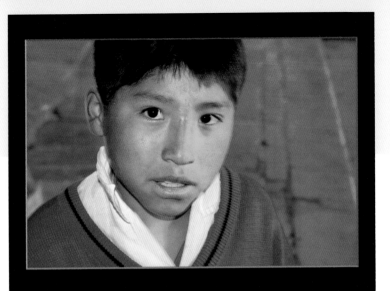

A tight, "up-close-and-personal" composition keeps the focus on the boy.

\#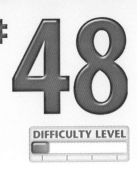

DIFFICULTY LEVEL

A dramatic low angle keeps the yellow agave flowers contrasted with the blue sky.

TIPS

Photo Tip!

Use a telephoto lens when you want to isolate a subject from its background. Long focal-length lenses have a shallow depth of field, and they therefore enable you to show a sharply focused subject against a soft, out-of-focus background. When you want to isolate a subject with a telephoto lens, use a large aperture setting to keep your subject in focus while creating a soft background. See Tasks 33 to 38 for more about focal length and depth of field.

Photo Tip!

Sometimes the best way to focus attention on a subject is to keep your composition as simple as it can be. This strategy helps to minimize the number of distracting elements that may compete with the main subject.

Shoot color for
DRAMATIC PHOTOS

Color is a tremendously powerful part of a photograph. It is more than simply "realistic" or a reflection of the world in color. Certain colors evoke emotions and create moods; others blend in and are hardly noticed. Red, for example, is always a color that is quickly noticed, even when it takes up a small part of a photo. Scenes or subjects can go from spectacular to relatively uninteresting, depending on the colors contained in the image frame. Heavily saturated bold colors can be dramatic, but so can soft, subtle colors — the key is to look at the colors

available to you and consider how they make or break your photograph.

Also, look for deliberate color contrasts. Move so your subject contrasts with colors behind it. Complementary colors create very strong color relationships, such as red/green, blue/orange, and yellow/violet. Another great contrast is saturated (the most vibrant) against unsaturated (or dull) colors. A third to look for is cold and warm contrast. But you can also look for an image with all similar colors for a very distinct mood.

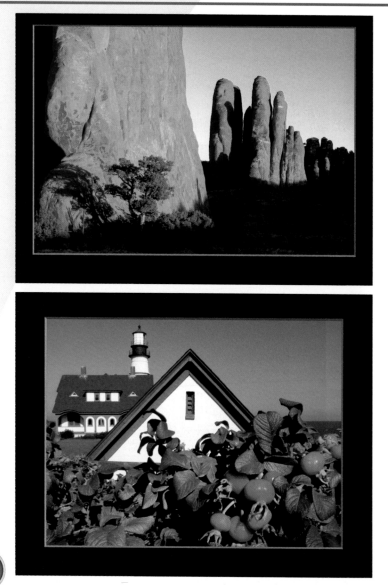

A setting sun warms the rocks of Arches National Park, but it is the cold/warm contrast that comes from the inclusion of the sky that makes for a lively photo.

Cover the red rose hips in the foreground of this image and you quickly see how important that bold color is to the photo.

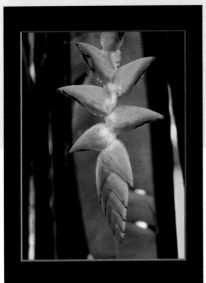

The green leaf directly behind the heliconia flower creates a strong contrast that both sets off the flower and creates a lively image.

#49

DIFFICULTY LEVEL

Simply emphasizing one bold color in a photo can also be an effective way to use color photographically.

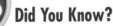

TIPS

Did You Know?

Color can sometimes say more in a photograph than the subject. Bold contrasting colors that are balanced between subject and its surroundings can give the viewer an entirely different impression of the photo and subject compared to a shot where bold colors overpower the subject.

Did You Know?

Some colors are more appealing than others. One of the reasons that the time just before and shortly after sunset is known as the "golden hour" is that the rich, warm, golden light bathes subjects in a very attractive rich, warm color. In contrast, colors in the blue family illuminate scenes in a cool, less friendly color.

Show movement with a
NEUTRAL DENSITY FILTER

A slow shutter speed records a moving subject as being partly to wholly blurred and offers you a great way to interpret movement. However, sometimes you cannot choose a slow enough shutter speed when shooting in bright light. Limitations of available apertures may require a shutter speed that is too fast to show motion. In such cases, you can use a neutral density filter to get a longer shutter speed.

A *neutral density filter* is nothing more than a dark, neutral-toned glass lens filter that reduces the amount of light that gets to the image sensor in your digital camera without having any effect on color. Neutral density filters are usually rated as 2X (also labeled 0.3), 4X (or 0.6), and 8X (or 0.9), and they decrease the light by 1, 2, and 3 stops, respectively. Hoya and Singh Ray filters even include variable density filters. Generally, when you use a neutral density filter and a slow shutter speed to show motion, use a tripod.

To learn more about showing motion in your photos, see Tasks 31 and 32.

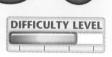

DIFFICULTY LEVEL

The combination of light clouds and a neutral density filter allows an exposure of ½ second to show off the movement of this water.

Without the use of a neutral density filter, this photo of a motorcycle could not have been taken because there was too much light to use a slow enough shutter speed to create this panning effect.

Control color and reflections with a
POLARIZER

DIFFICULTY LEVEL

A *polarizer* is a filter that attaches to your lens. Polarizers have three primary uses: to intensify skies, to remove light reflections, and to enhance or deepen the color saturation in outdoor scenes. When you use a polarizer to intensify skies, you gain the strongest effect at a right angle to the sun. All polarizers can be rotated, which enables you to control the level of the effect.

To affect reflections on glass or water, look through the polarizer and rotate it until the reflections diminish. A polarizer is useful, for example, when you want to shoot through a glass window and show what is on the other side or to shoot toward water and show what is beneath the surface. For outdoor scenes, the polarizer will remove glare from shiny surfaces such as rocks or leaves, allowing the color underneath to show through.

When you use a polarizer to enhance colors, watch what happens to the scene as you rotate the polarizer. Be careful to not overuse the effect because it can result in a contrasty and harsh-looking photo.

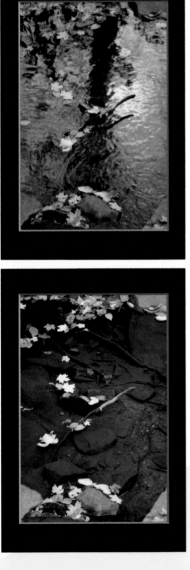

Reflections of colors of the trees and sky make the bottom of this shallow stream hard to see.

A polarizer filter removed the reflections so that the bottom of the stream is now visible.

Shoot photos for a
PANORAMA

For as long as photographs have been taken, it has always been a challenge for photographers to capture the beauty found in wide-sweeping scenes. Wide-angle lenses do okay, but often show too much foreground or sky. Digital photography gives you the opportunity to shoot multiple photos across a scene and then stitch them together in a long panoramic shot by using one of the digital stitching applications or a feature such as Adobe Photoshop Elements Photomerge.

You do have to carefully shoot images for stitching so that they will blend together seamlessly. No matter

what you do, you must overlap each photo by one-third to one-half so that the images have duplicate detail to allow a seamless blending. It is important to use a tripod, plus keep the camera level so the individual shots line up properly. Finally, maintain the same exposure throughout your photos (it often helps to use manual exposure for that purpose). Avoid shooting moving subjects such as clouds or ocean waves that make photos too different to be combined.

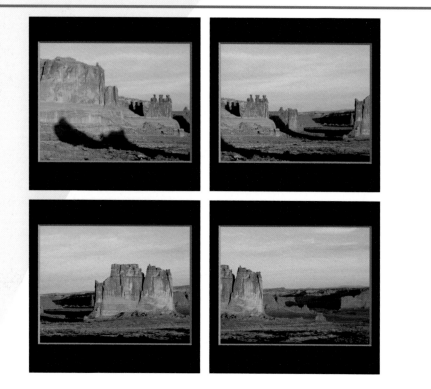

These four overlapping photographs of a landscape in Arches National Park were taken with a camera mounted on a tripod with a head that allows panning.

This photo was created by digitally stitching together the four photos shown on the prior page. Adobe Photoshop Elements was used to stitch the images together.

#52

DIFFICULTY LEVEL

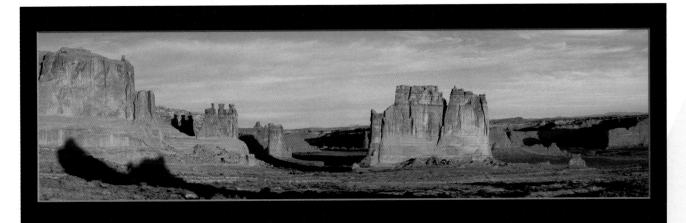

TIPS

Did You Know?

You can use the Adobe Photoshop Elements Photomerge feature to combine multiple photos into a single, large photo. If your digital camera does not have a wide enough focal length to capture what you want of a scene, you can shoot overlapping photos that cover the entire area you need captured and combine them in Photomerge. Follow the same ideas discussed about photographing a panorama.

Did You Know?

You can take multiple photos of vertical subjects and create vertical panoramas as easily as you can create horizontal panoramas. Good subjects for vertical panoramas include tall trees and buildings. Shooting from a distance with a telephoto lens can help minimize unwanted perspective distortion caused by using a lens with a shorter focal length.

Shoot photos with a "WOW!" FACTOR

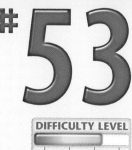

DIFFICULTY LEVEL

Photographs are everywhere. You see them almost from the time you wake up until the time you go to bed. For your photos to stand out in that crowd, you need to at least occasionally make pictures that really grab viewers, photos with a "Wow!" factor.

You do this by finding images that are unexpected and surprising for the viewer. A beautiful photo of a mountain looks like a lot of other beautiful mountain photos unless you can find a way to really make it different. Sometimes the trick to getting a photo with a high "Wow!" factor is being in the right place at the

right time and then using your skills to capture the perfect shot.

But you can get "Wow!" images more often by deliberately looking for ways that compel the viewer to get involved with the image. Great ways of doing this include the use of striking, unusual color; a new angle of shooting for a particular subject; great timing that captures action that is not usually seen; and exceptional light on the subject, light that goes way beyond simple illumination.

A unique and striking moment of action in a soccer game gives a "Wow!" factor to the photo due to timing and shutter speed.

Sunrises are always attractive, but it takes something extra to gain a "Wow!" image, such as bold color and a shot showing swirling clouds under the sun.

Shoot scenes with
LOW CONTRAST

#54

DIFFICULTY LEVEL

Soft, diffused light tends to reduce contrast and can be used to produce wonderful photographs. Unlike bright light that can create more contrast than you can capture on an image sensor (or film), soft light enables you to show good detail in all parts of an image, and it enables you to get excellent smooth gradations that can make superb photographs.

Learn to look for low-contrast light and take advantage of it when you find it. Early-morning or late-evening light is usually a good time to find low-contrast light with good color. Mist, fog, haze, or clouds can also create excellent low-contrast light that is a joy to shoot. Besides reducing contrast, these lighting conditions can also reduce color saturation and enable you to capture monochromatic images that can be simple and powerful.

Finding low-contrast light is not always easy. Some geographic areas rarely have anything but brightly lit skies, and other places are known for rarely having direct sunlight. Being able to shoot in low-contrast light is often a matter of place, time, and chance.

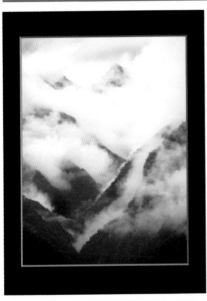

Heavy clouds and bad weather reduced the contrast in this photo taken in Peru, proving you do not have to have sunny weather for great shots.

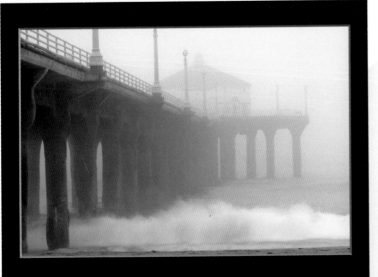

A heavy marine layer and fog gave a mysterious, romantic look to the Manhattan Beach pier in California.

Shoot in
ALL SEASONS

DIFFICULTY LEVEL

As the seasons change, you will always find excellent opportunities for great photos, yet some photographers only bring their cameras out at certain, limited times. If you want to expand your photographic skills and gain the best possible photos, get out and photograph through the whole year in your area. In early spring, you can find new buds that can be fascinating to watch as they open. Spring also brings a nice contrast between the dark browns of winter plants and the green colors of the new spring plants.

Summer brings lush greens and many flowers at its beginning, with shades of brown and hints of fall appearing toward the end. Undoubtedly, the rich bold colors of fall can be a key factor for getting extraordinary photos that are hard to match when shooting at any other time of the year. Winter brings new opportunities with its bold, stark patterns and forms that will challenge you to improve your composition skills. Do not let your camera hibernate!

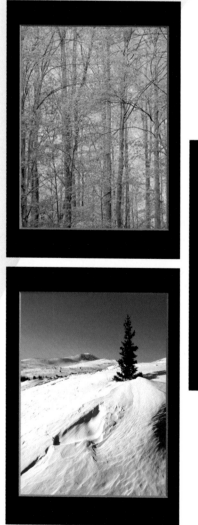

Spring is a time of new growth and wonderful soft greens.

By fall, much more than a color palette has changed and you gain whole new subjects.

Winter simplifies scenes in terms of colors, shapes, and forms, then offers its own compositions to be found by the alert photographer.

Shoot
PATTERNS AND SHAPES

As a photographer, you can choose from many elements to draw attention to your photographs. Patterns and shapes can often become the strongest elements in a photograph, and you can find them everywhere after you develop a skill for noticing them and capturing them with your camera.

Our minds are always working to make sense of what our eyes see by looking for patterns and shapes in the complex and often over-cluttered environment that we live in. The result is that patterns and shapes are pleasing. Patterns are formed by the repetition of objects, shapes, lines, or colors. Sometimes it is the pattern or shape that makes a photograph a good one, rather than the subject itself. In fact, many good photographs feature a strong pattern or shape that is made by something that is not even recognizable.

When you find a pattern or shape, think how you should shoot it to make an interesting photograph. Use light to make a silhouette, or maybe even use bright highlights to strengthen the pattern or shape.

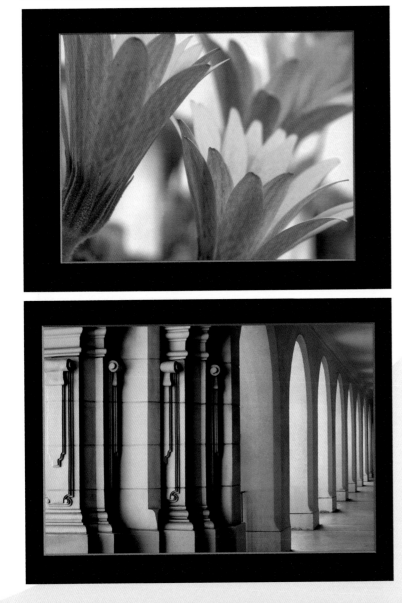

A pattern of flower shapes from trailing daisy flowers fills the frame and echoes into the background.

Several patterns are at work in this image: the pattern of repeating columns, the pattern of arch shapes, and the pattern of light and dark from the light.

COMBINE
flash and ambient light

An effective way of giving your photos a very professional look is to use flash and balance its brightness to the ambient or existing light so that both are recorded by the camera. Most digital cameras allow you to use fill flash with existing light quite nicely, as explained in Task #16.

However, this task is about using flash as a pure light source, not simply something to fill shadows. To do this well, use an accessory flash for your camera that gives you enough power to deal with bright ambient

light. In addition, a flash cord helps get the flash off-camera for a more directional light. Most cameras have a setting that automates the exposure between flash and ambient light, but it varies from one manufacturer to another. Check your manual. Also, try keeping your flash at its normal strength while you turn down the exposure for the ambient light for a most dramatic effect — a simple way of doing that is to shoot manual exposure and use a shutter speed that underexposes the ambient light.

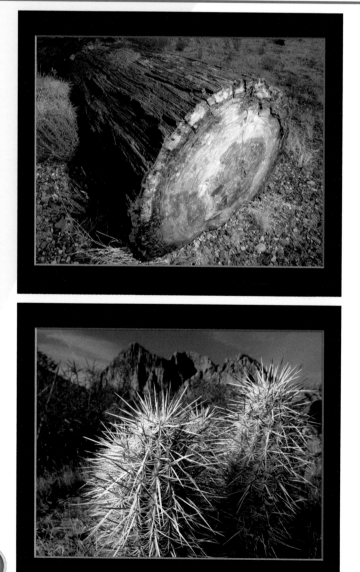

A flash gave dimension, highlights, and shadows to this petrified wood log, while the ambient light from a cloudy day kept detail throughout the photo.

This low-angle shot of cactus in the Mojave Desert was taken with a flash off-camera to the right to light the cactus, while the existing light lit the mountains behind.

Compare this and the following photo. This photo was taken with a standard flash setting that captured only the light from the flash.

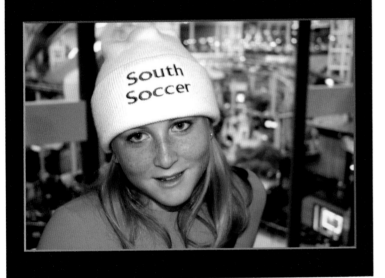

This image also uses flash, but now the ambient light has been captured, allowing the background and setting to appear in the photo.

TIPS

Photo Tip!

Try modifying your flash so that it gives a less harsh light. There are many modifiers on the market, such as those from Lumiquest, which spread out the light over a reflector or diffuser. This, in turn, makes the light gentler on the subject, giving smoother tonal gradations from highlight to shadow.

Did You Know?

You should always work to take the best photo that you can when shooting. Many photographers new to digital photo editing believe that they can fix anything wrong with a photo after they have taken it. That is not always the case. You will always end up with a better photo after editing it if you first start with an excellent photo.

EXPERIMENT
to create unique photos

Break all the photography rules and guidelines that you know. Shoot with a slow shutter speed without a tripod. Zoom or pan your lens with the shutter open while shooting with a slow shutter speed. Intentionally overexpose and underexpose, shoot in high-contrast light, shoot in low light, shoot in the rain or a snow storm. Shoot a subject that you ordinarily do not shoot. Take 50 photos while shooting from ground level. Take 50 photos with your camera set to the smallest aperture. Shoot using extremes — extreme vantage points, extreme focal lengths, extreme aperture settings, and extreme distances to the subject.

When you shoot a popularly photographed subject or scene, think carefully about all the obvious and common shots that are taken and then try to come up with a dozen new ways to shoot the same subject or scene. Maybe you change the angle of view or the vantage point, or shoot with a different light, or shoot from a distance and frame the subject with some foreground element. Experimentation and careful thinking about each photograph that you take are always good.

DIFFICULTY LEVEL

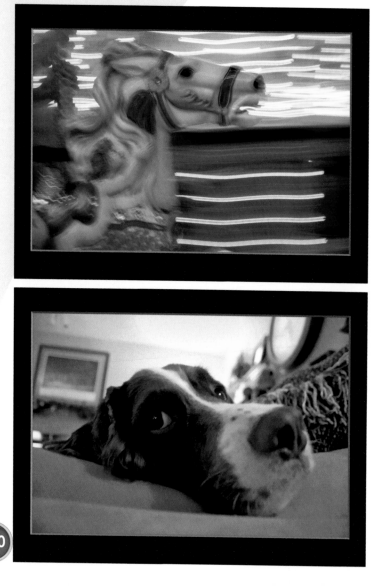

A slow shutter speed was used to create this photo of a carousel horse.

A wide-angle lens was used against many guidelines about focal length in order to create this unique close-up of a dog.

SHOOT AT NIGHT
for drama

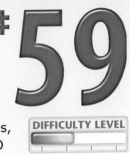

Long exposures and night scenes create rich, glowing colors that can make spectacular photographs. City streets at night, building interiors, or nighttime reflections in windows are good subjects to shoot. Digital makes it easy because you can see the results right away and correct any problems while you are still with the subject.

In addition, digital gives you a lot of options as to how to render the colors of the lights. A daylight white balance setting creates a warm scene, and tungsten makes the lights more neutral (and may actually make it seem colder because you expect night lights to be warm).

When you shoot in low-light levels, you can try using the highest ISO settings on your digital camera along with the widest aperture. This can get you handheld street scenes. For other shots, use a tripod to get the sharpest photographs. To minimize camera shake caused by pressing the camera's shutter release and to further reduce any blur caused by camera movement, you can use a timed shutter release feature if your camera has one.

DIFFICULTY LEVEL

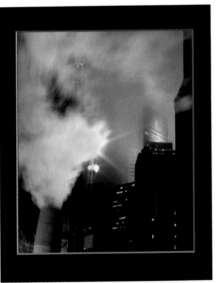

A foggy night in New York City was shot with a camera braced on a beanbag, using a tungsten white balance.

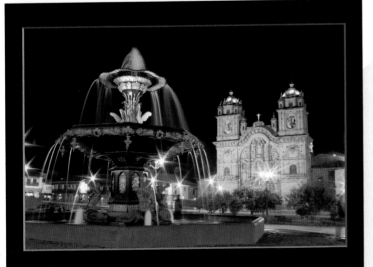

The glowing color of a town square in Cusco, Peru, was created with a tripod-mounted camera and with a daylight white balance.

Basic Image Workflow with Adobe Photoshop Elements

After you have taken photos with your digital camera and have downloaded them to your computer, they are ready to be digitally processed. Using an image processor such as Adobe Photoshop Elements, you can substantially improve the quality of an image, plus transform or alter your digital photos in an almost infinite number of ways. This chapter requires familiarity with basic Elements commands; to learn these commands or refresh your memory of them, see *Teach Yourself VISUALLY Photoshop Elements 4* (Wiley, 2005).

The first thing you should do before performing any edits is to evaluate each photo so you have an idea of what needs to be done to the image. A key to working an image in

Photoshop Elements is to keep focused on the photo and not on how many features of the program you can remember. Tasks #60 to #66 offer you an order of processing that can be used as the basic steps of image-processing workflow. Follow them in that order and you will gain a solid and consistent way of working your images.

Developing a consistent workflow will help you to better process your photos to get the results you want. The order of the steps that you take to work on your images is important. However, if you use features such as Undo History and adjustment layers, you will be able to go back to early steps and change settings or delete the steps entirely and start from that point on.

Top 100

Learn the best
WORKFLOW

The order of the steps that you take to process your digital photos matters. Anytime you work directly on a digital photo, you alter some of the original picture data; therefore you affect pixels. Although the image may look better, you have less original picture information than you did when you first opened the image. So although every photographer will have a slightly different overall workflow, it is important to establish a consistent way of working on your images in order to optimize their quality.

The key to getting the best from your image is to do these four things first and in this order: adjust blacks and whites, correct midtones, fix color, and make local or small-area changes. Note that color comes after the first tonal adjustments — if you do not have blacks set properly, especially, colors will never quite look right. Note that the photos for this task do not show Photoshop Elements. It is important to think about adjusting the *photo* as seen here, not about using tools in Photoshop Elements.

Here is a detail of a fern leaf that came straight from the camera without any adjustments.

Blacks and whites give an image contrast and better color.

Color has not been directly adjusted on this image until this point, yet color is affected by the other changes. Now color is adjusted so the color fits the subject.

TIPS

Did You Know?

No matter how you increase the size of a digital photo, the image quality decreases to some extent. Because of this, you should generally complete your edits on the original-sized image and increase image size only when you know the specifications of the print size and the target printer (see Task #84).

Did You Know?

The best image-sharpening settings to use when applying the Adobe Photoshop Elements Unsharp Mask filter depend on the size of the image and how you are going to use it, whether that is a type of printing medium, in a flyer, e-mail, and so forth. For this reason, you should apply the Unsharp Mask filter only when you know how you are going to use the image and what size you need. Sharpening is explained in Task #85.

PROTECT AND PRESERVE
original photo files

Saving a digital photo file is not all that hard. The challenge is remembering to save it properly. One of the most common mistakes made by those new to digital photography is to save a digital photo file over the original file after processing it in an image-processing program. If you do this, you no longer have an original image file, which can later prove to be a disappointing loss. Even though you think that you have made the photo look better, over time your skills and knowledge of digital photo editing will improve, and you will wish you had the original file.

Never overwrite your original image files; they have the most "picture information" you will ever have. Any image processing that affects pixels makes it impossible to go back to original image data. If you make a mistake, or later, you want to try reprocessing an image as you learn new skills, you need that original digital photo file.

SAVE AS

① Click File.

② Click Save As.

The Save As dialog box appears.

RENAME YOUR PROJECT

③ Navigate to the folder in which you want to save the image.

④ Click here and select the Photoshop .PSD file format.

⑤ Type a new and different name.

⑥ Click Save.

You now have a working file that cannot be confused with the original.

Whenever you have spent more than 30 minutes or so working on your image, protect your work by saving your file. (Choose File→Save or press Ctrl/Command+S).

RETAIN ADJUSTMENT LAYERS

- Anytime that you use adjustment layers to add additional elements to your image, you should save the file as a PSD file so that you can access your layers later.

 Note: See Task #73 to work with adjustment layers.

 Note: If you save your layered image as a JPEG or TIFF file, you will never be able to access the separate layers again.

#61

DIFFICULTY LEVEL

SAVE BEFORE SHARPENING AND RESIZING

After you have completed all of your work on the photo and before you have increased the size of the image or sharpened it, you should save the image as a master file that can be adjusted for printing and other specific uses.

- Sharpen an image and change its size only to output the image to a specific printer and display size.

TIPS

Did You Know?

Although Photoshop Elements gives you multiple options for saving an image file, only three are of value for most photographers. The PSD, or Photoshop, format is a good working format and allows you to save layers. TIFF is a common working format that can also be opened in most programs. JPEG should be used only for e-mail and archiving, never as a working file format.

Did You Know?

All images from a digital camera need sharpening to reveal the true sharpness of the original image by using the Adobe Photoshop Elements Unsharp Mask filter. Unsharp Mask should be applied to an image only when you have sized an image for use and saved it for that purpose. The optimal settings for the Unsharp Mask are highly resolution-dependent.

CROP AND STRAIGHTEN
your photos

Cropping is an important technique to understand. Cropping simply allows you to cut part of an image out from the larger original frame and throw out the unneeded parts of the image. One common problem with photos is that they are not "tight" enough, which means the subject is too small in the image area. Cropping a photo removes the excess image around the outside so you can better emphasize your subject and composition.

There are other reasons why you might have problems in a photo besides too-small a subject,

such as distractions along the edge, problem parts of a background, or a crooked image. All of that can be fixed with a judicious use of the Crop tool. It helps to do this crop at the beginning of your image processing so you can work with a clean image without problems that can be distracting to your processing.

Do not overdo cropping, though — you are removing pixels, which results in lowered image quality if done too much.

CROP AN IMAGE

① In Photoshop Elements Editor, click the Crop tool in the Toolbox.

② Drag a box on the photo over the approximate area you want to show.

A crop box appears over the image, darkening the areas that will be removed.

③ Click and drag any of the small squares along the sides.

In this example, the top border of the crop box is dragged downward.

ROTATE THE CROPPING AREA

④ Position your cursor outside of the box, and it changes to a curved cursor that allows you to click and rotate the crop box to straighten an image.

⑤ To finish, click the checkmark at the bottom of the crop box or simply press the Enter/Return key.

● To cancel the cropping, click here.

TIPS

Photo Tip!

Straighten an image with the Crop tool. When you click and drag a crop box, make it long and skinny around the horizon. Position the cursor outside the box to get the curved cursor, then click and rotate the crop box until it parallels the horizon. Now click and drag the crop box edges to the right size and accept the crop.

Did You Know?

Many photographers want to crop an image to a specific size, such as 5 x 7 inches or 8 x 10 inches. It is usually best to do it at the end of the processing. The reason is that you really should have a master file that can be cropped to any specific size. If you crop to that size too early, you will have to recrop and lose pixels to change that cropping.

Process for
STRONG BLACKS AND WHITES

Many photographers go into Photoshop Elements and immediately start trying to adjust color, or they use the Brightness/Contrast adjustment. Neither is a good idea. You need to establish good blacks and whites in your image first because they strongly affect colors and contrast. Colors need a black somewhere in the image to look their best, and Brightness/Contrast does not allow the proper adjustment of blacks and whites.

The way to do this is to use Levels, which is under the Enhance menu (choose Enhance, Adjust Lighting,

then Levels). You get what may look unfriendly to photography, but it is really easy to use for this purpose. You only care about the black and white sliders under the graph. Press Alt/Option while you slide the black slider to the right and the image turns white. This shows the black threshold screen — as you move the slider, colors and then blacks appear. The blacks are pure blacks in the photo. With the white slider and Alt/Option, a black screen appears. Usually you move the white slider left until white specks just appear.

❶ Click Enhance.

❷ Click Adjust Lighting.

❸ Click Levels.

The Levels dialog box appears.

❹ Press Alt/Option and drag the left, black slider to the right to show where the blacks are appearing as you adjust.

⑤ Press Alt/Option and drag the right, white slider to the left to show where the whites are appearing as you adjust.

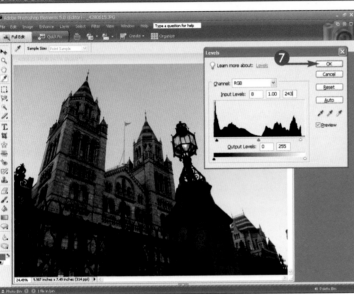

⑥ You will immediately see an increase in contrast and color for the image.

⑦ Click OK.

Elements applies your changes.

Note: *If the image becomes dark, you can correct that in Task #64.*

TIPS

Did You Know?

There is really only one black and white tone in a photograph. The plurals, blacks and whites, are commonly used, however, as seen in this task. The reason for that is because you are adjusting multiple areas of black and white, so most photographers use the shortcut, blacks and whites, to refer to them.

Tips to Apply

How much black or white do you use in your photo? This is very subjective and depends on your subject as well as your aesthetic needs. Unless you are after a special effect, you do have to be careful not to go too far or the photo will look harsh and may start to lose gentle tonalities.

Adjust
MIDTONES

The midtones of a photo are all the tones between black and white. They can be considered highlights with details, shadows with details, and middle tones in an image. These tones bring brightness and life to your photo. Colors are strongly affected by how you adjust these tones.

The best way to deal with these tones is with curves because it allows you to adjust each area of tonality separately. In Photoshop Elements, this adjustment is called Color Curves and is found under the Enhance menu. This adjustment window first gives you some

visual "Samples" showing effects of certain curves adjustments. You can see a preview image — just click to select any adjustment.

The curve itself appears when you click Advanced Options — it is a graph with a diagonal line that moves with adjustments (hide Samples by clicking on it). You cannot directly move the center line to create "curves" in that line (hence the name) as you can in Photoshop. However, as you select any Sample or you adjust the sliders, you change the curve.

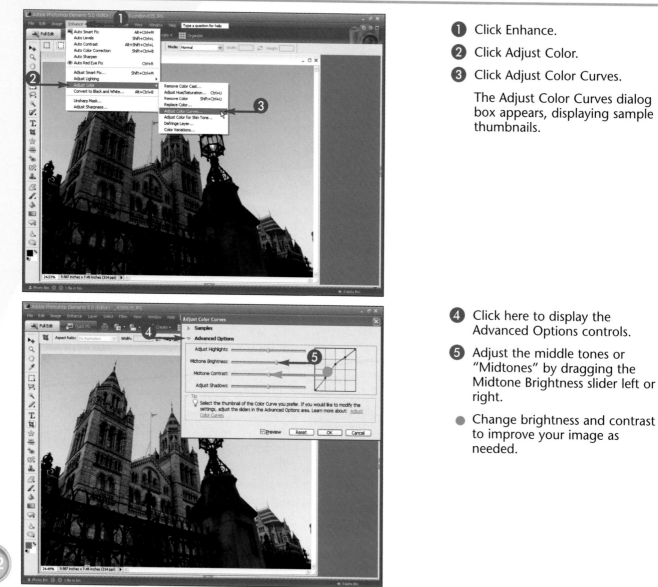

① Click Enhance.

② Click Adjust Color.

③ Click Adjust Color Curves.

The Adjust Color Curves dialog box appears, displaying sample thumbnails.

④ Click here to display the Advanced Options controls.

⑤ Adjust the middle tones or "Midtones" by dragging the Midtone Brightness slider left or right.

● Change brightness and contrast to improve your image as needed.

6 Adjust the dark areas by dragging the Adjust Shadows slider.

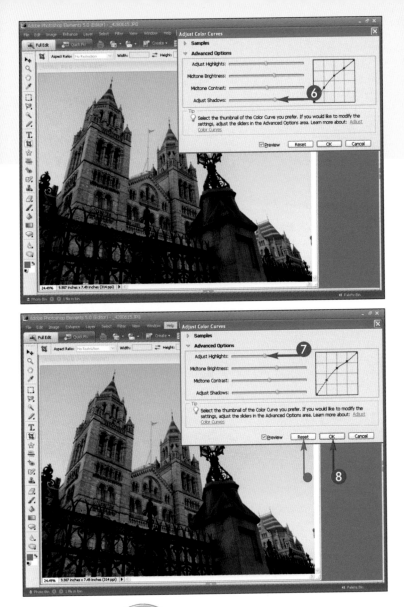

7 Adjust the highlights by dragging the Adjust Highlights slider.

8 To apply your changes, click OK.

● You can reset your curve adjustments back to the midpoint at any time by clicking the Reset button.

TIPS

Photo Tip!

If you have an older version of Photoshop Elements without any Color Curves, you can still adjust midtones. In that case, you have to do it with Levels again. Finish blacks and whites, then open Levels again just for midtones. Use the middle-gray slider to make midtones brighter or darker. This does not have as much control as curves.

Did You Know?

Adobe Photoshop Elements has a great Help function. In most adjustment boxes, you see a tip (look for the light bulb icon) about that adjustment, and often a link to more specific help information. In addition, you can always type in a question in the small question box to the right of the Help menu.

Easy
COLOR CORRECTION

Digital cameras do not always see colors the way our eyes do. This is especially true when the light is colored and brings a color cast to the scene. Such color casts are captured all too well by a camera, even though our eyes do not see them.

An easy way to color correct an image is to use Levels again (do this as a separate adjustment). At the bottom left of the Levels control window, you will find three eyedroppers. Ignore the black and white ones (they represent rather heavy-handed black and white point adjustments). The gray eyedropper

should be called the white-balance eyedropper (Adobe labels it "Set gray point," which is very misleading).

After you select this eyedropper, move the cursor onto the photo. Wherever you click the photo, Photoshop Elements makes that point a neutral gray. So try to click something that should be neutral black, white, or gray. If the first click does not give you the right colors, keep clicking different tones until the photo looks right.

① Open the Levels adjustment dialog box and click the middle, gray eyedropper.

Note: See Task #63 to display the Levels dialog box.

② Move the cursor onto the photo and click something that should be neutral.

Your first tries may give you wacky colors.

③ As you try different spots on the photo, you will find the photo changes overall color quite dramatically.

④ Most of the time, you should be able to click a spot and get a good overall color after a few tries, but this varies from photo to photo.

⑤ When you are satisfied with the photo's appearance, click OK.

Elements applies the changes to the image.

TIPS

Did You Know?

The black and white eyedroppers can be used like the gray eyedropper. Clicking with the black dropper makes that point and everything darker pure black. The white dropper makes a clicked point and everything brighter a pure white. The effect is rather blunt and much harder to control than using thresholds with Levels as shown in Task #63.

Did You Know?

As you adjust an image and reopen Levels, you may notice that the graph or histogram has white lines breaking it up. This is called *combing* or a *comb pattern* because it looks like a comb for your hair. This represents gaps in your image data. That may or may not be important — it really depends on your photo.

Adjust color with
HUE/SATURATION

The Hue/Saturation adjustment in the Enhance menu under Enhance Color directly affects color. Hue changes the color of a color, while saturation affects its intensity or richness (a third control, lightness, is available, but in general, should not be used). Many photographers go right to this adjustment when they want to affect color in a photo, but it should not be used until first blacks, whites, and midtones have been adjusted, and then colors can be corrected.

Strong adjustments in Hue/Saturation are best done when limited to specific colors. The default for the

changes is all colors under Edit: Master. At that setting, keep your saturation change to 10 to 15 points maximum. To do specific colors, click the Edit drop-down menu to get a list of colors. Choose the most appropriate and use Hue to tweak an off color, and Saturation to increase or decrease the intensity of a color. You can also dramatically change a color by making a major change to hue (for example, to change the color of someone's jacket).

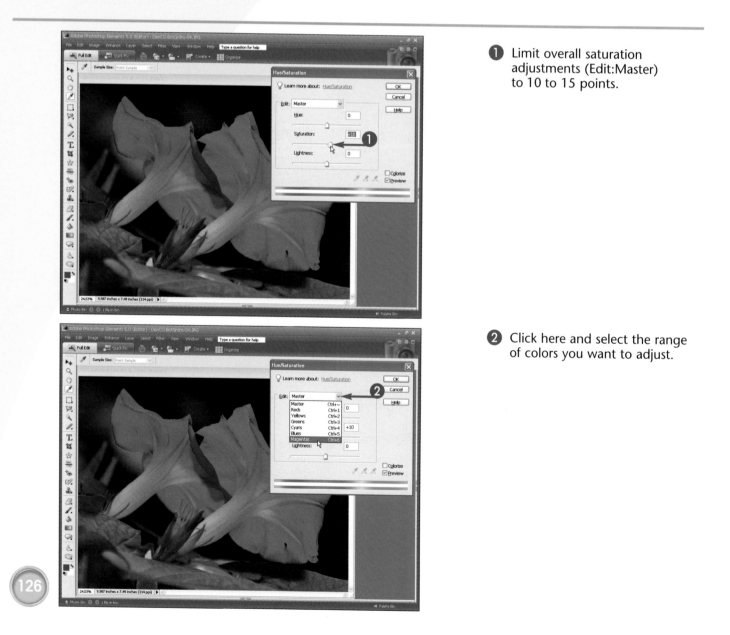

1 Limit overall saturation adjustments (Edit:Master) to 10 to 15 points.

2 Click here and select the range of colors you want to adjust.

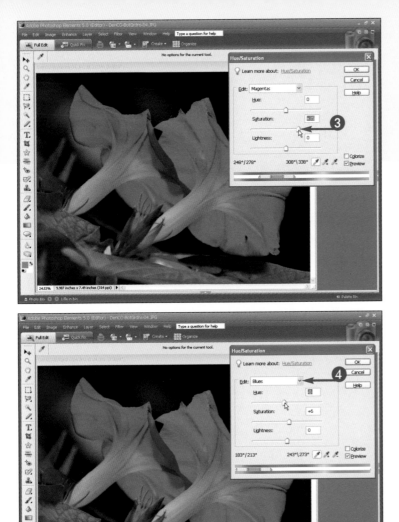

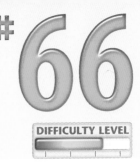

③ Change the hue or saturation of the specific color chosen and Photoshop Elements will limit that change to the chosen color.

④ Repeat steps 2 and 3 as needed for adjusting other colors.

You can now adjust colors based on their specific needs so that you do not over- or under-adjust unrelated colors just because in changing one color, you had to adjust them all.

⑤ When you like the way the image looks, click OK.

Photoshop Elements applies your changes.

TIPS

Did You Know?

You can get very precise color adjustments by moving your cursor onto the photo. Click something in the photo with the color you are working with. This now shifts the spectrum in the color bar at the bottom of the dialog box to show you how the adjustment will be limited.

Did You Know?

Many adjustments and commands can be made by using keyboard commands. You can find keyboard commands by going to the adjustment you want in the menus — to the right of the name of the adjustment will be any available keyboard commands. A good command to start with is Ctrl (Win) or Cmd (Mac)+0 — this makes the photo as large as possible in the work area.

CONVERT RAW FILES
with Adobe Camera Raw

When you use the RAW format in your camera (not all compact cameras have it, though), your image is recorded to the memory card with much more tonal and color information than can be saved with a JPEG file. This additional data offers you considerable control over how you adjust your photo in Photoshop Elements. You can make more extreme adjustments and improved color corrections because the program has more data to work with.

Because RAW files are proprietary to each camera vendor, there are differences between vendors and

even specific camera models. Before using the Adobe Camera Raw software that comes with Photoshop Elements (or any other RAW image file converter), you have to have the latest version that recognizes your camera's files or it will not work.

You can open RAW files through the file browser in the Adobe Camera RAW dialog box and convert them there, or you can open them by using the Open dialog box. Regardless, you will get a new Camera Raw interface to work with.

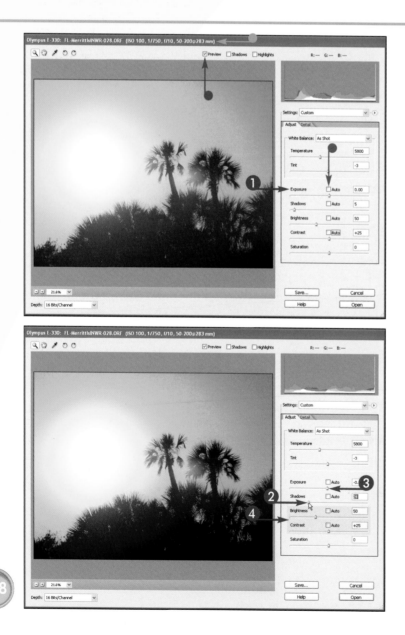

① When working in Camera Raw, the adjustment controls have different names, but you can follow the same tonal and color adjustment order from the rest of this chapter.

● The Adobe Camera RAW program lists the camera, filename, and EXIF information in the title bar.

● If the Auto boxes are checked, uncheck them — you are better off following the procedure listed in this task.

● These options control the image preview.

② Blacks are adjusted with Shadows (use the Alt/Option key to see the threshold screen).

③ Whites are adjusted with Exposure (use the Alt/Option key to see the threshold screen).

④ Midtones are adjusted with Brightness and Contrast.

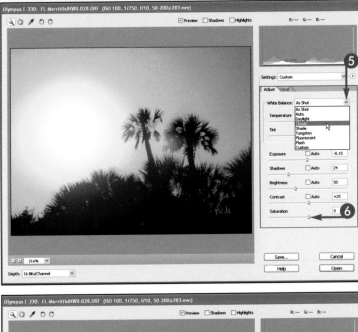

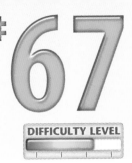

67

DIFFICULTY LEVEL

⑤ Color casts are adjusted with the White Balance drop-down menu, and the Temperature and Tint sliders.

⑥ Color intensity is adjusted with the Saturation slider.

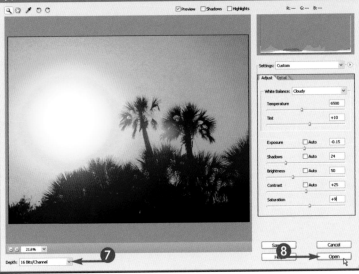

⑦ Click here and select 8 or 16 Bits/Channel (most of the time, 8 Bits is fine and requires less of your computer's memory).

⑧ Click Open to apply your changes, close the dialog box and open the converted image in Photoshop Elements.

Save will save your adjustments as a special instruction file that Camera Raw recognizes every time a particular file is reopened.

Did You Know?

Camera manufacturers provide their own proprietary RAW image file converter software. However, generally the converters that are included with the camera are not as easy or convenient to use as those provided by third-party vendors. Popular RAW converters include Adobe's Camera Raw program (which comes with Photoshop Elements), BreezeBrowser from Breeze Systems (www.breezesys.com), and Bibble from Bibble Labs (www.bibblelabs.com).

Did You Know?

One disadvantage of using the RAW format is that it takes considerable computer processing power and time to convert RAW images. In spite of a lot of hype about RAW, you can use JPEG-captured images and process them to very high-quality photos. However, JPEG images must be shot carefully because they have less data that can be processed if exposure or color is not captured correctly.

Understanding
COLOR SPACE

Photoshop Elements has not traditionally made a big issue of color space, yet it is important to know and understand, especially because version 5.0 has strong color space settings. Photoshop Elements calls this simply color settings, and they are found in the Edit menu.

You may see color space described as a quality issue. It is not. It is an adjustment control. Color space affects the range of color that can be adjusted in a photo, which you may or may not need. Photoshop Elements gives you two choices, sRGB and

AdobeRGB. These are first set in your camera (check your manual to see how, though many compact digital cameras offer only sRGB) or from the Camera Raw conversion.

AdobeRGB is the larger color space and offers more flexibility in controlling colors. However, sRGB (in spite of its reputation as the "monitor colors") often gives beginning Photoshop Elements users faster good results for printing because change is more limited. With experience, though, most photographers choose AdobeRGB for its control.

You cannot tell from looking at a photo if it comes from an AdobeRGB or sRGB color space. The color space affects how well you can adjust certain colors.

Consider color space like buckets of color: Adobe RGB is a big bucket with more choices than sRGB, as a small bucket.

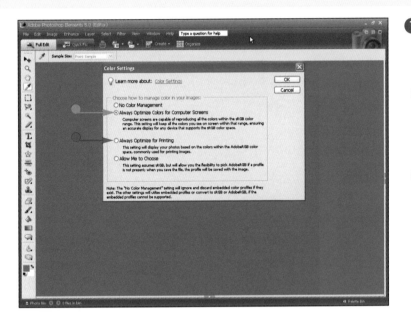

① Click Edit→Color Settings to open the Color Settings dialog box.

● Click Always Optimize Colors for Computer Screens if your original image is in the sRGB color space.

● Click Always Optimize for Printing if your original image is in the AdobeRGB color space.

You will usually choose one of these two options; the other two are specialized choices uncommonly used by photographers.

TIPS

Caution!

Although you can simply change color settings arbitrarily from sRGB to AdobeRGB or vice versa, that is not a significant benefit. Photoshop Elements should be set to match how your camera captured the colors. If you shoot RAW, however, the color space will be based on whatever you have set in the Color Settings dialog box.

Did You Know?

Color space settings in a digital camera are usually found in the camera menu. Once you set a color space, all images will be recorded with that space. In RAW, however, no color space is recorded, so it can be changed at any time by resetting the Color Settings and reconverting the RAW file in Camera Raw.

REVEAL DARK AND LIGHT DETAIL
with Shadows/Highlights

Sometimes it is surprising to see certain adjustment tools in action in Photoshop Elements. They can do some amazing enhancements to the image. The Shadows/Highlights control in Enhance, Adjust Lighting is one such adjustment. This can help bring detail out of very dark parts of a photo and tone down very bright parts, so much so at times that the results can be quite striking.

This works so well, however, that photographers want to use this control right away when they see too-dark or too-light parts of an image, before other

adjustments have been made. This should be avoided. Follow the workflow that this chapter uses — set your blacks and whites, then adjust midtones before going to Shadow/Highlight.

There is also a strong temptation to overuse this control. Most of the time, the default of 25 for highlights is the maximum you should use; 20 is a good maximum for shadows. Higher amounts make the image look unnatural because the highlights and shadows do not have the balance we expect them to have.

This is the original image, properly adjusted with blacks, whites, and midtones, yet the dark shadow is very dark and the bright areas too bright.

Here is the same image with Shadows/Highlights adjustments applied. Notice how much more detail shows in the shadows and the better color in the bright areas.

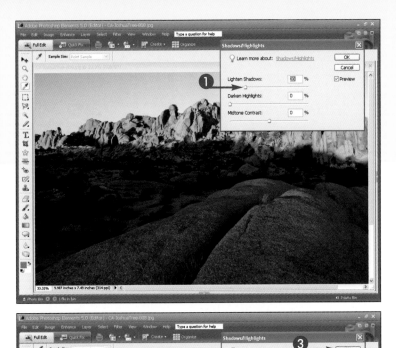

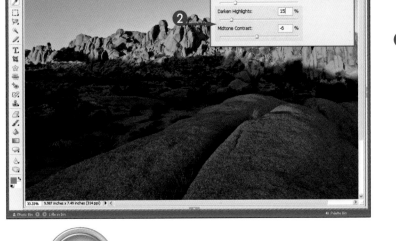

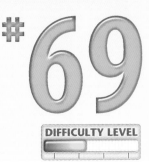

① When Shadows/ Highlights is opened, adjust the shadows first by clicking and dragging the Lighten Shadows slider.

② After the shadows look good, try tweaking the highlights and the midtone contrast. Often you can get a very rich image this way, but still be wary of overadjusting any of these sliders or the photo will look very "adjusted" to the viewer.

③ When you like the way the image looks, click OK.

Photoshop Elements applies your changes.

TIPS

Did You Know?
Noise is a common problem in digital photos. It is like grain in film and appears like someone put a layer of sand across the photo. It is worst in small-sensor cameras, under high ISO settings and shadows. Sometimes you may hear that Shadows/Highlights increases noise. It does not. What it does do is reveal any noise in the shadows. Underexposed, dark areas typically hide noise, so as you brighten them, noise is revealed.

Did You Know?
Highlights need some detail and tone, even if very bright, in order to make them look right in Shadows/Highlights. A completely overexposed photo with blown-out highlights will not look better through the use of this control. You need to be sure to expose well when shooting.

Adjust a
SELECTED AREA

Sometimes you may want to process your image in selected areas isolated from the rest of the photo. You need to do this in order to make an adjustment to only a portion of the image so that the rest of the photo is unaffected. To do this, you must first select the area that you want to edit. Adobe Photoshop Elements offers many different tools for selecting parts of an image. Depending on the characteristics of the area that you want to select, one tool may be more appropriate than another. Or you can use more than one tool and keep adding to a selected area until you have selected all of the area that you want.

Good tools for selecting parts of an image include automated selection tools like the Magic Wand and Magnetic Lasso, plus the shaped Rectangular and Elliptical Marquee tools, the point-to-point Polygonal Lasso tool, and the easy-to-use Selection Brush tool. All of these tools enable you to select parts of an image, then add or subtract from the selection by changing the selection mode in the Tool options bar.

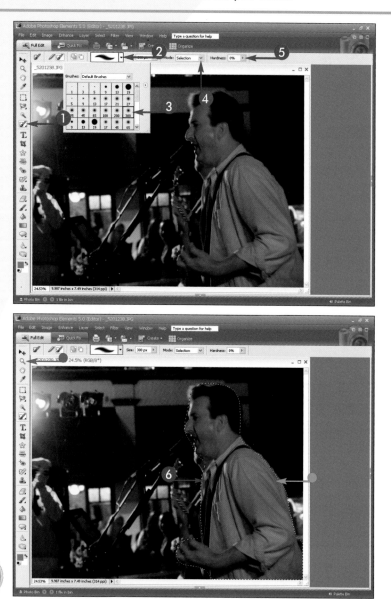

1 Click the Selection Brush tool.

2 Click here to select a brush style.

3 Click a brush size.

4 Click here and choose Selection.

5 Click here and choose how hard-edged the selection will be.

Soft edges often blend better, so try 0% before making the edge harder.

6 Using the Selection Brush tool, click and paint across the part of your photo that you want to select.

● A dotted line appears, showing your selection.

● Use the Zoom tool as needed to zoom in on the area that you want to select.

DIFFICULTY LEVEL

⑦ Click here to change the size of the brush to refine your selection.

⑧ Hold down Alt/Option while you click and drag with the brush to subtract from the selection.

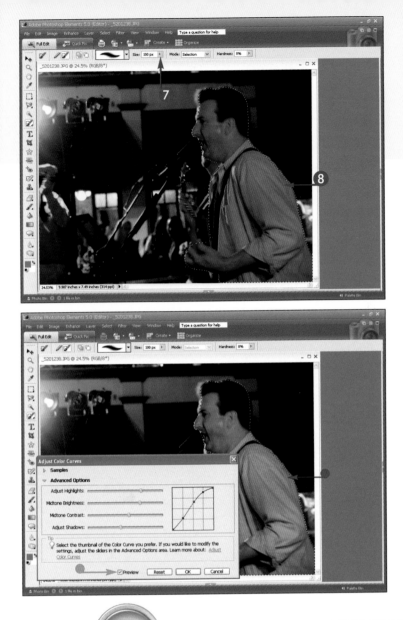

⑨ Make any changes that you want.

Note: Any adjustments that you make will be limited to just the selected area.

● In this example, a Color Curves adjustment was applied to just the man in the foreground.

● Checking the Preview check box displays your changes in the image as you work.

TIPS

Did You Know?

When you are making a complex selection and then you move on and do other things in the photo, the selection will be lost. If you think you may need to perform additional adjustments on a selected area or you just want to retain a really tough selection, you can save that selection in the Select menu under Save Selection. When you need it again, just go to Load Selection in the Select menu.

Adjustment Tip!

Use multiple selection tools to refine a selected area. For example, start with the Selection Brush and then go to the Rectangular Marquee to deal with a shape like a window. Simply press Shift to use the selection tool to add to a selection and press Alt/Option to subtract from a selection.

KEEP TRACK
of your adjustments

One of the great things about working with Photoshop Elements is that you can experiment and try adjustments through a process of trial and error. If you do not like the results, the program gives you two really great options to back up and try something else. First, you can simply use the keystrokes Ctrl/Command+Z and you will step backward through what you just did.

Second, the Undo History palette makes it easy to back up through your adjustments. Photoshop Elements keeps track of each processing step (called

a *history state*) you make. When you exceed the maximum number of history states set in Preferences (in the Edit menu), Elements deletes the earliest history state each time that you add a new one.

Using the Undo History palette, you can back up one or more steps and then move forward again by clicking each step in the palette while comparing the results. When you back up one or more steps and then make a new adjustment, however, Elements discards all steps from that point on.

① Click Window.

② Click Undo History.

The Undo History palette appears.

● As you perform adjustments, Elements creates a history state in the Undo History palette for each edit.

③ Click the history state at which you want to view the image.

● History states occurring after that time are "ghosted."

If you want to adjust the image differently from that point on, perform the next adjustment, and the Undo History palette will reflect the new adjustment history.

● In this example, the Hue/Saturation command was applied at a different point in the process.

TIPS

Did You Know?

When working on a large image, it can take considerable memory to maintain a long list of history states in the Undo History palette. You can increase or decrease the amount of Undo History states that are saved by changing the value in the History States box in the General Preferences dialog box (Edit→Preferences→General). The default value is 50.

Did You Know?

You can dock the Undo History palette to the right side of the Photoshop Elements interface so that it always stays open and it never covers the image. Do this by clicking the More button at the upper right of the palette, clicking "Place in Palette Well When Closed" in the drop-down menu, and then closing the palette by clicking the close button at the top of the palette.

Beyond the Basics with Photoshop Elements

Consider this: Ansel Adams is considered one of the great darkroom craftsmen. His dramatic and stunning prints are considered among the finest art by collectors everywhere. Yet, the only controls he had were making a photo lighter or darker, increasing or decreasing its contrast, and changing isolated parts of the photo apart from the rest.

In this chapter, you learn to go further with your image. A key element of this is something that scares a lot of photographers — layers. Go through this chapter carefully and you will discover how powerful layers are. Then try out the tasks with your own photos. You will learn to use layers . . . with a little practice! You have to practice, try the ideas, make mistakes,

and then learn from them until you succeed. And you will! Remember the four letters of Task #2.

As you work with Photoshop Elements, you will discover so many things you can do. You will also discover a lot of added controls not in this book. Use them if you find they help you, but do not feel you have to know everything in order to succeed with Elements. Always remember how much Ansel Adams did with very little compared to what can be done in the computer today. Knowing a lot of tools in Photoshop Elements is less important than being able to carefully craft your photo well with a few tools.

Create a
PANORAMA

How do you capture the beauty found in wide-sweeping outdoor scenes? As discussed in Task #52, digital photography gives you a great option in capturing more of a scene in a panoramic shot. Sure, wide-angle lenses can capture more of a scene than telephoto focal-length lenses, but wide-angle lenses can add unwanted distortion to the photos, and they still do not capture as much of a scene as is often wanted. With Photoshop Elements at hand, you can create a dramatic, wide-spreading panorama to show off that wide sweep of a scene.

Task #52 offers tips on how to take photographs that you can later digitally stitch into one panoramic print. Once you have taken pictures for such a purpose, you are ready to use the Photomerge command in Adobe Photoshop Elements to do the stitching. You quickly learn, however, that the steps in Task #52 are very important. You must overlap your shots properly, for example, so that they merge well in Elements.

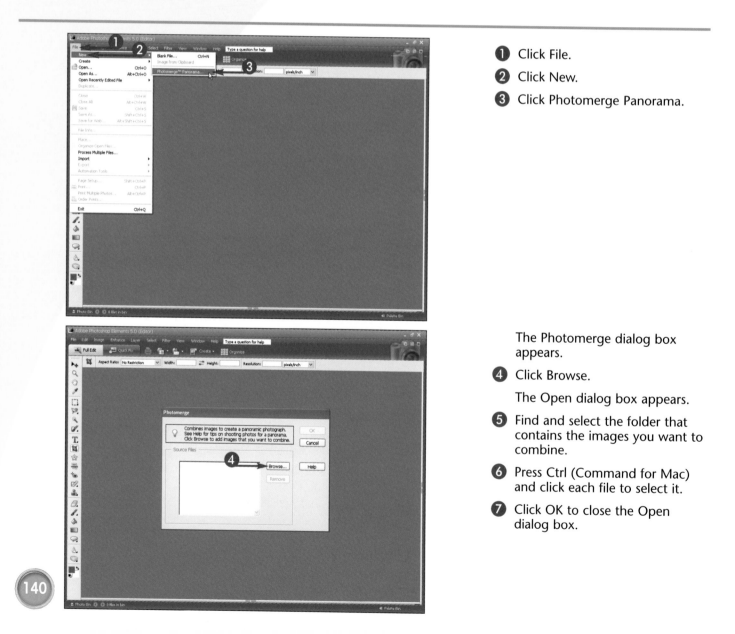

① Click File.

② Click New.

③ Click Photomerge Panorama.

The Photomerge dialog box appears.

④ Click Browse.

The Open dialog box appears.

⑤ Find and select the folder that contains the images you want to combine.

⑥ Press Ctrl (Command for Mac) and click each file to select it.

⑦ Click OK to close the Open dialog box.

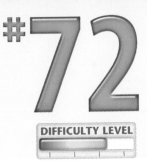

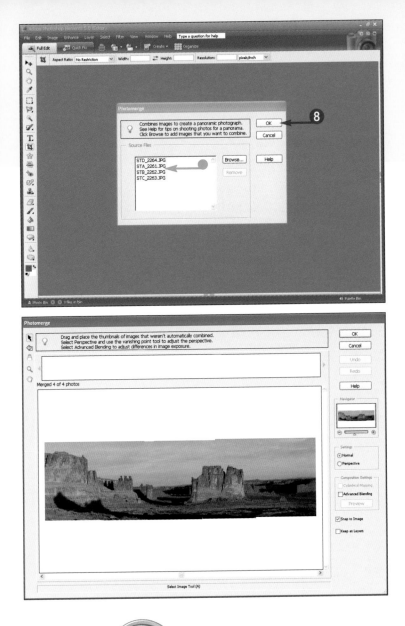

● The selected files appear here.

⑧ Click OK to launch the Photomerge process.

Photomerge automatically stitches the images together.

Photo Tip!

You can use the Adobe Photoshop Elements Photomerge feature to combine multiple photos into a single large photo for making large prints. If your digital camera does not have enough pixels to make a quality print in the size that you want, you can shoot several photos and combine them with Photomerge.

Did You Know?

You can take multiple photos of vertical subjects and create vertical panoramas as easily as you can create horizontal panoramas. Good subjects for vertical panoramas include tall trees and buildings. Shooting from a distance with a telephoto lens helps minimize unwanted perspective distortion caused by using shorter focal-length lenses.

Create a
PANORAMA

On rare occasions, Photomerge is not able to automatically align your digital photos. When that occurs, you will see the photos placed in a window at the top of the Photomerge dialog box. To align the images, simply drag and place the images that were not automatically aligned. When you get the images close to where they should be, Photomerge should be able to automatically and precisely position them.

If you want to create more perspective than is visible in the combined images, you can select the

Perspective radio button and then click once in the image to select the vanishing point. Photomerge adds some perspective to the combined image. If you use the Perspective feature, it is important to have up to a 50 percent overlap in the photos that you are using; otherwise, gaps may occur between each image at the top and bottom of the combined images. Placing a check mark in the Advanced Blending box results in a more seamless blend between each image.

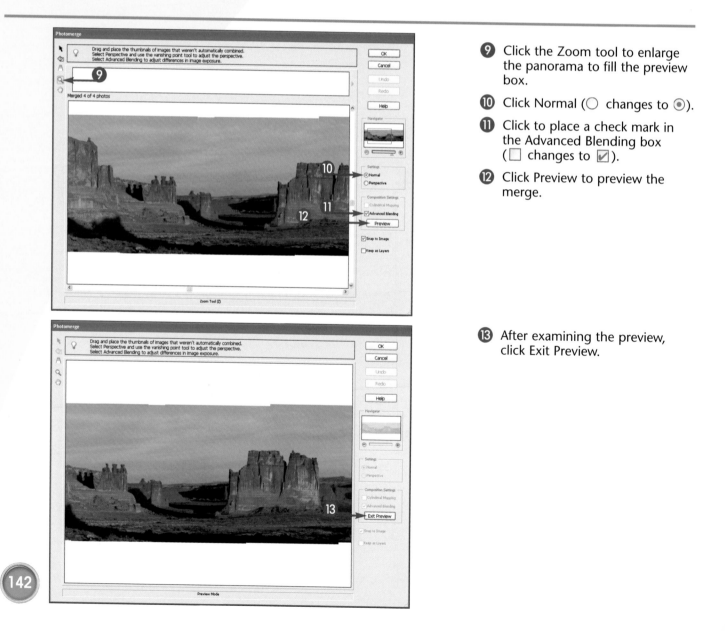

⑨ Click the Zoom tool to enlarge the panorama to fill the preview box.

⑩ Click Normal (○ changes to ◉).

⑪ Click to place a check mark in the Advanced Blending box (☐ changes to ☑).

⑫ Click Preview to preview the merge.

⑬ After examining the preview, click Exit Preview.

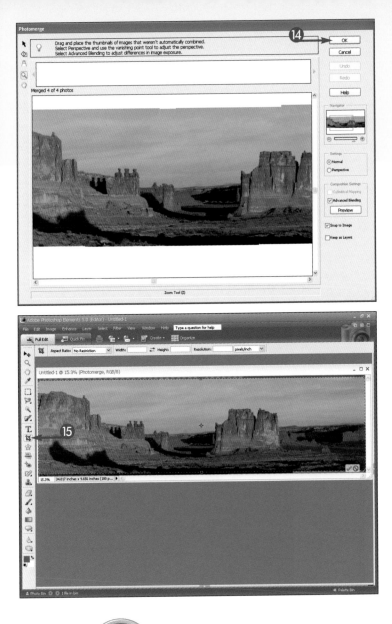

⑭ Click OK.

Photomerge begins the merge process.

The merged image opens in a new document window.

⑮ Select the Crop tool to crop the image.

Image Processing Tip!

Sometimes no matter what you do, the photos do not merge perfectly. You end up with lines or other mismatches in the final panorama. This can often be fixed by cloning over the area until it blends (see Task #79). It especially helps to clone to a new, empty layer that keeps the cloning separated from the original.

Photo Tip!

If you find that your panoramas consistently have trouble merging, check your photo technique when you are capturing the images for Photomerge. You need to be sure you have enough overlap of the photos, even up to 50 percent, plus you need to find distinct objects in the overlapped areas that Elements can find and match in the merge of images.

Understanding
LAYERS

Layers are an extremely valuable part of Photoshop Elements. They split the photo into "sheets" stacked on top of each other, isolating these picture elements so that you can isolate your adjustments and changes to the photo. In fact, they allow nondestructive adjustments, including experimenting, with no cost to image quality.

One of the very cool things about layers is that they give you the flexibility to go back and change those adjustments without hurting any pixels in your original photo. That is a big deal because when you adjust actual pixels in an image that has no layers, you are reducing your ability to make further changes without resulting quality issues.

Another great feature of layers is that they can be saved as a PSD (or Photoshop) file. You can then close an image, reopen it later, and the layers will be there, exactly as they were when you saved them. You can then readjust any layer as needed.

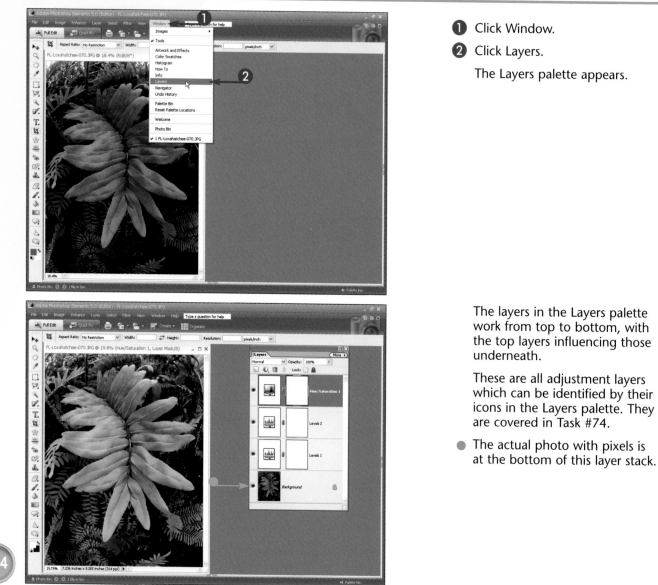

① Click Window.

② Click Layers.

The Layers palette appears.

The layers in the Layers palette work from top to bottom, with the top layers influencing those underneath.

These are all adjustment layers which can be identified by their icons in the Layers palette. They are covered in Task #74.

● The actual photo with pixels is at the bottom of this layer stack.

- Layers can be turned off by clicking the eye icon.
- You can delete layers by clicking and dragging them to the trash can icon.

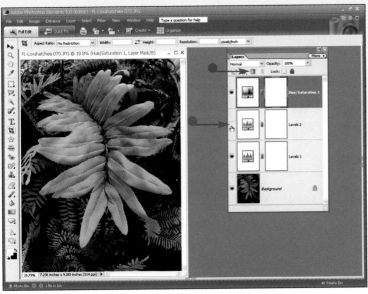

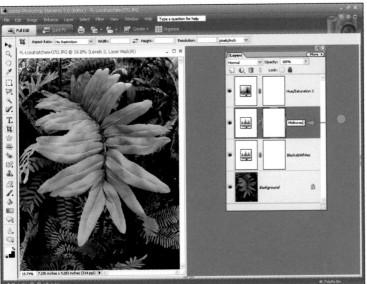

- Layers can be renamed to help you remember what they are doing to your photo by double-clicking the name and then typing a new one.

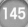

TIPS

Image Adjustment Tip!

Layers offer a great deal of flexibility. If your layer seems too strong after looking at its effect, you can very simply reduce its effect by lowering its opacity. The Opacity control is at the top right of the Layers palette. A quick and easy way to change it is to click the word *Opacity* and then drag your cursor left and right as you watch the percentages change and your layer's intensity adjust.

Processing Tip!

When you have created layers, save them in a master file for your photo. Do this by selecting Save As from the File menu, then choose Photoshop (*.PSD) for the format. Rename your image file so you can find it again, using a name appropriate to the subject and adding *Master* to the name.

Using
ADJUSTMENT LAYERS
to gain flexibility

Whenever you apply any adjustment directly to the photo, you make permanent changes to the pixels in the image. Once you make a series of adjustments, pixels are altered so that you cannot go back and make minor changes to your adjustments unless you use the Undo History palette. Then, if you change settings, you lose all the steps following that step.

However, adjustment layers can always be reopened and changed — you can always return to that layer and make changes to the settings. An adjustment layer is like a filter on the camera – it does not

change the scene (or pixels), but it alters how you see the scene (or pixels). In Photoshop Elements 5.0, adjustment filters include the key controls in Levels and Hue/Saturation, as well as other controls that you can try.

The easiest way to create an adjustment layer is to click the adjustment layer icon just above your layer stack in the Layers palette. It is a circle, half black and half white. Click it to access a drop-down menu of adjustment layers you can use.

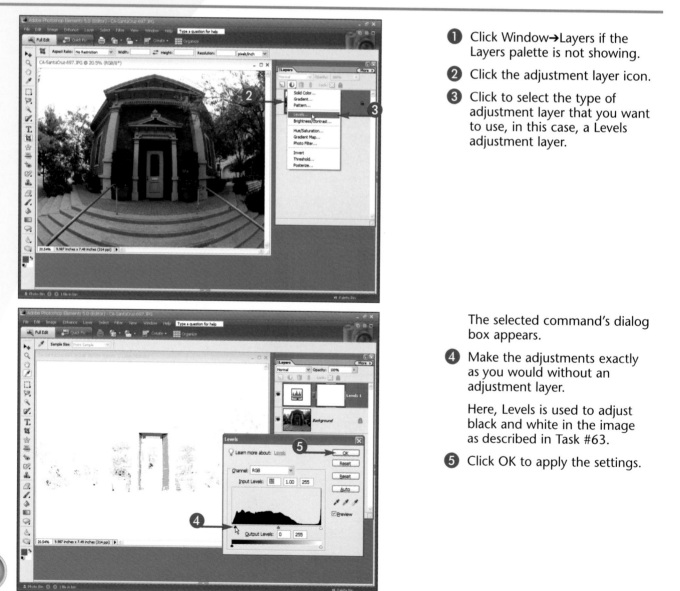

❶ Click Window→Layers if the Layers palette is not showing.

❷ Click the adjustment layer icon.

❸ Click to select the type of adjustment layer that you want to use, in this case, a Levels adjustment layer.

The selected command's dialog box appears.

❹ Make the adjustments exactly as you would without an adjustment layer.

Here, Levels is used to adjust black and white in the image as described in Task #63.

❺ Click OK to apply the settings.

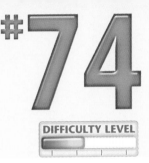

You can add one or more adjustment layers or one or more edit steps.

Remember to rename your layers so you keep track of your adjustments.

● To modify previous settings, double-click the adjustment layer thumbnail.

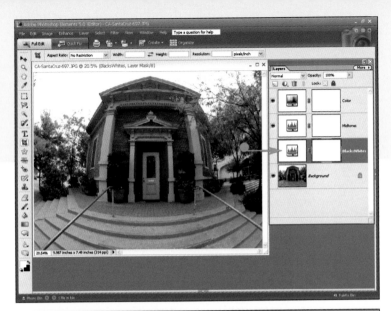

The dialog box for the type of adjustment layer appears. This example shows Levels being adjusted.

⑥ Make any adjustments to the initial settings that you want.

⑦ Click OK.

Elements applies the new settings to the adjustment layer.

TIPS

Did You Know?

You can turn on, or turn off, the effects of one or more adjustment layers by clicking the Layer Visibility eye icon at the far left of each adjustment layer in the Layers palette.

Did You Know?

When you are sure that you will not need to make any further changes to an adjustment layer, you can flatten your image to reduce its file size. Click the layer that you no longer need to make it the active layer. Then click the More button in the upper right corner of the Layers palette to get a drop-down menu. Click Merge Down to flatten one layer or click Flatten Image to flatten all the layers in the Layers palette.

USE LAYER MASKS
to isolate your changes

Layer masks offer tremendous benefits. They come automatically attached to adjustment layers and allow you to control precisely where you want the adjustment to happen and where to block it. They also let you change your mind and replace where the adjustment occurs and where it does not.

Layer masks include white, black, or both; those tones show up in the layer mask icon to the right of the adjustment icon in an adjustment layer. Consider white to be clear — it has no effect on the adjustment in the layer. Black, though, blocks any adjustments.

The default is a white layer mask that allows all — you then paint black in small areas to block the effect. Use a soft-edged brush and choose a size appropriate to the area you want to affect. The foreground color in the Toolbox is the color that will be painted. You can also fill a layer with black to block everything by clicking Edit, Fill Layer, and selecting black. You paint white in small areas to allow the effect.

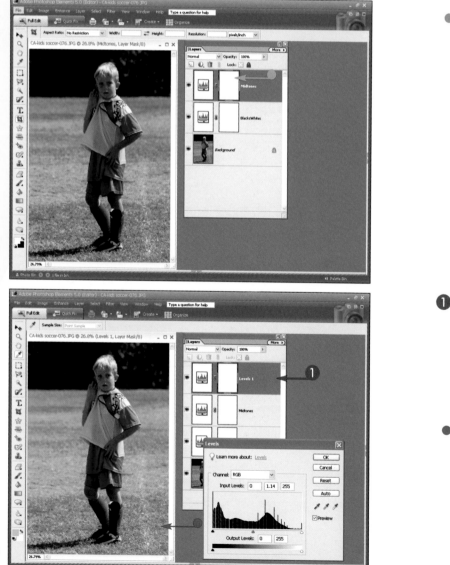

● All adjustment layers come with a layer mask (white by default).

The layer masks in this screen add nothing to the layers at this point.

❶ Add an adjustment layer to affect a specific part of the photo.

In this case, Levels was opened to adjust the shaded part of the boy.

The selected command's dialog box appears.

● In this picture, the shadow of the boy was lightened, but the overall adjustment made the grass too bright.

Here, the adjusted areas need to be small, so you need to fill the layer mask with black by clicking Edit, then Fill Layer.

② Click here and select Black.

③ Click OK to apply the settings.

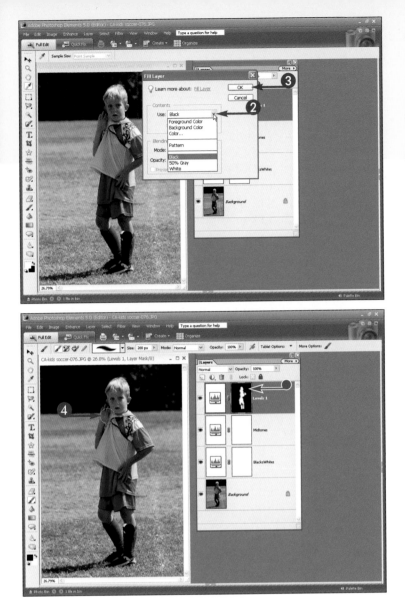

④ Paint in white using a brush sized for the area to allow the adjustment in those places.

The shadowed areas of the boy are now revealed.

● The layer mask icon shows black for the blocked areas and white for the allowed adjustment.

TIPS

Did You Know?

Layer masks have no direct control over the image. They only affect what can be changed by an adjustment layer. Painting black could make the picture lighter or darker — that all depends on the adjustment it is affecting. Black or white can only turn that adjustment off or on. Layer masks work only on the layer and have no effect up or down in the layer stack.

Did You Know?

Layer masks give another way to make nondestructive adjustments to your photo. They isolate areas for change similar to selections (more on that in Task #76), and they are infinitely adjustable themselves. To get exactly what you want, you can still alter the mask on the adjustment layer once it is set by adding to the mask (white) or subtracting from the mask (black).

COMBINE SELECTIONS
with layer masks

DIFFICULTY LEVEL

Selections are a great way to start a layer mask. It actually can make the process easier because Photoshop Elements automates the use of black and white areas where you need them based on your selection. Different than a selection, the resulting layer mask can be altered as needed to refine and improve what is affected and what is not. You simply paint on white where you want the effect returned or black where you want it blocked.

All you have to do is make a selection before opening an adjustment layer. Then, when you open any adjustment layer, the layer mask that now appears is not the white default layer mask, but a mask precisely based on the selection. The selected area is white in the mask; the rest is black. You can even get the selection back again by Ctrl- or Command (Mac)-clicking the layer mask icon. This gives you a tremendous tool for isolating your adjustments to specific parts of your photo.

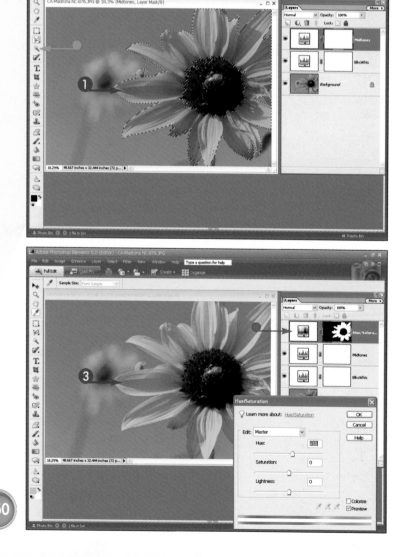

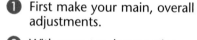

① First make your main, overall adjustments.

② With your top layer active, create a selection of an area you want to isolate in its adjustment.

 In this case, the flower color needed to be corrected.

● This selection was made mainly with the Magic Wand tool combined with the Polygonal Lasso.

③ Add an adjustment layer to affect a specific part of the photo.

 In this photo, Hue/Saturation was used to darken the background and make the flowers stand out better.

● The layer mask is automatically created based on the selection.

LIGHTEN OR DARKEN
a portion of an image

The camera simply does not see the world in its colors and tonalities the same way that we do. In fact, it can give very misleading interpretations of a scene that really does not represent what you saw. Often this is based on the camera seeing contrasts, the difference between light and dark parts of your photo, much differently than we do. By using a Levels adjustment layer to lighten or using Brightness/Contrast adjustment layer to darken, you can use their layer masks to selectively adjust the brightness of specific areas in a photo to help it better interpret your original intent for the image.

In addition, you will often find it helpful to darken or lighten a background around your subject so that you can better make the subject stand out in the photograph. To do this, select the easiest part of the scene. If that is the background, you may be done after some clean-up work using a lasso tool. If the easiest selection is your subject, you can then get the background selected by inverting the selection (choose Select, then Inverse).

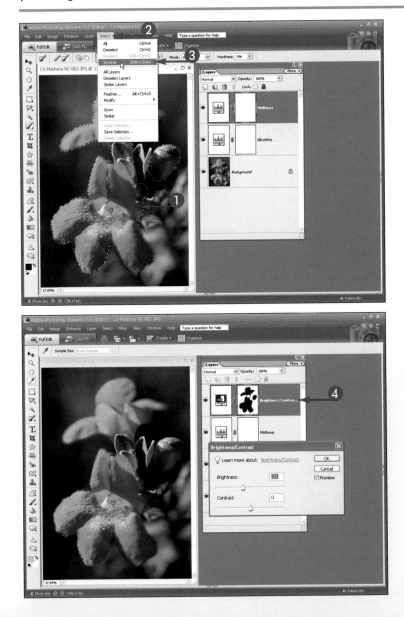

Note: The main adjustments should be done before completing this task.

1 Select the easiest part of the scene.

2 Click Select.

3 Click Inverse if you need the opposite part of the photo selected.

In this case, the background needed to be darkened, but it was easier to select the flowers first and then invert the selection.

4 Add an adjustment layer to darken or lighten the specific area now isolated in white in the layer mask.

In this case, Brightness/Contrast was used to darken the background and make the flowers stand out better.

Note: See the section "Using Adjustment Layers To Gain Flexibility" to work with adjustment layers.

If the selection edge looks too harsh, use the Gaussian Blur filter to soften the layer mask edges (Filter→Blur→ Gaussian Blur).

 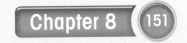

CORRECT EXPOSURE
problems

A common problem with photos is that they are either underexposed or overexposed. Although this is often a subjective evaluation, you can quickly lighten or darken an image by tinkering with a few of the layer blending modes available in Photoshop Elements. Blending modes tell Elements how to compare what is in different layers and then enable you to change the way pixels mix between two layers of an image. Elements offers a very large number of choices for blending modes, but you only need to know two, Screen and Multiply, for this task.

Screen, when applied to an underexposed photo, always makes the image appear brighter. The Screen blending mode gives you about one full f-stop increase in exposure.

The Multiply blending mode darkens the image colors, which is ideal for overexposed photos. Multiply gives you about one full f-stop decrease in exposure. You also use the Multiply blending mode to intensify image colors.

With either blending mode, fine-tune the exposure by adjusting the layer's Opacity setting found at the top of the Layers palette.

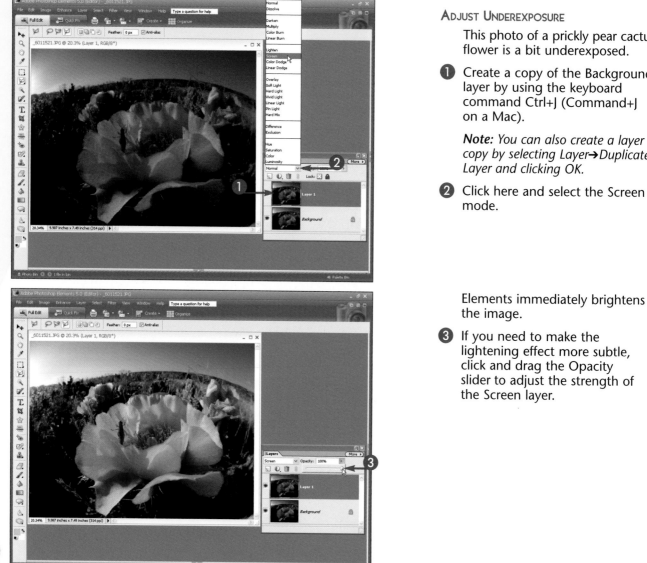

ADJUST UNDEREXPOSURE

This photo of a prickly pear cactus flower is a bit underexposed.

① Create a copy of the Background layer by using the keyboard command Ctrl+J (Command+J on a Mac).

Note: You can also create a layer copy by selecting Layer→Duplicate Layer and clicking OK.

② Click here and select the Screen mode.

Elements immediately brightens the image.

③ If you need to make the lightening effect more subtle, click and drag the Opacity slider to adjust the strength of the Screen layer.

152

ADJUST OVEREXPOSURE

This photo of a landscape in Arches National Park is a bit overexposed.

① Create a copy of the Background layer as before.

② Click here and select the Multiply mode.

Elements immediately darkens the image.

③ If you need to make the darkening effect not as strong, click and drag the Opacity slider to adjust the strength of the Multiply layer.

TIP

Did You Know?

Although you may be tempted to apply the Brightness and Contrast feature in Elements to correct overall exposure and contrast problems, this feature does not correct overly light or dark images. Instead, it either raises the brightness values in an image to make all the pixels brighter or lowers the values to make all the pixels darker. For most photos, you do not need to adjust all the pixels, just the ones affected by the exposure problem. For best results, use the blending modes and adjustment layers to correct exposure problems.

Chapter 8: Beyond the Basics with Photoshop Elements 153

REMOVE UNWANTED ELEMENTS

with the Clone Stamp tool

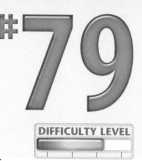

DIFFICULTY LEVEL

You can remove a variety of unwanted elements from your photos with Adobe Photoshop Elements. You can remove everything from unwanted telephone lines or vehicles in landscape photos to people or objects in group photos. Without question, some elements are easier to remove than others. Most often, the Clone Stamp tool can be used to "clone" existing areas over the unwanted elements.

The Clone Stamp tool enables you to set a source point in the image you are editing, or even another

image, then you clone that point over the problem area. The key to using the Clone Stamp tool is to blend the cloning well into the image. It helps to clone to a new layer because this lets you keep all of your other layers in their original state.

Enlarge the image with the Zoom magnifier tool to better see the problem area. Then click and clone in steps (do not paint the clone in strokes), change the size of the brush as you go, change the source point as you clone, and use a soft brush.

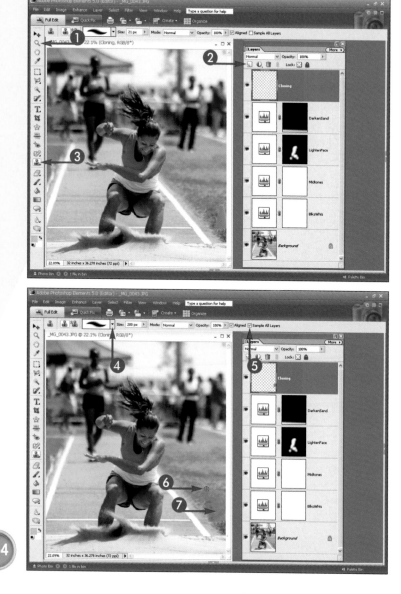

① Use the Zoom tool to zoom in on the area that you want to cover.

Note: *Make sure to keep the area that you will use as the source area visible.*

② Add a blank layer with the Add Layer icon in the Layers palette.

Change its name to "Cloning," as seen here.

③ Click the Clone Stamp tool.

④ Click here to select an appropriately sized soft-edge brush.

⑤ Click here to select Sample All Layers.

Leave the other options at their default settings.

⑥ While holding down the Alt (Option) key, click on the photo to set the source point.

⑦ Click on the photo over the unwanted element.

The cloned image area appears in the new layer opened for cloning and can be removed or deleted without affecting the rest of the photo.

CONVERT
color to black and white

Black and white is a very creative tool for making beautiful, unique images. Black and white is not simply a color image with the color removed. How that color is removed affects how each color is translated into the tonalities seen in the black and white. If, for example, color was simply removed from a green and red photo, the green and red would translate into the same shades of gray — not very interesting.

For effective black-and-white conversion, first make your adjustments to blacks, whites, and midtones so you are starting with a properly processed image (flatten it if necessary by choosing Layer, Flatten Image, but save the original first as a master). The Convert to Black and White control in the Enhance menu includes multiple choices for translating color to black, white, and gray tones. This is a very visual interface with a before-and-after image and choices for change in three categories: Select a style, Adjustment intensity, and a selection of thumbnails to click. You can use any or all of these as needed.

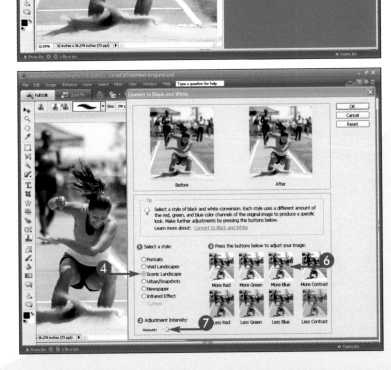

① Flatten the image and save it as a master file.

② Click Enhance.

③ Click Convert to Black and White.

④ Select a style.

Use the names for the styles only as ideas; try all of them and use the one that makes your photo look its best.

⑤ You can also make your color translations to black and white by clicking the thumbnails in the third section.

⑥ Keep clicking the thumbnails until the After photo and your large image look good.

⑦ Adjust the intensity of the changes in section 3 by dragging the Amount slider in section 2.

DOUBLE-PROCESS RAW
for more detail

Certain photos just do not adjust properly for highlights and shadows. If one looks good, the other does not. A great way to deal with this challenge is to shoot RAW and process the image twice in Camera Raw. You can then concentrate the first time on the shadows, getting them looking their best without concern for the highlights. Then you process a second time for the highlights without concern for the shadows.

This results in two images opened into Photoshop Elements. When you open the first one, you must save this file with a new name. Elements does not allow you to process another version of the image if it has the same name. You do not need to do a Save As with the second file, though it never hurts for protection against system crashes or other problems. Next, you must put the two photos together. Put the image looking best overall on top. Then you erase the problems of the top layer (literally, this is cutting holes in it) to reveal the better detail from the layer below.

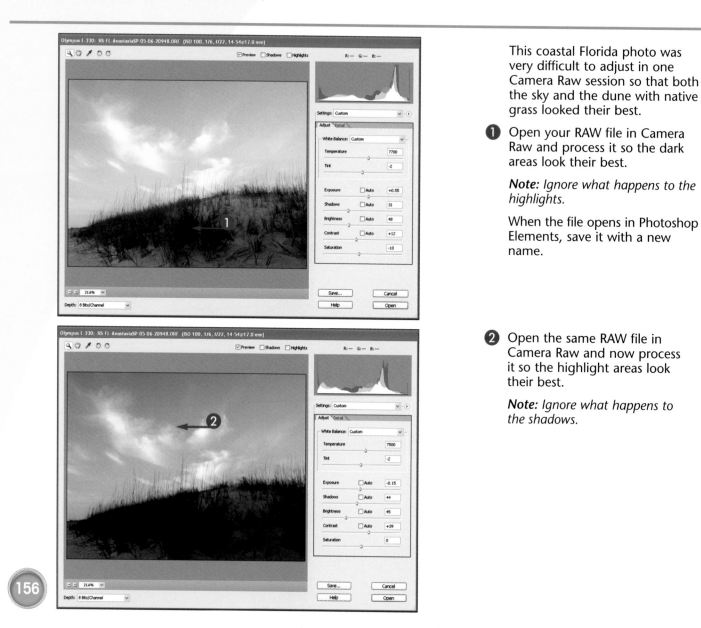

This coastal Florida photo was very difficult to adjust in one Camera Raw session so that both the sky and the dune with native grass looked their best.

❶ Open your RAW file in Camera Raw and process it so the dark areas look their best.

Note: Ignore what happens to the highlights.

When the file opens in Photoshop Elements, save it with a new name.

❷ Open the same RAW file in Camera Raw and now process it so the highlight areas look their best.

Note: Ignore what happens to the shadows.

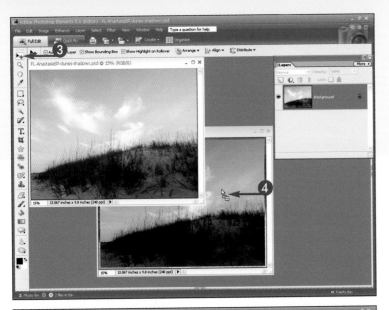

3 Click the Move tool in the Toolbox.

4 Press and hold the Shift key, then click one of the photos and drag it on top of the other.

You will know you are on the other photo when the cursor changes and the edges of the second photo change.

Note: You must press and hold the Shift key through the entire move, and release the mouse button first.

5 Click the Eraser tool in the Toolbox.

6 Use the tool options bar to select a large, soft-edged eraser brush.

7 Erase the weak part of the top photo so the underlying photo that is good in that area shows through.

81

DIFFICULTY LEVEL

TIPS

Processing Tip!

As you blend the two processed images together, try changing the opacity of the Eraser brush. You can always undo too-obviously erased edges by using the Undo History palette, then redoing the erasure with less opacity or intensity to the Eraser brush. Also experiment with changing the size of the brush.

Processing Tip!

Selections can be used to help blend the two images together. Often you will find the Magic Wand tool works very well to select specific parts of the top image that need to be removed. Try selections with Contiguous checked and unchecked. Also, try changing the Tolerance to get more or less of a tone selected. Finally, remember you can add to a selection by pressing and holding the Shift key as you select.

COMBINE TWO EXPOSURES
for a better tonal range

Sometimes the world throws such a high-contrast scene at the camera that its sensor cannot possibly handle the full tonal range of the subject. In that case, no amount of processing in Photoshop Elements will reveal detail that was never captured by the camera.

There is a way around this limitation of the technology. Take two photos of the scene, one exposed to gain optimum detail in the shadows, one exposed to gain optimum detail in the highlights. You can even do more-specialized exposures with this technique and a little practice. Then you blend

the two exposures together in Photoshop Elements, gaining detail in shadows and highlights from the two exposures that would have been impossible from one exposure.

To do this, though, you must lock your camera securely to a tripod. Otherwise, you will find it very hard to match up and blend the two images together. A good way to get the two exposures is to use auto-exposure bracketing if your camera offers it — set it to a two f-stop change, then use only the brightest and darkest exposures. Throw out the middle one.

① Adjust the first image the best you can for its exposure, then flatten the photo (Layer→Flatten Image).

② Concentrate on the best tonalities and color of the image and ignore the rest.

In this photo, the rocks and trees gain better color and tonality by the exposure and the processing, but the sky is washed out and the clouds have lost highlight detail.

③ Adjust the second image the best you can for its exposure and flatten the image.

In this photo, the sky and clouds gain better color and tonality by using adjustment layers to control their brightness and contrast.

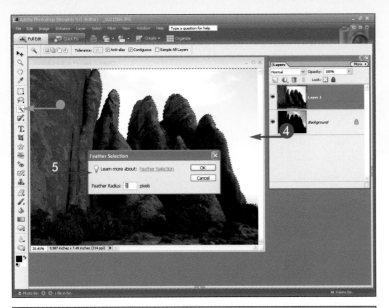

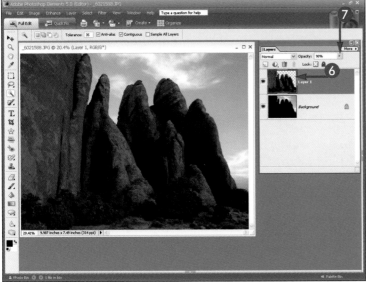

Using the Move tool and pressing and holding the Shift key, click and drag one image on top of the other as shown in Task #81.

④ Select the areas with poor color and tonality in the top image.

● The Magic Wand tool was used to select the sky.

⑤ Feather the selection with the Feather command in the Select menu to blend the edges by a few pixels.

⑥ Delete the selected area (the deleted area shows as a checkered pattern in the layer icon).

⑦ Adjust the opacity of the top layer as needed to make the two images look good together.

TIPS

Did You Know?

Photographers sometimes wonder why they should bother with two exposures when the Screen technique from Task #78 would lighten dark areas, too. The advantage of two exposures, one specific for the dark areas, is image quality. Color, tonality, and noise are much better when the exposure is correct for the area compared to "fixing it" with Screen in Photoshop Elements.

Processing Tip!

Using the Feather command in the Select menu removes the hard edge of any selection and creates a blended or soft edge that looks more natural. How many pixels you choose for this control affects how much blending is needed. Some edges, such as a sharp edge between rock and sky, need very little. Other edges need to blend across a wide area and so need much more feathering.

Make Photographic Prints

Even though taking pictures with a digital camera makes it easy to share digital photos electronically — on a Web page, as an e-mail attachment, or on a computer or TV screen — a photographic print on paper is still what photography is all about to many people. You can make photo-quality prints from digital photo files in many ways, including printing them on a desktop photo printer, ordering prints from an online photo-printing service, or using a local photo-processing lab.

Before you are ready to make prints, however, you may need to perform some basic image processing to get the best results. The workflow described in Chapter 7 strongly affects the appearance of a print. To make

prints that are more predictable, you need to take the time to calibrate your monitor with a monitor-calibration device such as the Datacolor Spyder or Pantone Huey.

Besides making basic adjustments to your digital photos, you also need to size the image properly for the print dimensions and sharpen the photo appropriately for that size and the subject. If you are using your own desktop photo printer, you can use Adobe Photoshop Elements or another imaging program to precisely position photos on a page, create multiple photo page layouts, or crop photos that will be printed in a book using an online printing service.

Top 100

UNDERSTANDING
color management

Your digital camera, computer screen, and printer all reproduce color differently, and each one has different limitations on how it can display color. *Color management* is a system of hardware and software products that have been configured to ensure predictable and more accurate color across all devices. In other words, if you have implemented color management properly on your hardware, the barn-red barn in front of the soft, pale blue sky that you see on your computer monitor will be interpreted as barn red against a soft, pale blue sky in your prints.

Important steps in color managing your hardware include calibrating your computer display and using the right color profiles for the specific combination of printer, ink, and paper that you are using. Taking, editing, and printing digital photos can be a joy and easy to do when you have predictable color across your hardware and software. Without some sort of color management, the same process of taking, editing, and printing digital photos can become frustrating.

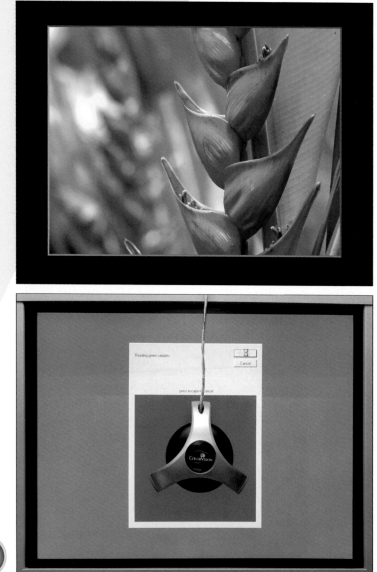

Colors need to be interpreted accurately and predictably by your computer for display and printing.

Calibrating your monitor is an important step to ensure color consistency.

This print of heliconia flowers is an accurate representation of the colors seen on the monitor and in life.

83

DIFFICULTY LEVEL

The flowers on this Dell LCD monitor have a consistent appearance on the print and when the photo was taken.

TIPS

Did You Know?

You can do a basic calibration of your Windows monitor using Adobe Gamma, which is a software utility added to the Control Panel when you install Adobe Photoshop Elements. To access the Control Panel, click the Start button and choose Control Panel from the menu. If you are using a Mac, you can use Apple's ColorSync utility, which can be found in System Preferences. Be sure to adjust your monitor in the lighting conditions that you normally work in.

Did You Know?

The best and most accurate way to calibrate your computer monitor is to use a hardware/software color calibration system such as the ColorVision SpyderPro2 (www.colorvision.com) or the Pantone Huey (www.pantone.com). A special sensor sits on your computer display so that it can read colors displayed by the special software to create an accurate color profile.

SIZE PHOTOS
for printing

For optimum results, your image needs to be sized properly for a print. Most digital cameras today have more than enough pixels to make standard-size prints such as 4 x 6 inches or 8 x 10 inch7es. If you need to make very large or very small prints, you need to resize the image.

Printing resolution should be set to 200–360 ppi. Photoshop Elements makes it easy to check this size in its Image Size control (choose Image, Resize, and then Image Size). First, find out how big your image can be without changing pixels (interpolating or resampling) by making sure the Resample option is

not checked. Then type **200 ppi** (pixels per inch) in the Resolution box to see the largest print size you can make and **360** to see the smallest. For any print size in-between, just type a dimension you want to use (you cannot yet choose a specific proportion, though).

To enlarge an image, use **200 ppi**, check Resample Image, choose Bicubic Smoother, and then type a dimension you need. To reduce the size of an image, use **360 ppi**, check Resample, and choose Bicubic Sharper before typing the desired dimension.

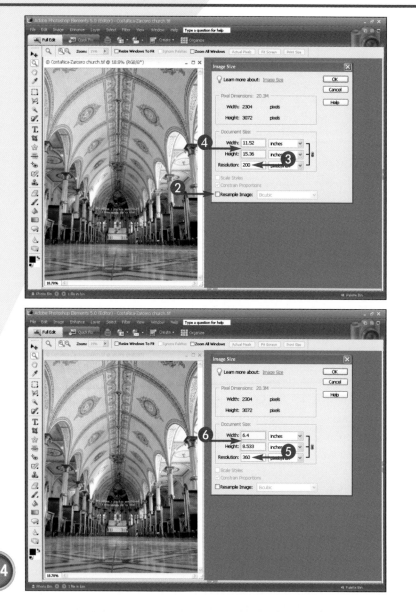

DETERMINE MINIMUM AND MAXIMUM PRINT SIZES

① Click Image→Resize→Image Size.

The Image Size dialog box appears.

② Make sure that Resample Image is not checked.

③ Type **200** in the Resolution box for ppi.

④ Check the Width and Height in the Document Size area to see how large the print can be.

⑤ Type **360** in the Resolution box.

⑥ Check the width and height in the Document Size area to see how small the print can be.

These are the largest and smallest prints you can make with your image file without changing pixels and potentially affecting image quality.

Type any dimensions in the Width and Height boxes that keeps the resolution between 200 and 360.

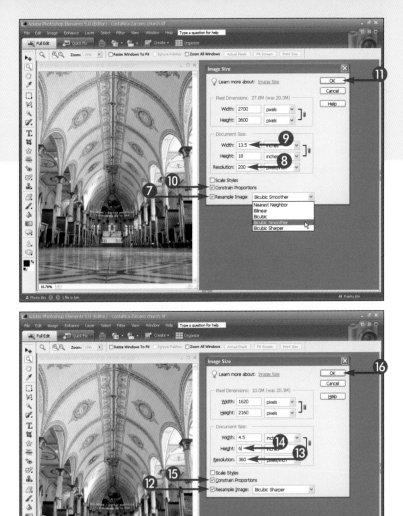

PRINT AN ENLARGED PHOTO

⑦ To enlarge, check Resample Image and choose Bicubic Smoother.

⑧ Type **200** in the Resolution box.

⑨ Type the width or height that you want in either the Pixel Dimensions area or the Document Size area.

⑩ Make sure that Constrain Proportions is checked to keep the aspect ratio constant.

⑪ Click OK.

PRINT A REDUCED PHOTO

⑫ To reduce, check Resample Image and choose Bicubic Sharper.

⑬ Type **360** in the Resolution box.

⑭ Type the width or height that you want in either the Pixel Dimensions area or the Document Size area.

⑮ Make sure that Constrain Proportions is checked.

⑯ Click OK.

DIFFICULTY LEVEL

TIPS

Did You Know?

When resizing images using the Image Size feature, you need to be careful to choose the most appropriate resampling algorithm. Use Bicubic Smoother when enlarging an image and Bicubic Sharper when reducing the size of an image.

Caution!

When enlarging or reducing any image, you should always save the resampled image to a new file and not overwrite the original image. Keep your original image as a master file with the original pixels that you can always use for new image sizes.

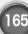

SHARPEN
a digital image

Sharpening is not about making a badly focused image sharp. You cannot do that. Sharpening is about revealing the maximum sharpness of your lens in the digital file. Digital cameras do not capture sharpness the same way that film cameras do. The digital process has some inherent softness to it that needs correction.

Using Photoshop Elements, you can bring back the correct sharpness of your photos and reveal what the lens actually captured. One easy way to sharpen a photo is to use the Unsharp Mask filter found in most image-processing software. It includes three specific

settings for the amount of sharpening, the radius of the sharpening effect, and a threshold for when the sharpening occurs.

There are many formulas for Unsharp Mask settings. Different sizes, varied purposes, and specific subjects all need different settings. For example, the best settings for a photograph of a landscape are different than the settings you need to sharpen a portrait of a woman. In addition, you need to sharpen a small file for web use much less than an image needed for a large print.

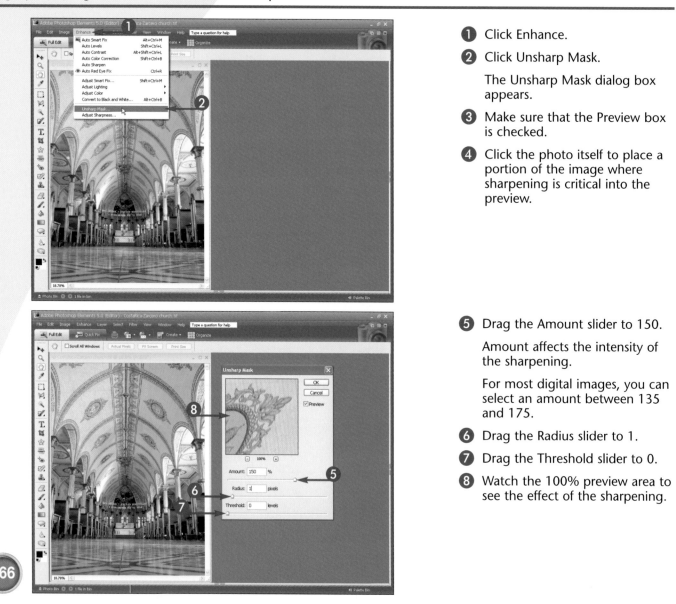

① Click Enhance.

② Click Unsharp Mask.

The Unsharp Mask dialog box appears.

③ Make sure that the Preview box is checked.

④ Click the photo itself to place a portion of the image where sharpening is critical into the preview.

⑤ Drag the Amount slider to 150.

Amount affects the intensity of the sharpening.

For most digital images, you can select an amount between 135 and 175.

⑥ Drag the Radius slider to 1.

⑦ Drag the Threshold slider to 0.

⑧ Watch the 100% preview area to see the effect of the sharpening.

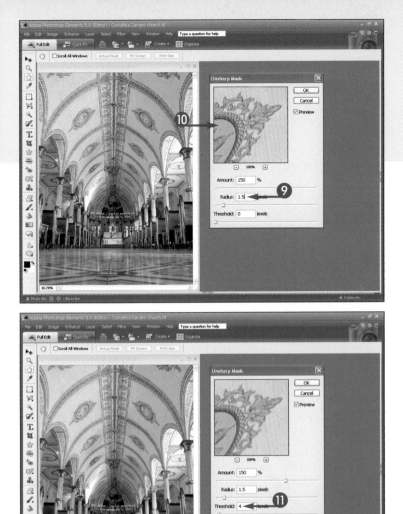

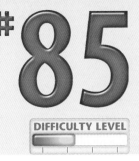

9 Change Radius to increase sharpening.

Radius affects how far sharpening goes from an edge.

Typically, you will use 1–1.5, but never over 2 for standard images.

DIFFICULTY LEVEL

Use a higher number for larger images (20MB and up) and a lower number for smaller images (under 10MB).

10 Watch the 100% preview for harsh edges or halos appearing around them.

11 Change Threshold to minimize sharpening of noise.

Threshold affects the point at which sharpening occurs and is used to deal with noise.

Most digital images will use a threshold of 3–4, but when noise is high, you can go up to 12.

With higher settings of Threshold, you need to increase Amount to compensate for a lowered sharpening effect.

Did You Know?

You cannot use Photoshop Elements to sharpen a poorly focused digital photo. The Unsharp Mask filter only increases the perceived sharpness of an already well-focused photo. If you want a good photo that appears "tack sharp," you must first shoot it in focus and then apply the Unsharp Mask filter to get the best results.

Did You Know?

There is an additional sharpening tool in Photoshop Elements simply listed as Adjust Sharpness under Enhance. It is the same tool as Smart Sharpen in Photoshop. It uses more-advanced algorithms for adjusting sharpness compared to Unsharp Mask, but it does not have a Threshold setting, so it can over-enhance noise.

CROP A PHOTO
to a specified size

You can crop your photos when you want to keep only a certain part of them, to revise a composition, or when you need to make a photo meet specific width and height requirements. Adobe Photoshop Elements offers two useful tools for cropping images — the Rectangular Marquee and Crop tools. First, you can select the part of the image that you want to keep using the Rectangular Marquee tool, and then choose Image, Crop to crop the image. Most of the time, however, you will use the Crop tool, which has a few

extra features that are useful for cropping images precisely as you want them.

Using the Crop tool, you can not only crop to a fixed aspect ratio, but also crop to a fixed size, specified in inches, and at a specified printer resolution. Additionally, the Crop tool enables you to drag the edges of a selection to select exactly the area that you want; it even enables you to rotate the image if needed.

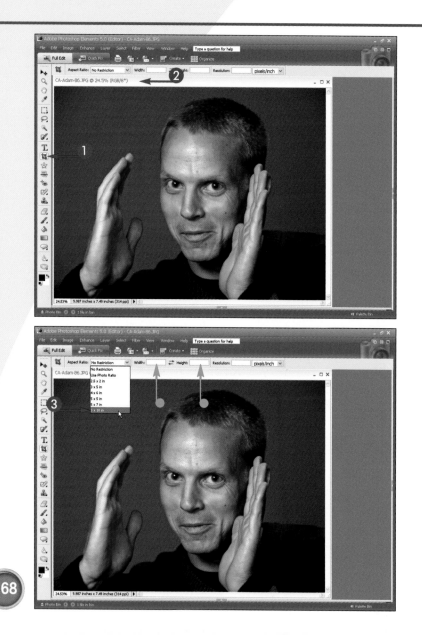

① Click the Crop tool.

② Double-click the document title bar to maximize the document window to make cropping easy.

③ Click here and select the aspect ratio.

● Alternatively, you can type the width and height that you want.

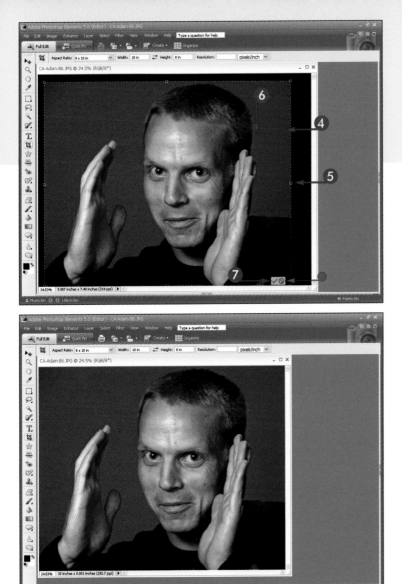

④ Click and drag your cursor to select the area of the photo that you want.

⑤ Position the mouse pointer on any box on the perimeter of the crop selection area.

Click and drag those points to make the selection smaller or larger.

⑥ Position the mouse pointer inside the crop selection area.

Click and drag the selection to better position it over the image.

⑦ Click here to apply the crop.

● To cancel the crop, click here.

The image is cropped and resized.

TIPS

Did You Know?

If your image is crooked, you can also rotate it during this step. This can be used to straighten horizons, for example. Position the mouse pointer outside a corner of the crop selection area. The cursor changes to indicate that you can rotate the image. Click and drag to rotate the selection until it appears as you like it.

Caution!

When you crop an image, its total pixel resolution is lowered because you are removing pixels. This could make the image smaller than needed for a good print. You can choose Image, Image Size, Resize Image Size to set the resolution. This is further described in Task # 84.

PRECISELY POSITION PHOTOS
on a page

You may have many reasons to precisely position one or more photos on a page. Maybe you want to create your own print portfolio, a scrapbook page, or a greeting card. Whatever the reason, you can take several approaches. Depending on the printer that you use, your printer software may have a feature that enables you to specify exactly where an image should be printed on the page. If you are printing a page with only one photo, using your printer software may be the best approach.

Using Photoshop Elements, choose the Image, Resize, Canvas Size command to "add paper" around an open image when you want only a single photo on a page. To use this feature, you need to calculate the amount of paper to add to each side. Or you can create a new blank page and drag and drop one or more open photos onto the new page and place them where you want using the Ruler feature, as shown in this task.

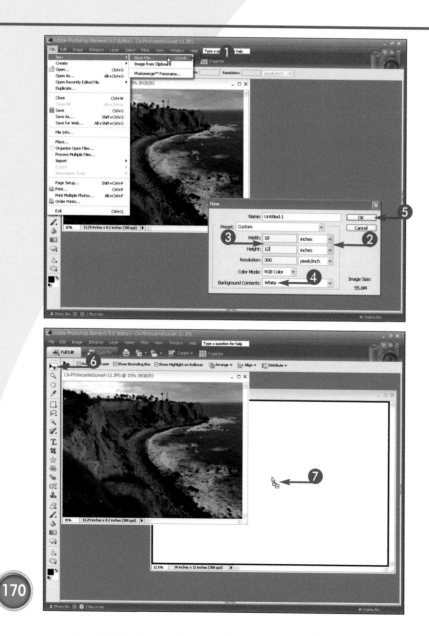

① Click File→New→Blank File.

The New dialog box appears.

② Click here and select inches.

③ Type the width, height, and desired resolution.

Use the same resolution as your photo.

④ Make sure that Background Contents is set to White.

⑤ Click OK.

Elements creates a new document to your specifications.

⑥ Click the Move tool.

⑦ Click and drag the photo you want to place over to the new, blank document.

The photo appears in the new document.

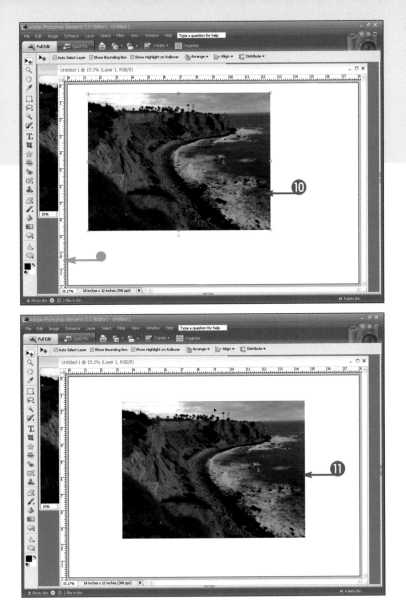

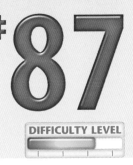

8 Click **View**.

9 Click **Rulers**.

● The rulers appear in the new document window.

10 Click the photo layer with the Move tool to move the image where you want it.

If you click and drag the handles around the photo, you can change the size of the image. Press Shift while dragging to maintain the aspect ratio.

11 Drag the photo with the Move tool until you have the image positioned as you want it.

You can also move the image up, down, and sideways by pressing your keyboard's arrow keys. Each press moves the image one pixel.

TIPS

Did You Know?

When you drag and drop, or when you cut and paste, images onto a blank page, the images are all placed on their own layers. To view and select these layers, open the Layers palette. You can easily add any one of many varieties of drop shadows or other effects by opening the Artwork and Effects palette and double-clicking the style of your choice.

Did You Know?

Each time that you place a new image on a page as a layer, you increase the size of the file. To flatten the layers, choose the Layer, Flatten Image command. First, save the file as a PSD file if you want to save the layers for future editing. When you place text on an image, a text layer is created, and text layers can be flattened as well.

PRINT MULTIPLE PHOTOS
on a page

You can save photo paper, printer ink, and money by creating a multiphoto layout and printing more than one photo per page. Although you can do this manually by using several of the features found in Adobe Photoshop Elements, the Print Multiple Photos command lets you quickly and easily make multiphoto prints that are similar to school photo pages.

Besides using one of the 20 preformatted pages, you can also customize your own layout. You can learn

more about making customized layouts by consulting the Adobe Photoshop Elements Help system. You can also automatically make a multiphoto print of every photo in a selected folder. The Picture Package's default layout is for multiple copies of a single photo. This part of Print Photos gives you many options for how many photos to put on a single sheet of paper. After you have selected a layout, however, you can click each photo and pick another photo to fill that space.

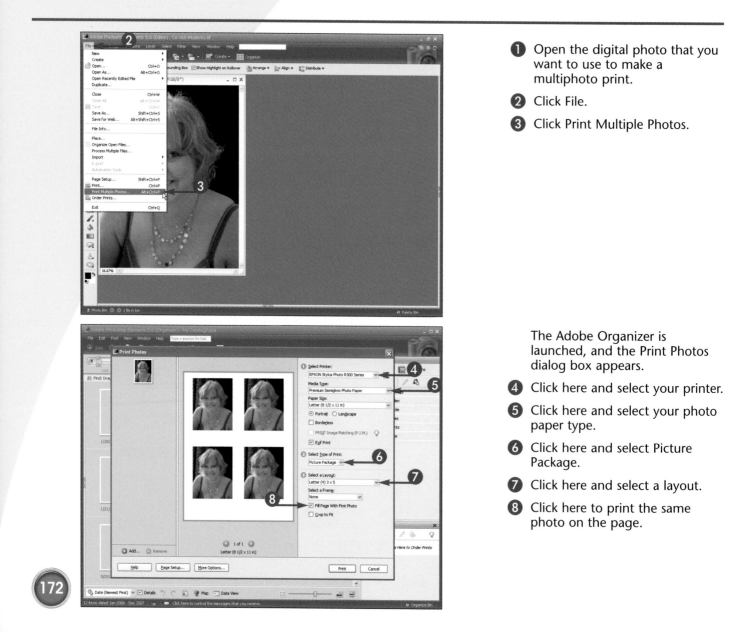

① Open the digital photo that you want to use to make a multiphoto print.

② Click File.

③ Click Print Multiple Photos.

The Adobe Organizer is launched, and the Print Photos dialog box appears.

④ Click here and select your printer.

⑤ Click here and select your photo paper type.

⑥ Click here and select Picture Package.

⑦ Click here and select a layout.

⑧ Click here to print the same photo on the page.

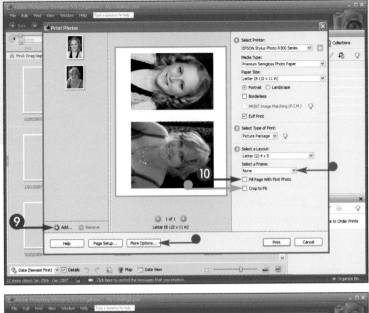

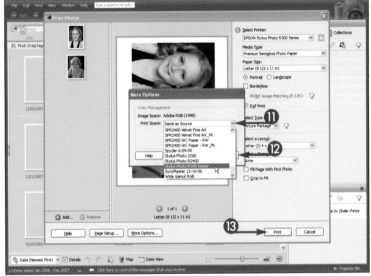

⑨ Click Add to add more images.

An Add Photos dialog box appears that you can use to select the photos you want to use. Then the thumbnails appear in the list on the left.

DIFFICULTY LEVEL

⑩ Uncheck Fill Page With First Photo to print different photos on a page.

● If you want the photos to be cropped exactly the same size, click Crop to Fit.

● If you would like a frame around your photos, click Select a Frame.

● If you want to use a media profile, click More Options.

The More Options dialog box appears.

⑪ Click here and select your media profile for the Print Space.

⑫ Click OK.

⑬ Click Print.

The printing process begins.

TIPS

Time-Saver!

When you use the Photoshop Elements Print Photos dialog box, you need to cut each photo from the page. If your photo-quality printer has a borderless print feature, make sure to check Borderless in the Print Photos dialog box. This will save you time in cutting the photos.

Did You Know?

You can use keyboard shortcuts for many of the commands in Photoshop Elements. This can speed up your image processing. For example, printing is accessed through Ctrl+P (Command+P on the Mac). Multiple photos is Alt+Ctrl+P (Option+Command+P using a Mac). Keyboard shortcuts are listed at the right of the command in each menu.

Chapter 9: Make Photographic Prints 173

ORDER PRINTS
online

If you enjoy using a one-hour photo-finishing service at a local photo lab, you may enjoy using one of the online printing services such as the Kodak EasyShare Gallery, which is built into Photoshop Elements. Although it is not possible to get your photo prints back in an hour, you can select, edit, upload, and order photo prints from your computer any time you like — without the hassles of going to a local lab to drop off your photos and to pick them up. After uploading your photos to an online printing service, your photos are printed and delivered to your mailbox within a few days.

Besides being able to order prints for yourself after you have uploaded them, you can also send a link via e-mail to anyone else with whom you want to share the photos. They can view the photos online in a Web browser; if they want, they can order prints themselves at their own expense, or you can order prints to mail to them. Besides just ordering photo prints at competitive prices, you can also have your photos printed in photo albums or books — or on hats, greeting cards, calendars, and many other photo objects.

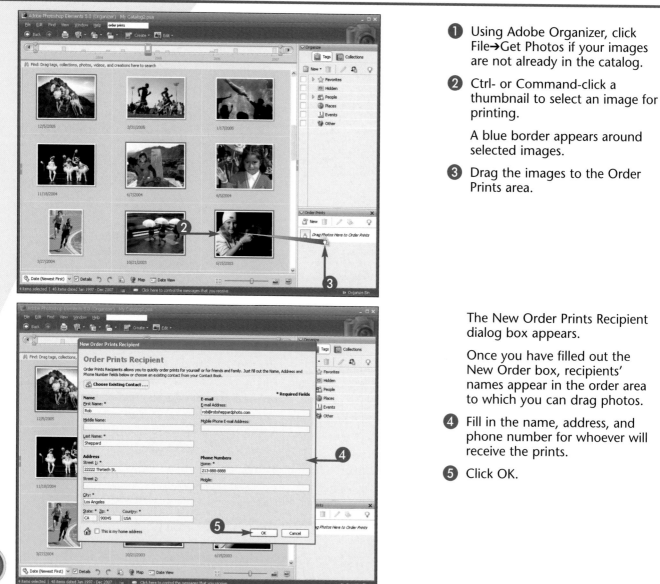

① Using Adobe Organizer, click File→Get Photos if your images are not already in the catalog.

② Ctrl- or Command-click a thumbnail to select an image for printing.

A blue border appears around selected images.

③ Drag the images to the Order Prints area.

The New Order Prints Recipient dialog box appears.

Once you have filled out the New Order box, recipients' names appear in the order area to which you can drag photos.

④ Fill in the name, address, and phone number for whoever will receive the prints.

⑤ Click OK.

The Welcome to Adobe Photoshop Services page appears. You must create an account if you do not already have one.

6 Type your name here.

7 Type your e-mail address in both fields.

8 Type your password in both fields.

9 Click Next.

The Order Prints/Review Order page appears.

10 Review the order details to make sure that the information is accurate.

11 Change the quantities or sizes of the images as needed.

12 Verify the delivery information.

13 Click Checkout.

You are then asked to provide billing information.

Finally, you upload the images to the Kodak service.

This happens automatically.

TIPS

Did You Know?

The best way to use an online photo-printing service is to crop, edit, and place all the photos that you want into a single folder before uploading them to the service. Crop each of the photos to the aspect ratio of the print size that you will want to order and save them in an appropriate file format.

Did You Know?

Other online photo-printing services you may want to consider in addition to Kodak EasyShare (www.kodakgallery.com) are MPix (www.mpix.com) and Shutterfly (www.shutterfly.com). If you are using a Macintosh, you can also upload and order photo prints and photo books easily by using Apple's iPhoto software.

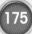

CREATE A PHOTO BOOK
online

Making a printed photo book is an exciting way to share photographs. The next time that you have a family get-together, you can create printed photo books and make them available to your family members. Or you may want to make your own 12- x 16-inch hardcover coffee table book featuring your top 40 photos.

One of the leading online photo book companies is MyPublisher. The MyPublisher service includes free software that you use to create your books, but your photos must be saved as JPEG files. To download the MyPublisher BookMaker software, visit www.mypublisher.com.

As this book goes to press, MyPublisher offers 5.75- x 7.75-inch pocket books with 20 pages and up to 80 photos for only $9.95. You can add additional pages for only $0.49 each. MyPublisher's 8.75- x 11.25-inch linen hardcover photo books with 20 pages and up to 160 photos are only $29.80, and you can add additional pages for only $0.99 each. And if you want a really big book, MyPublisher offers giant 11.5- x 15-inch full-bleed books with edge-to-edge printing, plus a hardcover binding made of imported linen for only $3.00 per page. A 20-page book costs $59.80.

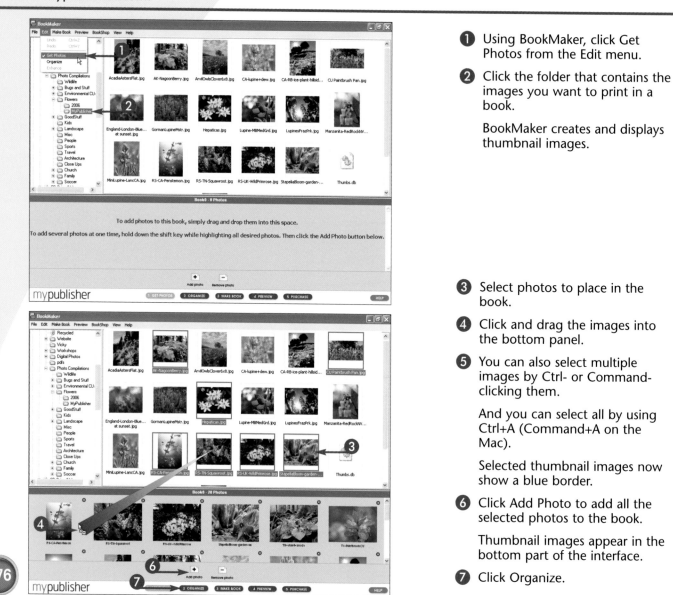

① Using BookMaker, click Get Photos from the Edit menu.

② Click the folder that contains the images you want to print in a book.

BookMaker creates and displays thumbnail images.

③ Select photos to place in the book.

④ Click and drag the images into the bottom panel.

⑤ You can also select multiple images by Ctrl- or Command-clicking them.

And you can select all by using Ctrl+A (Command+A on the Mac).

Selected thumbnail images now show a blue border.

⑥ Click Add Photo to add all the selected photos to the book.

Thumbnail images appear in the bottom part of the interface.

⑦ Click Organize.

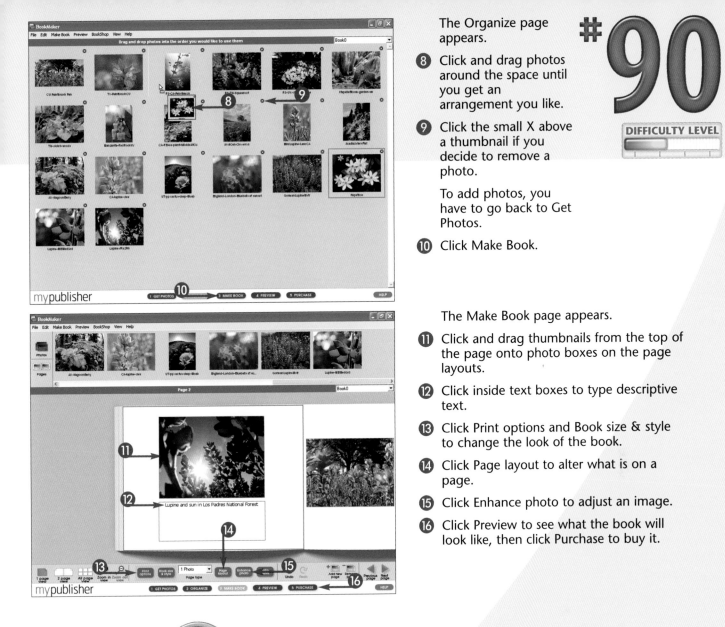

The Organize page appears.

8 Click and drag photos around the space until you get an arrangement you like.

9 Click the small X above a thumbnail if you decide to remove a photo.

To add photos, you have to go back to Get Photos.

10 Click Make Book.

90

The Make Book page appears.

11 Click and drag thumbnails from the top of the page onto photo boxes on the page layouts.

12 Click inside text boxes to type descriptive text.

13 Click Print options and Book size & style to change the look of the book.

14 Click Page layout to alter what is on a page.

15 Click Enhance photo to adjust an image.

16 Click Preview to see what the book will look like, then click Purchase to buy it.

TIP

Did You Know?

If you want to make your own photo books using the paper of your choice and a desktop inkjet printer, you can do so by purchasing a photo book cover made for this purpose. In particular, Unibind's PhotoBook system (www.unibind.com) and Epson's StoryTeller Photo Book Creator (www.Epson.com) custom book kits make excellent photo books that can feature your photos printed on your favorite inkjet paper, using a color profile — and printed to perfection. The easy-to-use binding features of these and other photo book products will provide you with a photo book that you will be pleased with.

Share Your Photos

After you have taken a few good photos and edited them, you are ready to share your photos in digital photo projects. The Web, for example, is so important today that you need to know how to prepare photos for that way of sharing. Also, to share and use your photos, you need to be able to organize your digital photo collection with an image manager and be able to archive your valuable digital photo collection to external drives or offline storage media.

One of the most exciting aspects of digital photography is that you can easily share and enjoy your digital photos in so many ways. You can attach one or more photos to e-mail, create slideshows to play on your computer

screen or even on a TV screen, publish online photo galleries, create digital photo albums, make collages, and more.

Many digital photo projects require software beyond what you use to edit photos. With increased interest in digital photography, the marketplace offers an incredible number of products from which to choose. Often you can choose one software product that enables you to complete most or all of your projects. Some of the more feature-rich and easy-to-use products include Adobe Photoshop Elements (www.adobe.com), Apple iPhoto (www.apple.com), Corel Paint Shop Pro (www.corel.com), and Ulead PhotoImpact (www.ulead.com).

PREPARE
photos for use on the Web

You can use the Adobe Photoshop Elements Save for Web command to convert your digital photos into images that are perfectly sized and suited to use on a Web page or as an e-mail attachment. Although it is possible to use the Save As command, the Save for Web command has many advantages.

Anytime that you save digital photos for use on a Web page, you are faced with a tradeoff between image file size and image quality. The more that you compress an image and the smaller the dimensions

of the image, the faster it downloads and displays; yet the more an image is compressed, the more the image quality is reduced. With the Save For Web dialog box, you can view the original along with the compressed image side-by-side for comparison. This enables you to select the file type and the level of compression to optimize the tradeoff between file size and image quality — the goal being the smallest file size with an acceptable image quality.

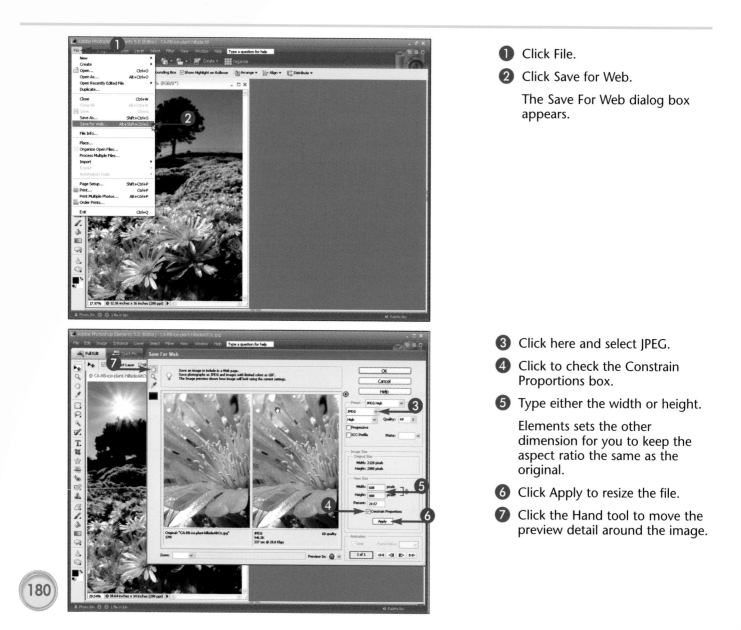

① Click File.

② Click Save for Web.

 The Save For Web dialog box appears.

③ Click here and select JPEG.

④ Click to check the Constrain Proportions box.

⑤ Type either the width or height.

 Elements sets the other dimension for you to keep the aspect ratio the same as the original.

⑥ Click Apply to resize the file.

⑦ Click the Hand tool to move the preview detail around the image.

8 Click here and select JPEG Medium.

Note: JPEGs are compressed images that are small and useful for displaying on Web pages.

● In this example, the size of the image on the right is 416.7KB instead of 17MB.

9 Click OK.

The Save Optimized As dialog box appears.

10 Click here and select a folder in which to save the file.

11 Type a name for the file.

12 Click Save.

The image is saved, optimized for the Web.

TIPS

Caution!

If you are shooting with many of the high-megapixel cameras common today, you may get a warning from Photoshop Elements when you try to use Save for Web. It will tell you the image exceeds the size Save for Web was designed for. It is hard to know what Adobe was thinking given how common high-megapixel cameras were at the time Elements was designed, but you should resize these photos down first in Enhance, Resize, Image Size.

Did You Know?

You can fine-tune compression levels with the Quality slider found in the Adobe Photoshop Elements Save For Web dialog box. In addition to using the presets, you can set Quality from 0 to 100. Watch the preview detail to be sure your image is not deteriorating.

ORGANIZE
your digital photos

Digital photography makes it easy to shoot a lot of pictures. Image management software helps you organize and manage these images. One of the more powerful and easy-to-use image managers is ACD Systems' ACDSee (Windows only – www.acdsystems .com).

After you pick one or more folders or a drive to manage, ACDSee automatically displays thumbnail images for every digital photo file in the selected folders or drives. You can very quickly edit and sort photos by using star ratings or colors selected by right-clicking the image.

In addition to viewing the images quickly by looking at the thumbnails, you can also batch rename, resize, and convert image formats as well as view a variety of textual information, such as the EXIF data that image files may contain. To learn more about working with EXIF data, see Task #46.

ACDSee not only keeps a database of the filenames and thumbnail images, but it also allows you to create virtual catalogs of images based on topics you select. In addition, you can add keywords to photos, save location information, add annotations, copyright information, and much more.

VIEW AND EDIT IMAGES

Note: ACDSee is only available for Windows.

1 Click a folder to view the images that it contains.

2 Select the appropriate file from the thumbnails.

● The Preview displays larger details about the selected image or images and can be resized.

● Thumbnail images display user-selected information below.

3 Edit your images by tagging them with numbers.

You can set the number for an image by pressing Ctrl + number.

4 Click the Sort button to sort images by tags, file names, and so on.

VIEW EXIF DATA

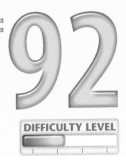

5 Click View→Properties to Open the Properties – EXIF panel.

6 You can check information such as shutter speed, f-stop, and focal length.

RENAME IMAGES

1 Select the images you want to rename by Ctrl-clicking them.

2 Click Tools→Batch Rename to open the Batch Rename dialog box.

3 To rename images with a template, click the Template tab.

4 Type a name for your photos that will help you identify it, using # for numbers.

5 Type in the starting number for the group of images.

6 Click Start Rename.

ACDSee renames the selected files.

TIPS

Did You Know?

ACDSee offers many features for viewing and editing digital photos. You can scale the thumbnails and view more or fewer of them at a time; you can customize the display to your needs; you can sort photos by a calendar view; and much more. You can also add keywords and other metadata to the image file that can be used for searching so you can more easily find photos later.

Did You Know?

ACDSee is only available for Windows. A browser/image manager with similar features for the Mac is Microsoft Expression Media (formerly iView Media — www.microsoft.com). Both ACDSee and Expression Media are much faster and more versatile programs than the organizing part of Photoshop Elements.

ORGANIZE
your digital photos

Many software vendors who initially created image managers have realized the value of adding features that not only increase your ability to organize and manage your digital photo collection, but also take advantage of a considerable number of project features such as slideshows, Web galleries, contact sheets, printed image catalogs, and much more. A few of the more feature-rich and easy-to-use image managers with useful project features are the following:

ACDSee (www.acdsystems.com)

Adobe Photoshop Elements (www.adobe.com)

Adobe Photoshop Lightroom (www.adobe.com)

Apple iPhoto (www.apple.com)

Cerious Software ThumbsPlus (www.cerious.com)

Corel Snapfire (www.corel.com)

Microsoft Expression Media (www.microsoft.com)

Ulead PhotoExplorer (www.ulead.com)

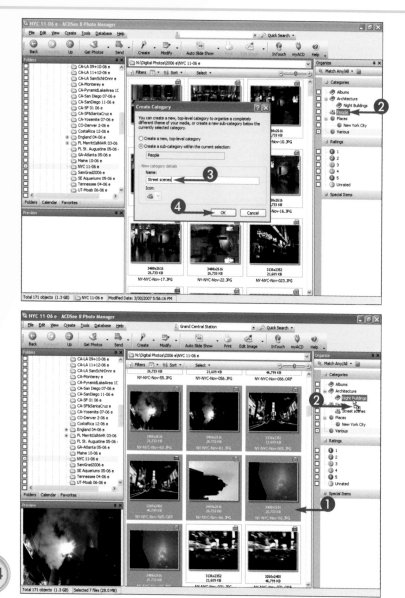

CREATE VIRTUAL ALBUMS

Note: ACDSee is only available for Windows.

① Click View→Organize Show.

② Right-click Categories to add a new virtual album.

Right-click any existing categories to add virtual albums.

The Create Category dialog box appears.

③ Type a name for the virtual album.

④ Click OK.

ACDSee creates a category that can be used to group images.

PUT IMAGES INTO VIRTUAL ALBUMS

① Select the images you want to include in an album by Ctrl-clicking them.

② Drag and drop the images onto the album name in the Categories list of the Organize panel.

References to the image file locations are written to the ACDSee database.

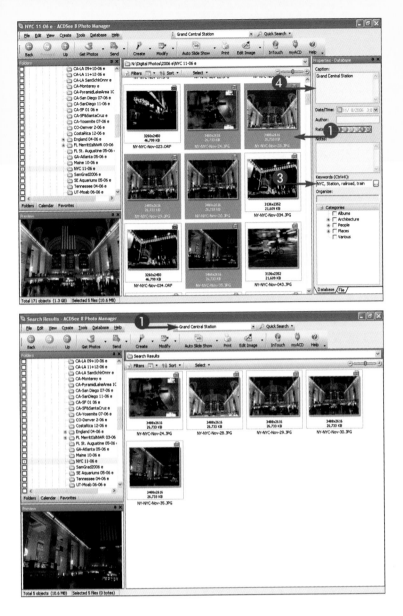

1 Select the image or
images to which you
want to attach
keywords.

2 Click View→
Properties to open
the Properties panel.

3 Type the keyword or keywords that you
want to assign to the image to use for
queries.

4 Type other information such as caption,
author, and notes.

The keywords and other data are written
to the ACDSee database.

FIND AN IMAGE CONTAINING KEYWORDS

1 Type a keyword or info from the caption.

2 Press Enter.

A window displays all images with the
selected keywords.

92
CONTINUED

TIPS

Did You Know?
When you add images to ACDSee's
virtual albums, no photos are actually
moved. They remain in place on your
hard drive. References are made within
the software as to where the images
are. You can then "move" images into
the albums from any folder on your
computer; then when you click on the
album, all photos that are referenced
to it will appear.

Did You Know?
You can automatically rename a batch
of your digital photo files using
ACDSee's Batch Rename command.
You can choose a prefix and a suffix as
well as add incrementing numbers.
This useful feature enables you to add
more meaning to your filenames. You
can also search using just parts of the
filename.

ORGANIZE
your digital photos

As you shoot more and more digital photos, you will find that increasing numbers of photos clog a hard drive and make it seem a daunting task to ever organize them. Even if you have unlimited storage space for your photos, you do not have unlimited time or capacity to deal with every single one of them.

This is why it is important to edit your photos, removing your less-than-successful photos, deleting duplicates, and so on. This cleans up your storage space, making it less likely you will need more storage in the near future.

A big benefit, though, is that this editing process purges your photos of bad photos you will never print and makes looking at what you have more efficient. You do not need to be reminded that you should have used a tripod or that your flash created ugly glare in a photo — delete those images. In addition, you do not want to go through 20 nearly identical images of Grandma every time you want a print of her.

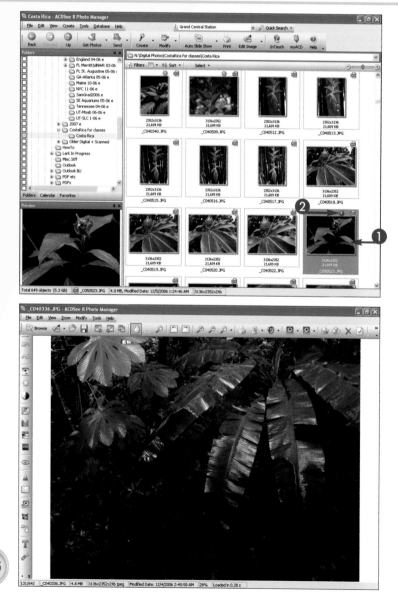

SELECT PHOTOS FOR DELETION

① Click poorly exposed images, out-of-focus shots, and other problem photos.

You can resize the Preview panel so that you can spot flaws more easily.

② As you click them, press Ctrl+1 to tag each one with a 1 rating.

③ You can go through the images full size by double-clicking a photo.

④ Click Zoom→Fit Image to view the entire image.

⑤ Click the Previous Image and Next Image icons on the toolbar or the Page Down and Page Up keys on your keyboard to move through the photos.

⑥ Rate the poor shots with Ctrl+1.

You can press the Esc key to return to the thumbnail view.

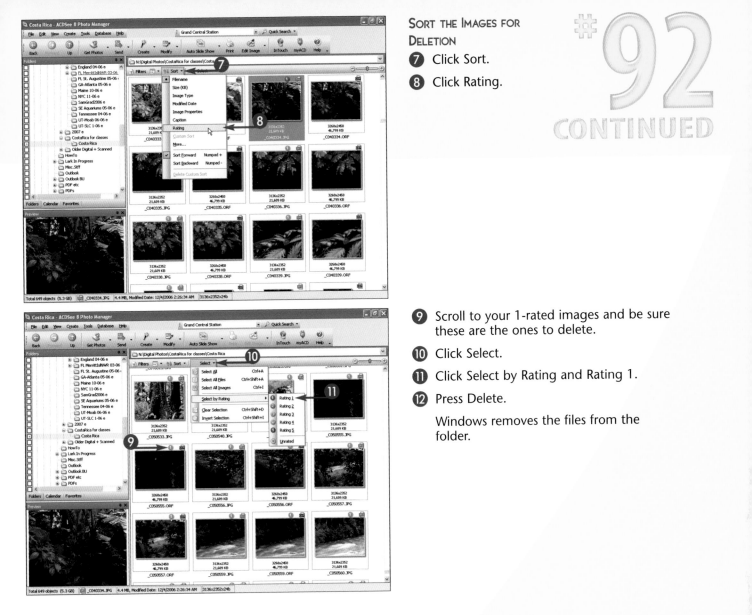

⑦ Click Sort.

⑧ Click Rating.

⑨ Scroll to your 1-rated images and be sure these are the ones to delete.

⑩ Click Select.

⑪ Click Select by Rating and Rating 1.

⑫ Press Delete.

Windows removes the files from the folder.

TIP

Did You Know?

ACDSee's virtual albums enable you to save disk space while being able to view thumbnails of the same digital photo in multiple categories. For example, you can save all the digital photos from a trip to Europe in a single folder. You can then create separate gallery folders for landscapes, cities, seascapes, and castles. By Ctrl-clicking a group of landscape photos in the Europe folder, you can drag them to the landscape gallery. You can do the same for all the city, seascape, and castle photos in the Europe folder. This lets you view all the thumbnails for images of a single subject by just clicking an album category, no matter what folder contains the original digital photo file — all while having only a single copy of the file.

ARCHIVE
your digital photo collection to a DVD

Hard drives fail. The older your hard drive is, the more likely it is to fail. To avoid losing all or part of your digital photo collection, you should keep your photos well organized with an image manager and have a procedure in place for periodically *archiving,* or copying, them to another hard drive or to removable media, such as a DVD.

One of the easiest and safest ways to archive your digital photos is to burn, or write, them to a DVD. To do that you need a *DVD burner* — a DVD drive that

both reads and writes DVD discs — and you will need software to manage the process. One excellent software product for archiving digital photos to a DVD is Sonic RecordNow! It is an easy-to-use product that enables you to archive just a few files or many files that require multiple DVD discs. It also comes with software for printing disc labels and jewel and DVD case inserts.

Turn to Task #92 to organize your photos with an image manager.

① Click Data Disc to select the record mode.

② Click Add Files and Folders.

The Select files and folders to add dialog box appears.

③ Find the folder containing the files you want to record.

④ Click the files you want to record.

⑤ Click Add.

The files appear in the Data Disc window.

⑥ Check to be sure you have included a total amount of files under the capacity of the DVD.

TIPS

Did You Know?

Though a DVD is said to hold 4.7GB of data, the actual amount of photos that can be included is less than that. A DVD holds slightly less than six CDs. Using an 8- to 10-megapixel camera to shoot in the RAW format, you can archive around 300-400 digital photos or the equivalent of about 11 rolls of 36-exposure film on a single DVD.

Caution!

Because it is not certain how long a DVD disc will safely store your digital photos, you should take all precautions to protect your archives. It is wise to purchase the highest quality DVD record-once media, not rewritable disks. Look for disks that advertise long life, such as Verbatim DataLife or Delkin Gold. This care may help prevent you from losing photos on defective media.

ARCHIVE
your digital photo collection to a DVD

When choosing a DVD burner and DVD discs, you must be careful to choose the right format. What is the right format? Unfortunately, drive and media manufacturers have been engaged in a standards war, so there are multiple competing formats in the marketplace. Some of the more common formats include DVD-R, DVD+R, DVD-RW, and DVD+RW.

When choosing a format to archive your digital photographs, you may want to make sure that you choose a drive that allows you to write digital video

slideshows to view on your computer or TV screen. Many manufacturers are making the choice easier by offering DVD burners that can write in multiple formats. To learn about creating a slideshow to view on a DVD player, see Task #97.

Even though there are competing DVD formats, there is *not* a good reason not to buy a DVD burner for archiving your digital photographs. DVD burners are currently one of the best ways to archive your digital photos for safekeeping.

● The Disc Info space shows the available space and how many disks are needed if the files total more than the size of the disk.

Note: Large digital photo collections may need to be archived to more than one disc.

● You can click a folder or file and then press Delete to remove that folder or file from the list of items to be copied.

❼ Click the Burn button.

The Burning Disc Progress graph shows a visual chart of the burning status and the estimated time to complete recording.

HP DVDRW 9 (E:)
Progress: 5:01 Remaining

Burning disc

Burning disc, please wait...

Estimated Time Remaining: 5:01

Cancel Burn

HP DVDRW 9 (E:)
Burn successful

Burn Completed

Your disc was created successfully.
To make another copy now, insert a blank disc and click Make Another. To save this file list so you can easily make another copy later, click Save. Otherwise, click Done.

Make Another Save Disc Label Done

● After verifying the photos were saved okay, you get a message that the disc was created successfully.

● You can create a label for the disc at this time.

#93 CONTINUED

TIPS

Caution!

Be very careful about how you label your DVD. Never use a small stick-on label — that creates a balance problem that can make the disc unreadable. Only use full-size, circular labels made for labeling discs. You can also use printable discs that can be printed in some Epson printers. In addition, you can use LightScribe drives that can also label a disc in the drive.

Did You Know?

DVD drives require firmware and a driver. If you are having problems with your DVD drive, you should check the vendor's Web site for new drivers or firmware. Vendors usually provide easy-to-follow instructions for downloading and installing both the drivers and firmware. When downloading the drivers, make sure to select the correct one for your operating system.

Create a
PDF SLIDESHOW

One of the more fun ways to share photos is to create and view them in a slideshow on a computer screen. You can use many applications to create slideshows. Adobe Photoshop Elements enables you to quickly and easily create a PDF slideshow. A *PDF* (portable document format) is a special file that can be read using Adobe Acrobat or the free Adobe Acrobat Reader. You can view PDF files on just about all computers. So, you can create a slideshow using a PC or Mac and share it with anyone, no matter what computer he or she is using.

After you have created a PDF slideshow, all the photos and the settings that you selected for playback are contained in a single file. A significant advantage to sharing your digital photos in PDF format is that there are a number of useful features built into Acrobat Reader that allow the images to be exported, edited, printed, and so on, which you cannot do with other slideshows.

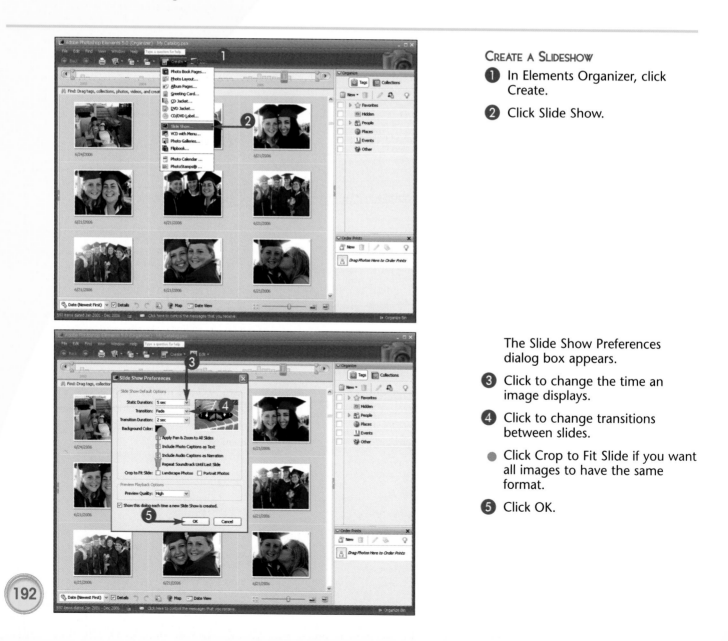

CREATE A SLIDESHOW

① In Elements Organizer, click Create.

② Click Slide Show.

The Slide Show Preferences dialog box appears.

③ Click to change the time an image displays.

④ Click to change transitions between slides.

● Click Crop to Fit Slide if you want all images to have the same format.

⑤ Click OK.

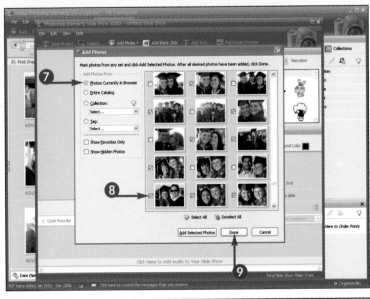

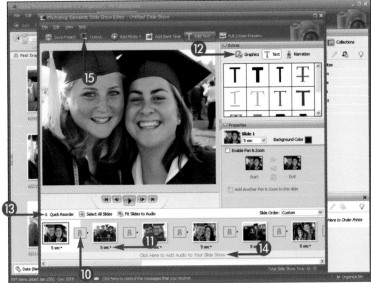

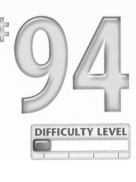

The Photoshop Elements Slide Show Editor dialog box appears.

⑥ Click Add Photos.

The Add Photos dialog box appears.

⑦ Click to select the source of the photos.

⑧ Check the images you want to select for the show.

⑨ Click Done.

You are returned to the Slide Show Editor window.

⑩ Click here to change an individual transition.

⑪ Click here to change a specific slide duration time.

⑫ Click here to add graphics and text to the photo.

⑬ Click here to reorder the photos.

⑭ Click here to add audio to the photos.

⑮ Click here to output the show to save the slideshow.

Click Save as File and PDF file.

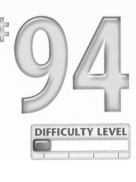

DIFFICULTY LEVEL

TIPS

Did You Know?

To view Acrobat slideshows created with Adobe Photoshop Elements, you need a copy of Adobe Acrobat or the free Acrobat Reader. You can download a free copy of Adobe Acrobat Reader at www.adobe.com. When using Acrobat Reader, you can easily export and edit pictures, print pictures, order prints online, and order photo objects online by simply clicking the Picture Tasks button in Acrobat Reader.

Did You Know?

An Acrobat-based slideshow is easy to create and easy to share because there is only a single file instead of one file for each photo plus additional files for a slideshow program and slideshow settings.

Create a
DIGITAL PHOTO ALBUM

You can create the digital equivalent of a photo album with virtual flipping pages with one of the FlipAlbum products from E-Book Systems, available at www.flipalbum.com. You can choose from multiple versions of FlipAlbum. FlipAlbum Standard automatically organizes your photos into realistic page-flipping albums that you can view on a PC (not Mac) and share on the Internet. FlipAlbum Suite has extra features that enable you to share your albums on CDs or to play them on DVD players. FlipAlbum Pro offers all the features of the other

two products plus security features, including a disc password option, image encryption, watermark capabilities, and a print lock feature to control how images are printed. Mac FlipAlbum is for a Macintosh.

When you create an album, FlipAlbum automatically creates a front and back cover, thumbnail image pages to be used as a table of contents, and an index. Images can be ordered based on the filenames, or you can click and drag the thumbnail images to order them as you want them.

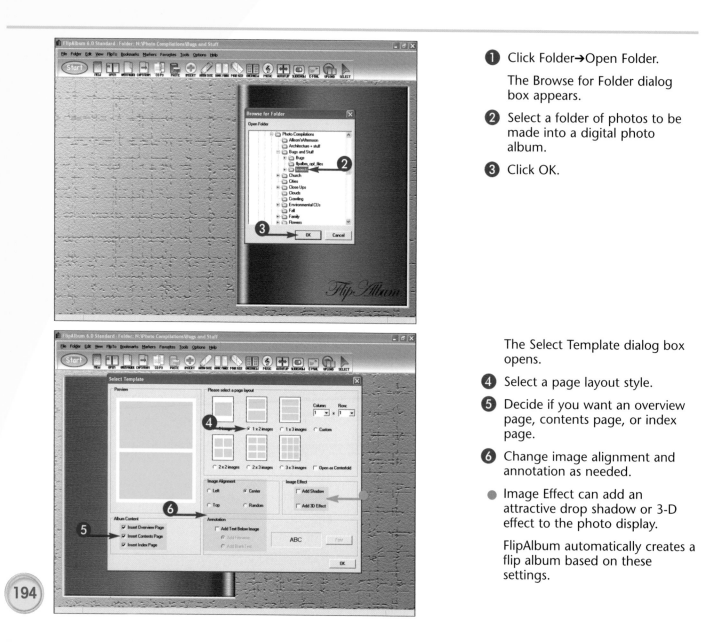

❶ Click Folder→Open Folder.

The Browse for Folder dialog box appears.

❷ Select a folder of photos to be made into a digital photo album.

❸ Click OK.

The Select Template dialog box opens.

❹ Select a page layout style.

❺ Decide if you want an overview page, contents page, or index page.

❻ Change image alignment and annotation as needed.

● Image Effect can add an attractive drop shadow or 3-D effect to the photo display.

FlipAlbum automatically creates a flip album based on these settings.

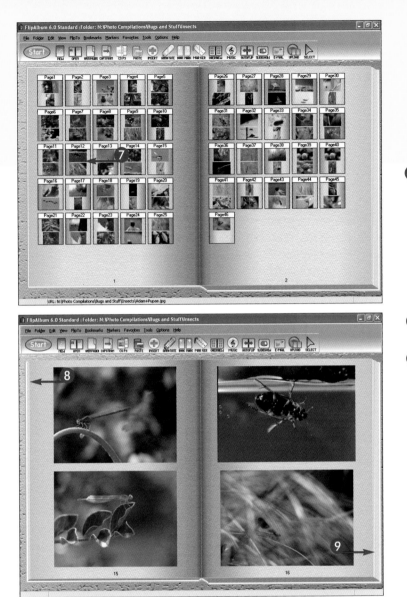

Thumbnails are automatically generated and placed at the front of the album.

To change the viewing order of the images, you can click and drag and drop the thumbnails.

7 To view a full-size image on an album page, click its thumbnail.

8 To turn a page, click the far side of a page to view a flipping page effect.

9 To view the index, go to the back of the album.

FlipAlbum automatically creates a clickable index at the end of each album when a folder is opened.

TIPS

Did You Know?

You can further customize a FlipAlbum by selecting a different cover style or by choosing your own cover color, cover image, texture, and binding. You can also choose the color and texture of the pages, the margins, and how the pages "flip." You can add background music and set the entire album to flip automatically. You can add text to each page in the font style and color of your choice, and you can even add a link to a specified Web page.

Apply It!

You can upload your FlipAlbums to the E-Book Systems Web site specifically for sharing FlipAlbums at www.myflipbooks.com.

Create a
WEB PHOTO GALLERY

If you want to show off your photos to anyone in the world who has a computer and a connection to the Internet, you can create an online photo gallery. To create an online photo gallery, you typically need digital photos sized and optimized for use on the Internet, thumbnail photos sized and optimized for use on the Internet, and HTML-based pages (Web pages) with links to the digital photos and thumbnails. Creating all of this without a tool such as Adobe Photoshop Elements is a tedious and time-consuming process.

Using the Adobe Photoshop Elements Web Photo Gallery feature, you can have your online gallery up and running in just a few minutes. Before you run the Web Photo Gallery feature, you should first prepare your digital photos and create a folder in which to put all the images. You should then select these images in Elements Organizer. Although you can use the Web Photo Gallery feature to automatically size and compress each digital photo, you may get better results sizing and compressing each digital photo with the Save for Web command (see Task #91).

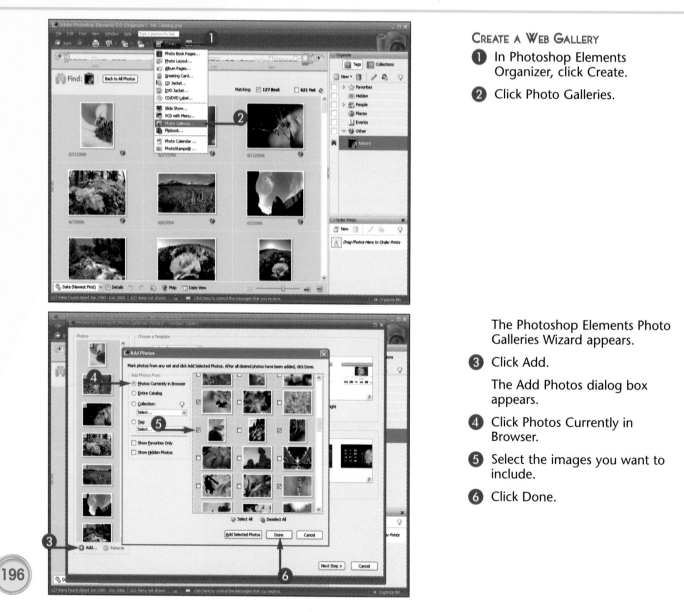

CREATE A WEB GALLERY

1 In Photoshop Elements Organizer, click Create.

2 Click Photo Galleries.

The Photoshop Elements Photo Galleries Wizard appears.

3 Click Add.

The Add Photos dialog box appears.

4 Click Photos Currently in Browser.

5 Select the images you want to include.

6 Click Done.

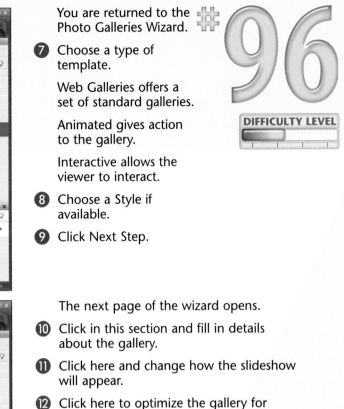

You are returned to the Photo Galleries Wizard.

7 Choose a type of template.

Web Galleries offers a set of standard galleries.

Animated gives action to the gallery.

Interactive allows the viewer to interact.

8 Choose a Style if available.

9 Click Next Step.

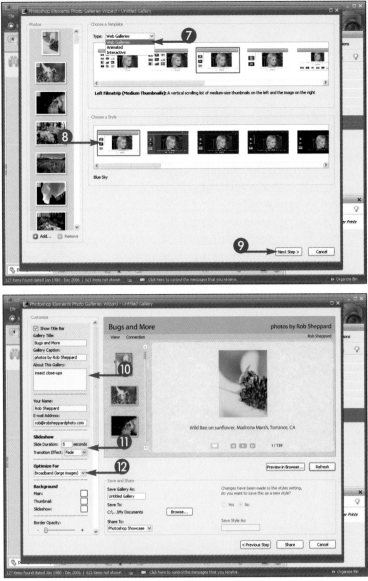

The next page of the wizard opens.

10 Click in this section and fill in details about the gallery.

11 Click here and change how the slideshow will appear.

12 Click here to optimize the gallery for download.

TIPS

Did You Know?

Most Internet service providers offer you 10MB or more of personal Web space that you can use for your digital photo gallery. Check with your service provider to learn more about the file transfer tools that it offers and how to upload your digital photo gallery. Often, you can find this information on your Internet service provider's Web pages.

Did You Know?

The Adobe Photoshop Elements Web Photo Gallery feature can automatically place a caption under each photo on each Web page. Use the File, File Info command in Photoshop Elements Editor to add a caption in the Caption box for each digital photo file.

Create a
WEB PHOTO GALLERY

Many photographers worry about having their digital photos stolen from online photo galleries and used without payment or permission. Although this is a reasonable concern because it does happen, small digital photo files are not all that useful for most commercial purposes. If you keep all your posted images small, with a maximum size of less than 400 pixels, you are not likely to suffer any great loss.

You can take steps to prevent an image from being copied, or you can add a copyright or watermark to online images so that they can be tracked and identified. However, the effort that it takes to add this extra protection is generally not worth it because there are ways around each different approach. If you have good reasons for not wanting your digital photos copied, you should not post them to an open-access Web page on the Internet.

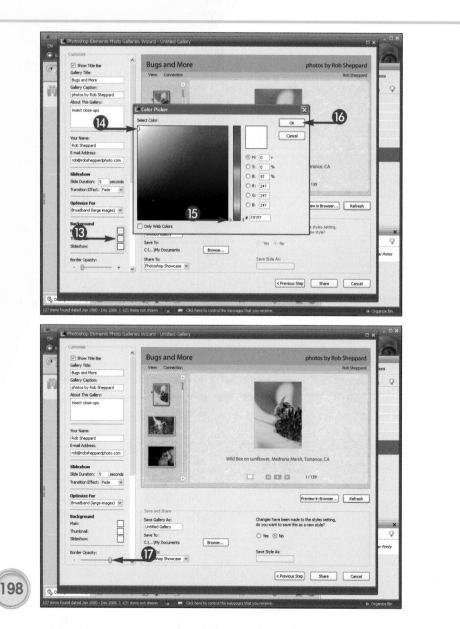

⑬ Click any Background option to change the colors of the gallery background.

The Color Picker appears.

⑭ Click and drag the small circle inside the box to change the brightness or saturation of a color.

⑮ Click and drag the sliders along the vertical color bar to change the hue of the color.

⑯ Click OK.

⑰ Click the Border Opacity slider to change the intensity of the borders between the parts of the gallery.

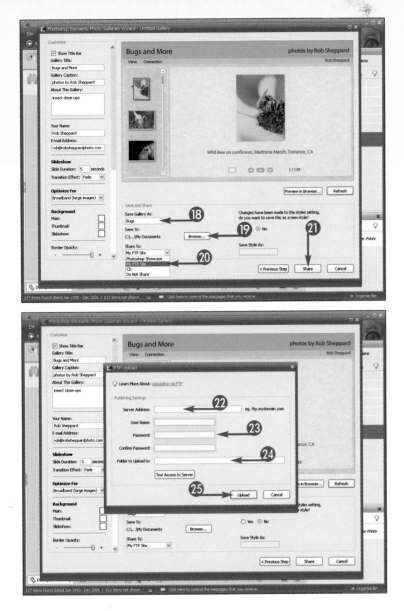

⑱ Save the gallery with a name that makes sense to you.

⑲ Save it to a specific location on your hard drive.

⑳ Select how to share the gallery — for your Web site, it will be My FTP Site.

㉑ Click Share.

The FTP Upload dialog box appears.

㉒ Type the server address with information you get from your Internet service provider.

㉓ Type your user name and password as you have set them up with your Internet service provider.

㉔ Type the folder you will upload to based on your Web site.

㉕ Click Upload.

Elements begins the automatic generation of the Web pages, thumbnails, and any image resizing that is required.

TIPS

Did You Know?

GlobalSCAPE's CuteFTP (www.globalscape.com) is one of the most popular file-transfer software tools used for uploading Web pages and images to an Internet sever. You can download a trial version from the vendor's Web page.

Did You Know?

You can change the graphics and the layout of any of the preset Web page styles that are supplied with Adobe Photoshop Elements. You can find a separate folder in the C:\Program Files\Adobe\Photoshop Elements 5.0\shared_assets\templates folder for each of the styles. To modify a style, first copy the contents of the folder containing the style that you want to a new folder with a different name. Then edit or replace the images or modify the HTML code with an HTML editor.

Create a
VIDEO SLIDESHOW

People create slideshows for many reasons. Maybe you have just returned from an overseas trip with lots of great photos, and you want to share them with friends and family. Or maybe you have dozens of flower or antique car photos that you would like to share. You may even want to create a slideshow featuring your children or your parents over the years. Whatever the reason, there are many ways to both create and present slideshows.

Adobe Photoshop Elements can create slideshows on VCDs or DVDs to be played back on a DVD player

and displayed on a TV. Using the Photoshop Elements Slide Show Editor, you create slideshows that you can view on a computer screen or on a TV by putting them on a Video or VCD.

An advantage of using a DVD player and a TV for viewing your slideshows is that you can control each slide with the DVD player control, which enables you to go forward or backward, or go to a main menu to select another slideshow.

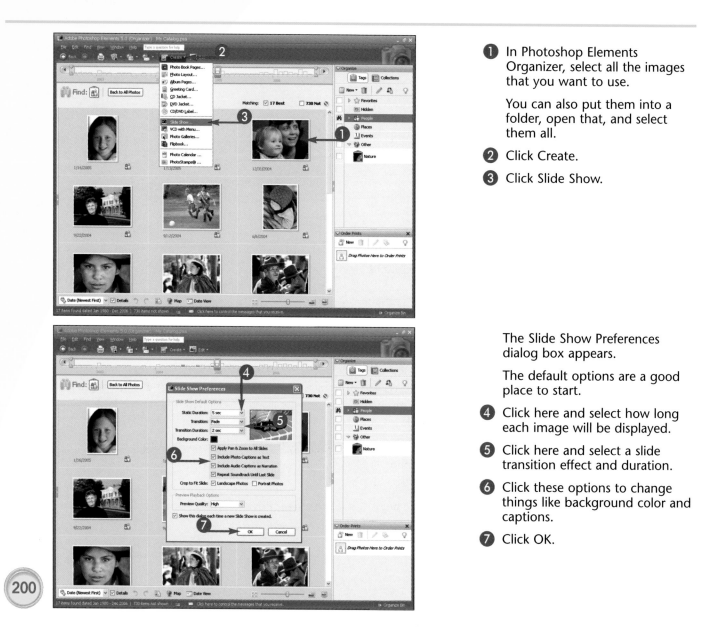

① In Photoshop Elements Organizer, select all the images that you want to use.

You can also put them into a folder, open that, and select them all.

② Click Create.

③ Click Slide Show.

The Slide Show Preferences dialog box appears.

The default options are a good place to start.

④ Click here and select how long each image will be displayed.

⑤ Click here and select a slide transition effect and duration.

⑥ Click these options to change things like background color and captions.

⑦ Click OK.

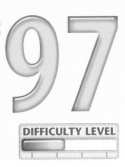

The Slide Show Editor page appears.

- Cartoon characters can be dragged onto photos.

8 Minimize choices by clicking the triangular arrow.

- Selected photos appear in a filmstrip at the bottom.

 Photos can be dragged and dropped to a new order.

9 Click here for a slide table view for reordering photos.

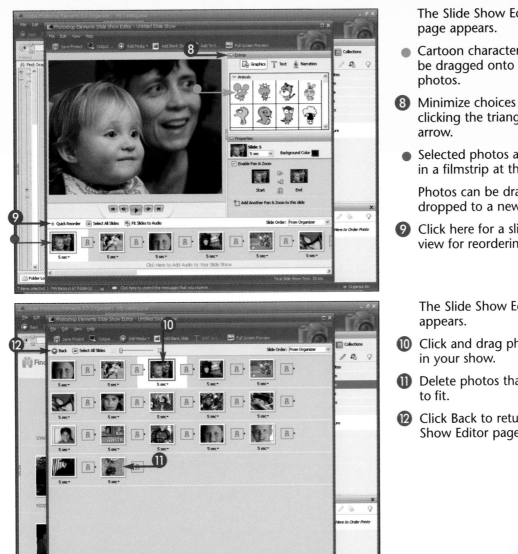

The Slide Show Editor slide table panel appears.

10 Click and drag photos for a better order in your show.

11 Delete photos that now do not seem to fit.

12 Click Back to return to the main Slide Show Editor page.

TIP

Did You Know?

Video CDs (VCDs) are CD-recordable discs containing audio, video, and still images encoded in the highly compressed MPEG (moving pictures experts group) format. The VCD format offers lower-quality images than either the SVCD or DVD formats. Image resolution of full-motion video typically falls below standard VHS videotape, but still images display clearly.

Super video CDs (SVCDs) offer better image and sound quality than VCDs, but are not as good as DVDs. However, SVCDs are a good choice for photographers because they represent an acceptable compromise between inexpensive media and high-resolution images.

A DVD is a DVD-recordable disc that can be played in most standalone DVD players and computer DVD-ROM drives. The DVD format holds the most content and has the highest image quality.

Create a
VIDEO SLIDESHOW

CDs, DVDs, and set-top DVD players play many prerecorded media, but there is no reason why you should not enjoy the benefits of this technology now for your slide shows. Carefully check documentation and consult knowledgeable sales staff when purchasing new hardware and media, and read the documentation that came with products you already have.

Each of the many types of discs and file formats has advantages and disadvantages. If you have only a CD burner, it is possible that you can use it to create

a VCD or SVCD featuring a photo slide show that can be viewed on a computer with a CD-ROM reader or on a newer DVD player.

To output a DVD slide show, you must have a DVD burner and DVD-recordable discs (DVD-Rs or DVD+Rs — do not use RW discs). For a VCD or SVCD slide show, you need a CD burner and CD-Rs. Picking the right disc for the CD or DVD reader or set-top DVD player is as easy as reading the manuals or checking with the vendor.

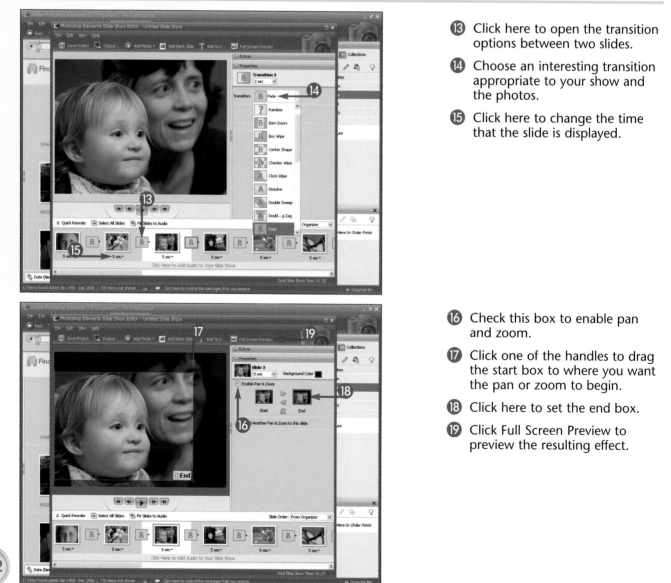

⑬ Click here to open the transition options between two slides.

⑭ Choose an interesting transition appropriate to your show and the photos.

⑮ Click here to change the time that the slide is displayed.

⑯ Check this box to enable pan and zoom.

⑰ Click one of the handles to drag the start box to where you want the pan or zoom to begin.

⑱ Click here to set the end box.

⑲ Click Full Screen Preview to preview the resulting effect.

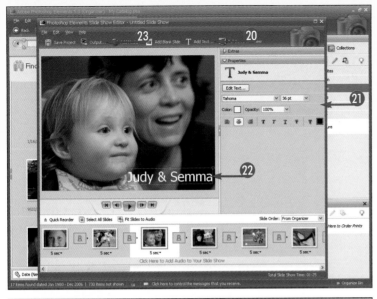

20 Click here to add a title.

21 Use these options to change the font, size, color, and more.

22 Click and drag text into position.

23 Click Output Slide Show to view all the output options.

Choose DVD or VCD depending on if you have a DVD or CD burner.

Click Burn to Disc.

The Burn dialog box appears.

Note: The default settings are usually best.

24 Click OK.

The burn-to-DVD process begins, and a status bar indicates the percentage that is completed.

After the disc has been burned, it ejects and is ready to be played in a DVD player.

TIPS

Caution!
Older set-top DVD players may not be able to play either the VCD or SVCD discs. Some of the newer-model set-top DVD players may have problems playing a CD-R disc, but will play a CD-RW disc. Normally CD-RWs are not recommended because they are not as stable as CD-R discs, but in this case, you may need to try a CD-RW disc.

Did You Know?
When you create a video slideshow using Adobe Photoshop Elements Slide Show Editor, you can add digital video clips, music, and multiple slideshows. You can also create your own title screen with selectable menu options similar to those generally found in commercially produced DVD movies; this enables you to have more than one slideshow on a DVD.

Create
SCRAPBOOK PAGES

Scrapbooking is very popular and based on cutting up printed photographs and creatively placing and gluing them on a single page, making a photo collage. The photos can go together for many reasons, plus you can use backgrounds to visually support the group. However, the process of creating a collage in this manner takes some skill and lots of time.

Adobe Photoshop Elements, on the other hand, includes a handy Photo Layout option in the Create feature that will help you make excellent scrapbooking pages. The wizard creation page offers many standard and easy-to-use options for photo layout and backgrounds. Elements resizes your photos to fit the page layouts, so you do not have to resize images first. You can, however, change the way Elements sizes and places photos by moving them around and resizing them as needed. You can also add any additional images you want.

Scrapbooks make superb gifts. The next time that you need to give a gift, consider making a photo scrapbook, customized for the recipient using your photographs.

① In Photoshop Elements Organizer, select photos that you want to use.

② Click Create.

③ Click Photo Layout.

The New Photo Layout Wizard appears.

④ Click to select a size.

⑤ Click to select a layout.

⑥ Click Auto-Fill with Selected Images from the Organizer.

⑦ Click the check box to include captions.

8 Click to select a theme.

● The number of pages is generated automatically based on your photo selections.

9 Click OK.

The photos appear laid out on a page in the Elements editor.

● Every photo is in its own layer.

● Multiple pages appear here.

● You can move and resize images with the Move tool.

● The Text tool lets you add text to a new layer.

You can save your page as a Photoshop (.psd) file and retain the layers for revision at another time.

TIPS

Did You Know?

You can have photo captions printed below each photo. Place a check mark in the Captions box in the Photo Layout Wizard and then enter captions in the digital photo files. To enter captions into the digital photo files using Photoshop Elements Editor, click File, File Info to open the File Info dialog box. Then type the caption in the Caption box and save the file.

Did You Know?

Many scrapbookers like to use 12-x-12-inch pages, but to do that, you must have a printer capable of printing that size. Standard-size printers are 8.5 x 11 inches, which can be used with Photo Layouts when that size is selected in the wizard. The next-size-larger printer does up to 13-x-19-inch prints, which easily prints a 12-x-12-inch page.

Create a
PHOTO GREETING CARD

The next time that you need a greeting card, you can make your own personalized card especially for the recipient using one or more of your photos. As you work through each step of the Create a Card Wizard, your steps are automatically saved in a file so that you can quickly make another copy or modify an existing card to create a new one.

One of the strengths of Adobe Photoshop Elements is that the product is designed so that you can download new templates or styles for many of the

creation types when they become available. You can also use various online services such as MyPublisher print services and Shutterfly. After you have signed up for one of these services, you can use it as quickly as you can complete your digital photo projects. To see if new services are available, choose Edit, Preferences, Services, and then click Updated Creations. If new services are available, they will be integrated into Adobe Photoshop Elements.

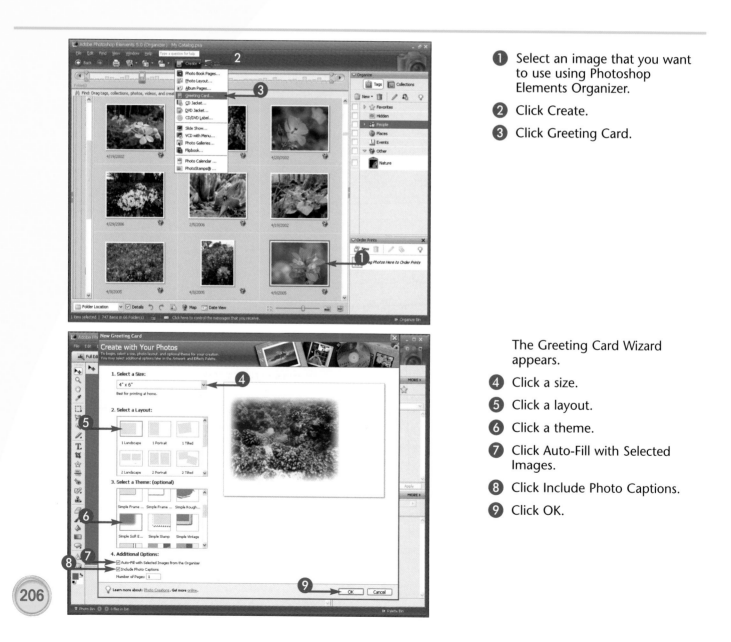

① Select an image that you want to use using Photoshop Elements Organizer.

② Click Create.

③ Click Greeting Card.

The Greeting Card Wizard appears.

④ Click a size.

⑤ Click a layout.

⑥ Click a theme.

⑦ Click Auto-Fill with Selected Images.

⑧ Click Include Photo Captions.

⑨ Click OK.

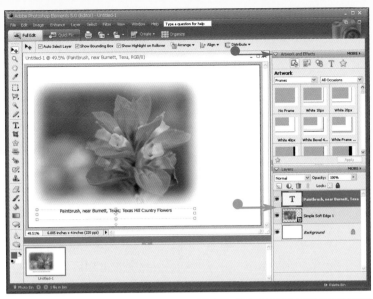

The card design appears in the Photoshop Elements Editor.

● The photo and caption appear as layers.

● Artwork and Effects is visible to give you additional effects for the photo.

DIFFICULTY LEVEL

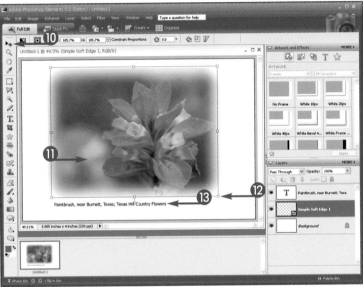

⑩ Click the Move tool.

⑪ Click the photo to move it.

⑫ Click the small squares around the move frame to resize the photo.

⑬ Do the same with the caption.

TIPS

Did You Know?
The Adobe Photoshop Elements Create a Card Wizard makes it easy for you to print greeting cards with your own desktop printer. You can also publish a card as a PDF file or as an attachment for e-mail; plus, you can save the card to a CD or order the card to be printed professionally from an online service vendor.

Did You Know?
Many stationery vendors make greeting card paper and matching envelopes especially for use with inkjet printers. You can find tinted, glossy, embossed, matte, and many other varieties in a pre-scored format for easy and accurate folding. Check your local office supply store or order online from www.staples.com or www.officedepot.com.

Create a
PHOTO GREETING CARD

Greeting cards give you the opportunity to use and share your photos with friends and family. As a digital photographer, you will start to have a lot of images on your hard drive. Putting them on greeting cards lets you express your creativity, plus the cards are always welcome. Hallmark is such a strong name in the business because it has done such a good job in promoting cards and all sorts of holidays.

You can start your own holidays, plus you can make each card a very personal creation specific for a recipient. You can use a person's name in Happy

Birthday text, for example. If you save your file as a Photoshop (.psd) file, you can always reuse the photo and text by simply changing the name in the text.

You will find that simple designs for greeting cards generally work best. That means keeping photos and text to a minimum. In addition, keep the text font simple and easy to read, too. Odd fonts may look interesting, but the classic, simple fonts will give your card more elegance.

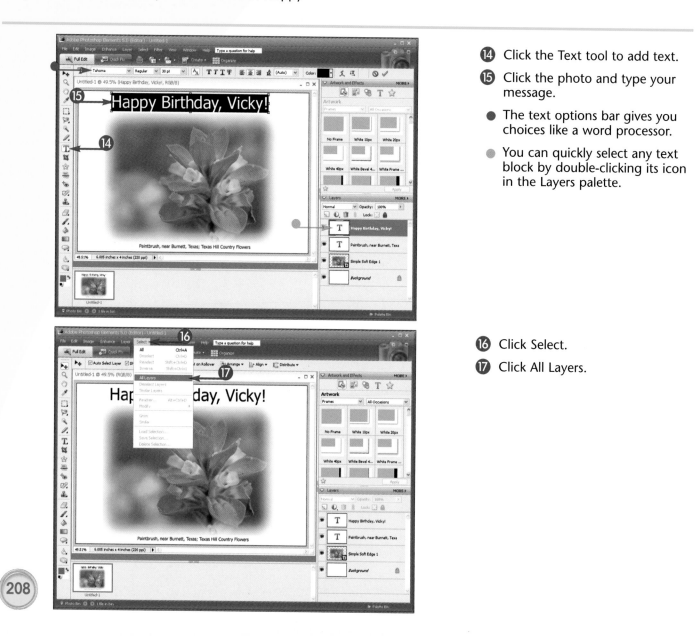

⑭ Click the Text tool to add text.

⑮ Click the photo and type your message.

● The text options bar gives you choices like a word processor.

● You can quickly select any text block by double-clicking its icon in the Layers palette.

⑯ Click Select.

⑰ Click All Layers.

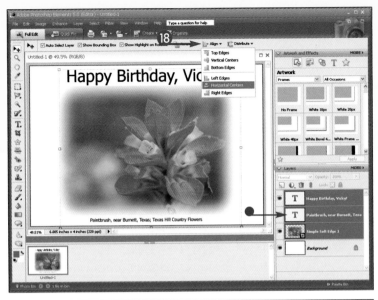

- Selected layers appear highlighted in the Layers palette.

⑱ Click Align for options on aligning all of the layers together in relation to the edges of the card.

In this example, both text layers and the photo are center-aligned horizontally.

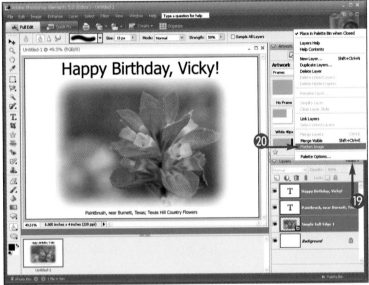

⑲ Click More on the Layers palette for its menu.

⑳ Click Flatten Image to create a complete photo that can be saved compactly and printed at any time.

If you think you might want to change the text, save the photo as a Photoshop file without flattening.

Your greeting card is ready to print. Choose the right size paper for the card you made.

TIPS

Did You Know?

You can create a PDF file instead of printing the greeting card to your own desktop printer. When you complete the card, choose File, Save As, and choose Photoshop PDF. Then you can select settings to optimize the file for viewing on-screen, for printing, or for full resolution. This is a nice feature if you want to create a greeting card that can be shared easily by e-mail.

Did You Know?

The Artwork and Effects palette offers many options for customizing your card. You can change backgrounds, background themes, frames around photos, and more. Simply open the section of the palette that offers the choices you need. Click the image in the card, then double-click the effect and it will appear in the card. You can freely experiment with the effects by continuing to double-click them.

Create a
PHOTOMONTAGE

A fun way of displaying photos is to assemble a group of photos taken on a vacation, a family get-together, or a sporting event. Cutting out individual photos and sticking them on a backing before putting them into a frame is awkward and frustrating.

In sharp contrast, making a photomontage with Adobe Photoshop Elements is both easy and fun. Not only are all the photos printed on a single page, which is why it is called a *photomontage* instead of a *collage*, but the process enables you to size and easily crop each image as needed.

Pick photos that go together and support each other in some way, either from a theme or even a story. Before you begin placing the digital photos on a new blank document, first roughly size the photos so that you minimize the work that it takes to resize them as you place them. When you have resized each photo, dragging, dropping, placing, and sizing each digital photo is a simple process.

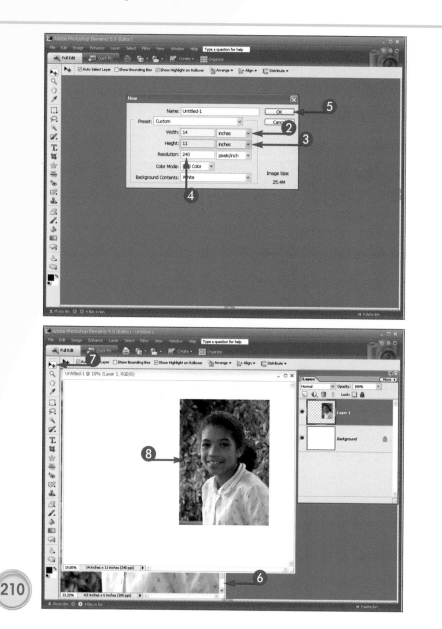

CREATE A PHOTOMONTAGE

① Click File→New.

The New dialog box appears.

② Type the width, in inches, that you want for the finished photomontage.

③ Type the height, in inches, that you want for the finished photomontage.

④ Specify a resolution of 240 ppi.

⑤ Click OK to create a new document.

⑥ Open one or more images to use in the photomontage.

⑦ Click the Move tool.

⑧ Drag the images to the new document.

The images appear in the new document window.

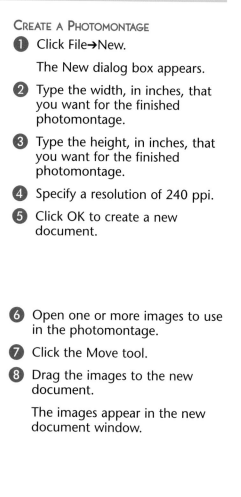

210

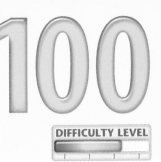

100

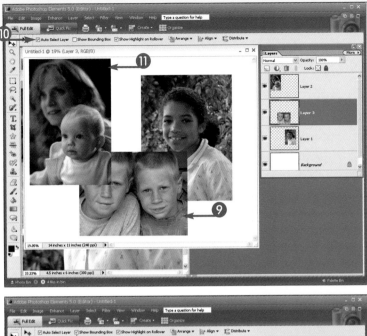

⑨ Repeat Steps 6 to 8 until you have added all the photos to the new document.

⑩ Click Auto Select Layer if it is not already checked.

⑪ Drag images to where you want them in the new document window.

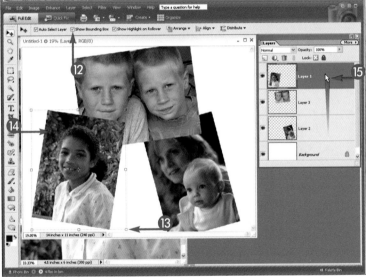

⑫ Click Show Bounding Box.

⑬ Click and drag the squares of the bounding box to resize images.

Rotate the boxes by moving the cursor just outside a corner and click and drag.

⑭ Click the image to highlight it in the Layers palette.

⑮ Click the highlighted layer in the Layers palette and drag it up or down until the layer order is as you want it.

TIPS

Did You Know?
When arranging photos in a photomontage, keep it simple. With Photoshop Elements, it is certainly possible to add lots of photos, make them all sorts of sizes, and then rotate them in every direction. This will be very confusing for people viewing the montage. Keep your photomontage design simple so it is better understood and enjoyed.

Did You Know?
When you have completed placing, sizing, and ordering all the images in a photomontage, you can easily add a shadow line to each photo to add depth to your work. Simply click each layer in the Layers palette and then click your choice of shadow from the Drop Shadows styles found in the Layer Styles palette.

Index

Numbers and Symbols

35mm equivalent focal length, digital cameras, 68–69
+/- button, exposure compensation, 50–51

A

ACDSee
 annotations, 182
 batch rename, 182, 183, 18
 calendar view, 183
 copyright information, 182
 deleting images, 187
 EXIF data display, 182–183
 image format conversions, 182
 image management software, 182–187
 image sorts, 183
 keywords, 182, 183, 185
 metadata, 183
 preview image display, 182
 renaming images, 183
 resizing images, 182
 selections, 186
 sorts, 187
 thumbnail image display, 182–183
 viewing/editing images, 182
 virtual albums, 184–185, 187
 virtual catalogs, 182, 184
action shots, "Wow" factor, 104
Add Photos dialog box, printing multiple photos on a page, 173
Adjust Sharpness tool, Photoshop Elements, 167
adjustment layers
 Brightness/Contrast, 151
 enabling/disabling effects, 147
 image flattening, 147
 layer masks, 148–150
 Photoshop Elements, 146–147
 retaining original, 117
 unlimited readjustments, 7
Adobe Acrobat Reader, PDF files, 192–193
Adobe Acrobat, PDF files, 192–193
Adobe Camera RAW
 double-processing images, 156–157
 RAW file conversion, 128–129
Adobe Gamma, monitor calibration tool, 163
Adobe Photoshop Elements. See Photoshop Elements
AdobeRGB color space, Photoshop Elements, 130–131
advertising, high-impact techniques, 83
ambient light, flash combinations, 108–109
aperture priority mode (A/Av), use guidelines, 44–45
aperture size
 background control, 72–73
 depth of field element, 62–63
 depth of field guidelines, 73
 fractions, 73
 going to extremes, 79
 lens speeds, 63
 shallow depth of field, 66–67
 subject focus techniques, 96–97
 sunburst effect, 79

aperture value mode (Av), use guidelines, 44–45
aperture-priority mode, deep depth of field, 64–65
Apple's ColorSync, monitor calibration tool, 163
archives, DVD discs, 188–191
art shows, distinct style/theme advantages, 85
auto rate, disabling for vertical shots, 89
Auto White Balance (AWB)
 consistency issues, 16–17
 shade inconsistency, 27
auto-bracketing, exposure levels, 41
autofocus points, off-center subjects, 47

B

backgrounds
 control techniques, 72–73
 subject bracketing, 88
 subject focus techniques, 97
backlight, bright sunlight conditions, 26
bags, gear guidelines, 20
black and white images, color conversion, 155
black/white adjustments
 Levels, 120–121
 workflow process, 114
blending modes, Photoshop Elements, 152–153
blown-out highlights, avoiding, 52–53
botanical gardens, photo opportunities, 2, 5
bounce flash
 indoor lighting, 36
 red eye prevention, 37
bracketing, composition techniques, 88–89
brightness level, histogram display, 48–49
Brightness/Contrast adjustment layer, Photoshop Elements, 151
building interiors, night shot opportunities, 111

C

calendar view, ACDSee, 183
camera controls, digital camera, 8–9
camera-to-subject distance
 background control factor, 72–73
 depth of field element, 63
captions, scrapbook pages, 205
center-weighted mode, use guidelines, 46–47
city streets, night shot opportunities, 111
Clone Stamp tool, unwanted element removal, 154
close-up photos, details, 86–87
cloudy conditions
 photo opportunities, 25
 white balance adjustments, 16–17
color casts
 white balance influence, 16–17
 window light, 33
color contrasts, dramatic photo techniques, 98–99
color corrections
 Hue/Saturation, 126–127
 Photoshop Elements, 124–125
 workflow process, 114–115
Color Curves, midtone adjustments, 122–123

Index

Index

Index

Index

Read Less–Learn More®

Want more simplified tips and tricks?

Take a look at these

All designed for visual learners—just like you!

978-0-7645-9616-2

978-0-470-04574-9

978-0-471-93382-3

Visual®
An Imprint of ®**WILEY**
Now you know.